Simply
Beautiful
Photographs

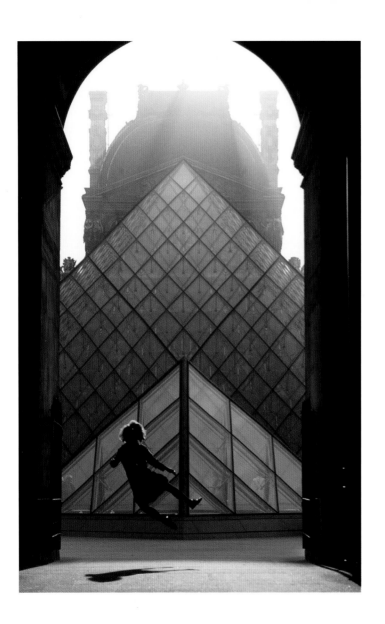

Simply
Beautiful
Photographs

Annie Griffiths

**NATIONAL
GEOGRAPHIC**

WASHINGTON, D.C.

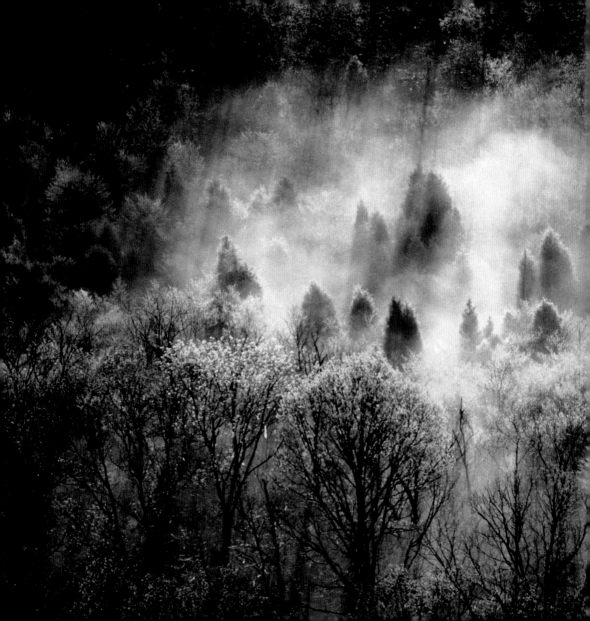

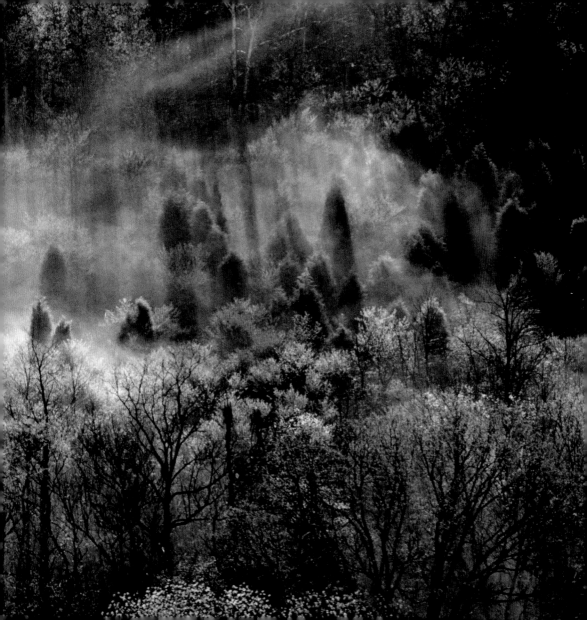

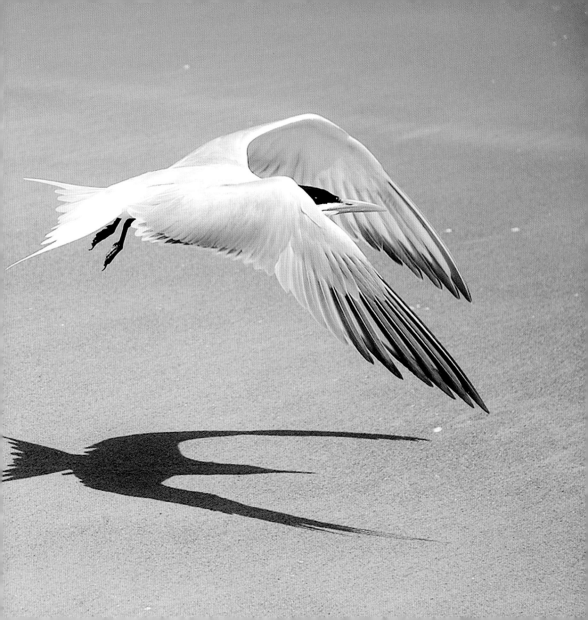

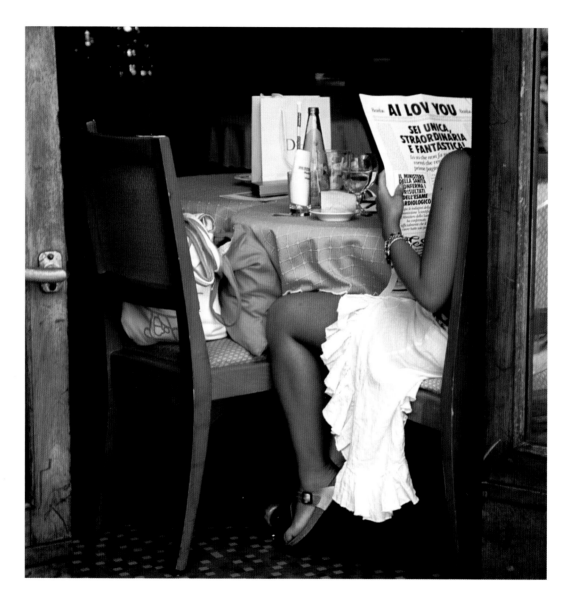

Contents

❧

opposite: **JODI COBB** | Florence, Italy | A woman in a café reads a cleverly designed greeting card

preceding pages (2-7): **JAMES L. STANFIELD** | Paris, France | A young Parisian is backlit by the Louvre

SAM ABELL | Kelly's Ford, Virginia | Spring blooms in the Virginia hills

ABIGAIL EDEN SHAFFER | A tern takes flight

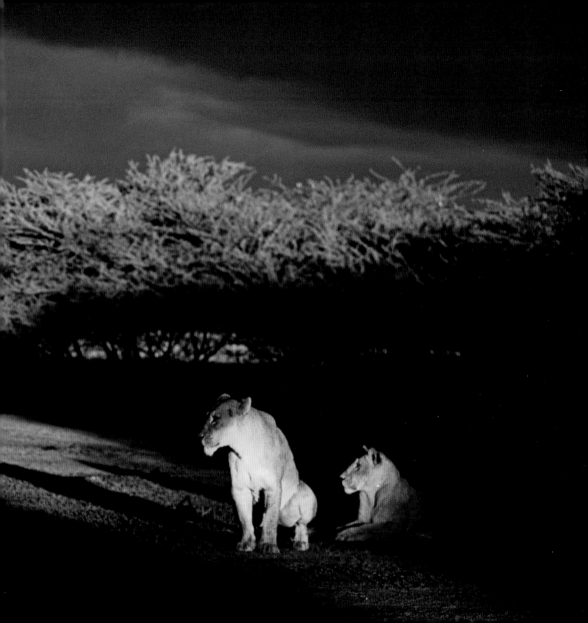

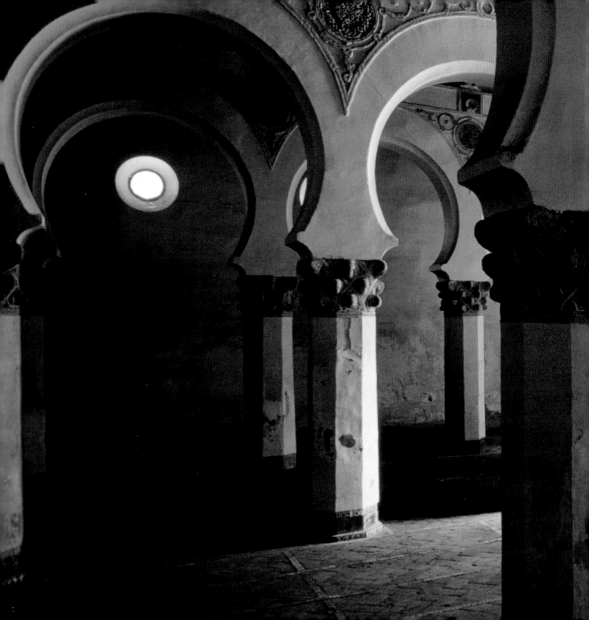

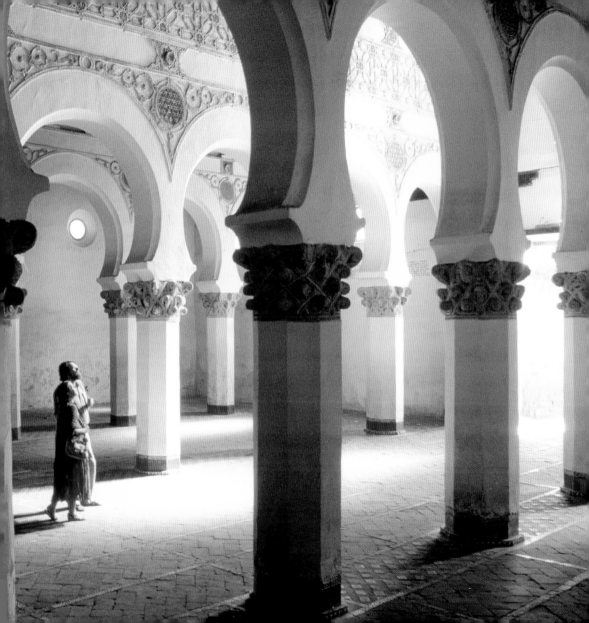

Over the 30 years I have worked in the National Geographic Image Collection, we have received thousands of requests from around the world for prints of our photographs. Typically, a reader turned a page in National Geographic magazine and the image resonated with an emotion or memory. Maybe it evoked a time or place in which the reader lived; maybe it brought to life a vision of a wondrous place; maybe the unquestioned beauty of the image gave the person hope in a time of personal trial. ≈ In the predigital era, providing copies of photographs could be time consuming, often expensive. But, whenever possible, we provided the print. As people who have dedicated their careers to caring for great photography, we understand the power of a beautiful image. We know, too, that there is no choice more personal or more individual. ≈ Our archive holds images dating back to the late 1800s and is an amazing visual repository in size, subject matter, and range of photographic mediums. But what sets the collection apart as the most valuable in the world is the artistry, personal vision, and skill that National Geographic photographers have brought to the photographic art form for more than a century. ≈ Although the editorial process for this book, *Simply Beautiful Photographs,* was long, and in the end, members of the team did not agree on all the images—or even, in some cases, on the very definition of beauty—the structure for the book provided us with a framework for discussing our choices and viewpoints. We have our talented author, Annie Griffiths, to thank for this. Annie, a long-standing National Geographic photographer, decided that we would focus on the basic elements of a photograph and visually demonstrate how the creation of an exceptional image requires not only a

Foreword

by Maura Mulvihill

compelling subject and the photographer's personal vision but a successful execution of these elements. Each chapter focuses on a critical aspect or element of an image: light, composition, moment, time, palette, and wonder. Capturing light, composition, and the right moment are common photographic themes. In her manuscript, Annie brought us around to the idea that time exposure, palette (colors muted or vibrant, or monotone or discordant), and wonder are elements that can push a photograph to the next level. Of course, a truly great photograph is one that combines all these elements, with the photographer's own unique vision. ≈ Our gifted researcher, Lori Franklin, has worked on every kind of visual research project, from encyclopedias to advertisements. She has helped science writers find rare arachnids, graphic designers find "mainly blue" images, and art directors find images that say "trust." But finding beauty was uncharted territory. In creating a book that said "simply beautiful," we all wanted a set of images that would transport the reader to a beautiful place, be that space physical, emotional, or spiritual. First we had to ask ourselves, "What is the definition of beauty?" Can there be resilience and grace in tragedy? Yes. Is there an awe in a perfect mushroom cloud overpowering the horizon? Yes. But is that the beauty we wanted to portray? No. ≈ Encouraged by the words of Ralph Waldo Emerson, "Beauty is its own excuse for being," we decided that this book should take us to a world of beautiful dreams, memories, and meditation. So Lori, Annie, and the rest of the team searched for the most beautiful of pictures: by memory, by photographer, by place, and by subject. After months of reviewing jaw-dropping landscapes, breathtaking portraits, swirling abstracts, and intimate moments, this collection of images emerged. I hope you will agree that each photograph has earned its place in this collection of our most beautiful images. Enjoy!

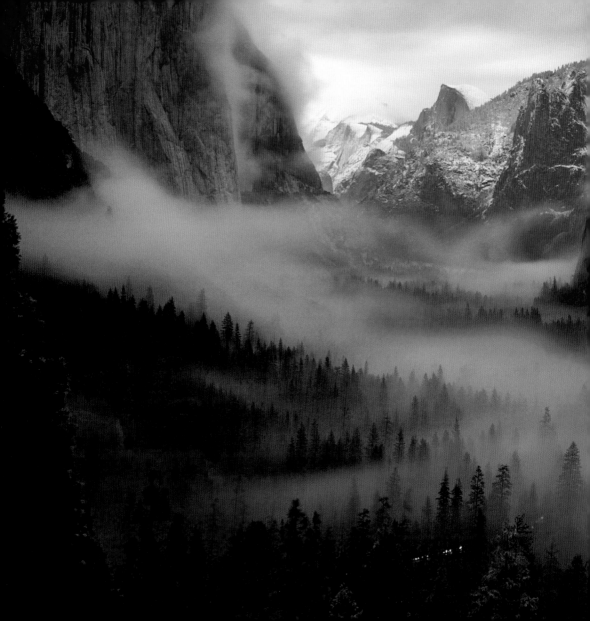

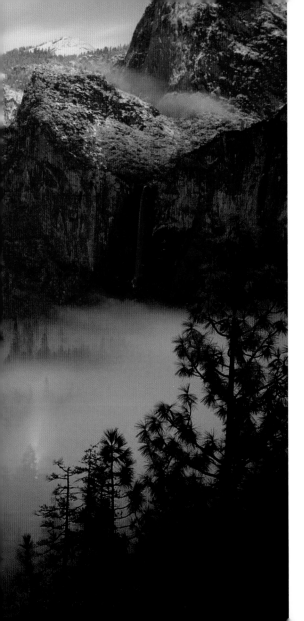

PHIL HAWKINS

Yosemite National Park, California

Mist and moonlight shroud the
Yosemite Valley

preceding pages (10-17)

BEVERLY JOUBERT

Savuti, Botswana

Two lionesses rest in the afternoon
sunlight

FLIP NICKLIN

Hawaii

A researcher films a yearling humpback
whale and its mother

MARTIN KERS

Netherlands

Yellow flowers cover a tree-lined road

JAMES P. BLAIR

Toledo, Spain

Tourists admire the Moorish architecture
of the Church of Santa Maria La Blanca

following pages

MELISSA FARLOW

Shingletown, California

Mustangs wander through the
Wild Horse Sanctuary

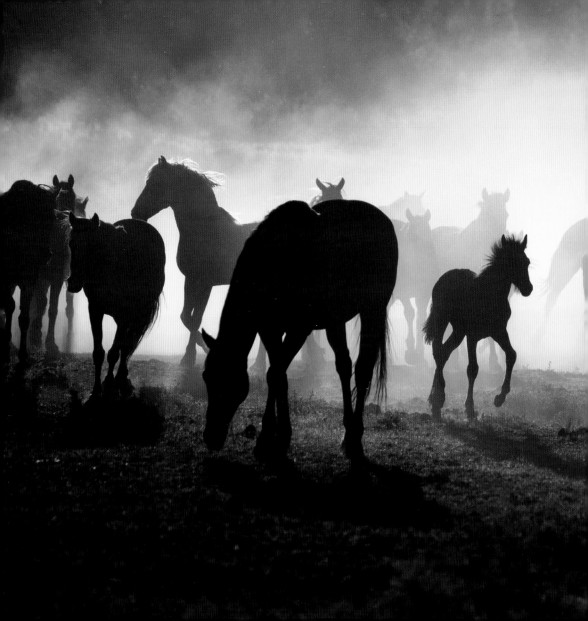

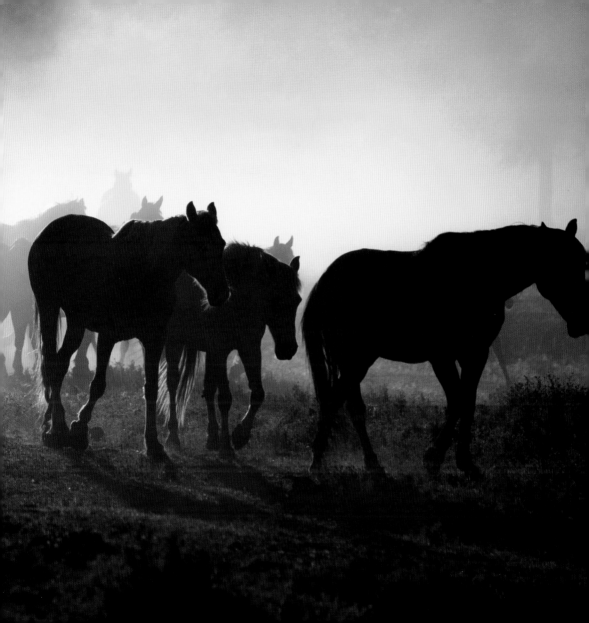

Had the price of looking

been blindness,

I would have looked.

~ Ralph Ellison

In a study published in 1973, a team of primatologists at the University of Edinburgh conducted an experiment whereby chimpanzees were given paint and paper and encouraged to create. While the chimps appeared to enjoy the process of splashing paint on paper, their "art" was realized only through human involvement. Observers took away each painting when they deemed that it had merit. Left to their own devices, the chimps splashed on until they tired of the game. They had no sense of a beginning or end to their creations. Later, the chimps showed no further interest in their paintings, even when they were hung on the walls of their cages. The "beauty" of their own work was beyond them. ✢ In the quiet evolution that has elevated man above beast, we have taken pride in claiming

Introduction

our opposable thumbs, our upright gait, and our larger brain. But perhaps the strongest indicator of evolution is the elevation of the impractical in our lives. Not only do we want to survive, we want to live. Fire, created for warmth, also mesmerized with dancing tongues of intrigue. Food, necessary for life, was adapted for pleasure. Rhythm and melody evolved from simple communication to complex sounds that have comforted every culture. Oral tradition moved from mere communication to sagas, stories, poems, legends, wit. Even the least sophisticated or artistic among us can be moved by the right combination of notes or movements or fragrance or play of light. Most of us are moved to create beauty in our own lives with a vase of flowers, a picture on the wall, the perfect hat. We hum and sniff and arrange and sample and see. When we are touched by a moment of visual beauty, we want to hold it in our hearts. And photographs have become our

memory keepers. ☙ Photos are evidence that we have lived and traveled and experienced and loved. We are the first generation who, mostly, know what our parents and grandparents looked like; who recognize a familiar earlobe or dimple or brow. There is comfort in seeing that we are part of history . . . of knowing what our parents looked like on their wedding day, or how our children appeared within minutes of their first breath. Such pictures are profoundly beautiful to us. When people are asked about possessions they would rescue from a burning building, photo albums are usually at the top of the list. Each family's troves of prints and slides and hard drives are proof that beauty truly is in the eye of the beholder. ☙ But even among our own family photographs, there are some that rise above the others. These are the photos that have caught a moment of emotion or composition or light that makes them ignite a deeper response in the viewer. ☙ Photography has opened our eyes to a multitude of beauties, things we literally could not have seen before the advent of the frozen image. It has greatly expanded our notion of what is beautiful, what is aesthetically pleasing. Items formerly considered trivial, and not worth an artist's paint, have been revealed and honored by a photograph: things as pedestrian as a fence post, a chair, a vegetable. And as technology has developed, photographers have explored completely new points of view: those of the microscope, the eagle, the cosmos. ☙ Working in the mid-19th century, the earliest photographers were consumed with the science of "fixing" an image. It is hard for us to imagine, now, what a thrill that possibility held. Painters had tried to faithfully reproduce reality. But the thought of recording the actual subject, of freezing the real thing, of holding a permanent mirror to ourselves and the world, seemed miraculous. ☙ This book is about the beauty discovered by the seers among us—the

beauty they have discovered through the miracle of photography. In 1841, when William Henry Fox Talbot patented the photograph, he called it a "calotype," from the Greek words for "beautiful impression." He called the camera "the pencil of nature." In the century and a half since then, photography has become a treasured part of most lives. In the right hands, the camera has become as powerful as a paintbrush, a pen, a keyboard. It is a true and permanent record/mirror of ourselves. ❧ Early in my career as a photographer, I was privileged to experience the thrill that early photographers must have felt. While in the southern African country of Namibia, I had the extraordinary experience of photographing a small group of remote, desert tribeswomen. Upon meeting them, I decided it would be a friendly gesture to take a Polaroid picture for them. As I handed them the developing image, it was clear that they had no idea what I was doing. But as they watched the image appear on the Polaroid, I got a glimpse of what my predecessors must have seen. Living in a desert devoid of reflective surfaces, these women had never seen their own faces before. They squealed with laughter and delight as they confirmed with one another which face belonged to whom. It didn't matter whether the image was poorly or beautifully fixed. The photograph had given them a memory to keep forever, to share with their neighbors or revisit privately or tack on a tree. ❧ So what is it that delights the human eye and allows us to proclaim that a photograph is beautiful? Photography depends on the trinity of light, composition, and moment. Light literally makes the recording of an image possible, but in the right hands, light in a photograph can make the image soar. The same is true with composition. What the photographer chooses to keep in or out of the frame is all that we will ever see—but that combination is vital. And the moment that the shutter is pressed, when an instant is frozen in

time, endows the whole image with meaning. When the three—light, composition, and moment—are in concert, there is visual magic. ❧ Let us begin with light. Light literally reveals the subject. Without light, there is nothing: no sight, no color, no form. How light is pursued and captured is the photographer's constant challenge and constant joy. We watch it dance across a landscape or a face, and we prepare for the moment when it illuminates or softens or ignites the subject before us. Light is rarely interesting when it is flawless. Photographers may be the only people at the beach or on the mountaintop praying for clouds, because nothing condemns a photograph more than a blazingly bright sky. Light is usually best when it is fleeting or dappled, razor sharp or threatening, or atmospheric. ❧ On a physiological level, we are all solar powered. Scientific studies have proved that our moods are profoundly affected by the amount of light we are exposed to. Lack of sun has been linked to loss of energy and even depression. Light in a photograph sets an emotional expectation. It can be soft or harsh, broad or delicate, but the mood that light sets is a preface to the whole image. ❧ Consider the light in a stunning scenic by Sam Abell (pages 4-5). It is the quality of light through morning fog that blesses this image and turns a forest into a field of light, shadow, and color, where every tree takes on a personality. ❧ Composition represents the structural choices the photographer makes within the photographic frame. Everything in the photo can either contribute or distract. Ironically, the definition of what makes a picture aesthetically pleasing often comes down to mathematics: the geometric proportions of objects and their place- ments within the frame. When we look at a beautiful photograph with an objective eye, we can often find serpentine lines, figure eights, and triangular arrangements formed by the objects within

the frame. ⮞ Look closely at photographer James Stanfield's charming composition of a child jumping for joy in a doorway at the Louvre (page 2). It is the moment that draws us in, but that moment is set in a striking composition of the doorway and the architecture beyond. The geometric composition of the photograph makes the child look small, and even more appealing. ⮞ The third crucial element in a photograph is the *moment* when the shutter is pressed. The moment captured in a beautiful image is the storytelling part of the photograph. Whether a small gesture or a grand climax, it is the moment within a picture that draws us in and makes us care. It may be the photographer's most important choice. If a special moment is caught, it endows the whole image with meaning. Often, waiting for that moment involves excruciating patience, as the photographer anticipates that something miraculous is about to happen. At other times it's an almost electric reaction that seems to bypass the thought process entirely and fire straight to instinct. Capturing that perfect moment may be a photographer's biggest challenge, because most important moments are fleeting. Hands touch. The ball drops. A smile flashes. Miss the moment and it is gone forever. ⮞ Light, composition, and moment are the basic elements in any beautiful photograph. But there are three other elements that draw the viewer in and encourage an emotional response. These are palette, time, and wonder. ⮞ Palette refers to the selection of colors in a photograph that create a visual context. Colors can range from neon to a simple gradation of grays in a black-and-white photograph. Even in the abstract, colors can make us feel elated or sad. The chosen palette sets up the mood of the whole image. It can invite or repel, soothe or agitate. We feel calm in a palette of pastels. Icy blues can make us shiver. Oranges and reds tend to energize. ⮞ For example, Martin Kers's photograph on pages 14-15 of this book

has a soothing palette of yellows and greens that almost glows. It beckons us to walk down a path in the Netherlands. It's a simple composition made memorable by its palette. ℞ Other images stand out because of the freezing or blurring of *time*. There are the lovely images of raindrops falling, lightning flashing, and athletes frozen in midair. There are also time exposures that allow us to see a choreography of movement within the still frame. The laundry flutters, the traffic merges, the water flows. ℞ In Abigail Eden Shaffer's photograph of a tern in flight (pages 6-7), the high-speed exposure allows us to see things that our eyes literally cannot see: every feather supporting the bird's flight, the arc of the wings, the catchlight in the bird's eye. High-speed photography has been a gift to both art and science. ℞ Wonder refers to the measure of human response when the photograph reveals something extraordinary—something never seen before, or seen in a fresh, new way. Wonder is about insight and curiosity. It is an expression of the child inside every one of us. Some photographers, following their childlike sense of wonder, have literally given their lives in pursuit of images so wonderful that they must be seen. The National Geographic Society has supported their efforts for more than a hundred years. In sending photographers up in balloons, down in submersibles, into remote rain forests, and across empty deserts, the Society has delivered wonder on a grand scale. ℞ Light, composition, and moment come together in a photograph to bring us the ultimate reality: a view of the world unknown before the invention of the camera. Before photography, the basic artistic rules of painting were rarely violated. Images were made to please, not to capture reality. But as photography evolved, painterly rules were often rejected in the pursuit of fresh vision. Photographers became interested in the real world, warts and all, and it was the accidental detail that was celebrated.

Photography invited the world to see with new eyes—to see photographically—and all of the arts benefited from this new point of view. Painters, sculptors, designers, weavers, dancers all expanded their vision of beauty by embracing the photographer's love of reality. 🖎 A surprising truth about photography is that each element is most effective not when it captures *perfection* but rather when it reveals the *imperfect*. Photographs are most eloquent when they impart a new way of seeing. What is more wonderful than the imperfect moment, when a simple scene turns sublime because a cat entered the room, the mirror caught a reflection, or a shaft of light came through the window. 🖎 And real beauty depends upon how the image moves us: A photograph can make us care, understand, react, emote, and empathize with the wider world by humanizing and honoring the unknown. Photographs have been a crucial element in saving whales, demystifying cultures, and bringing the wide world closer. 🖎 With these basic aesthetic tools, photographers have evolved from scientists longing to "fix" an image—any image—to artistic visionaries. Along the way, the still image has evolved from being merely a document to being a stunning documentary of the 19th and 20th centuries. Photographs have created a new ethic of seeing. They have greatly expanded our notion of what is beautiful. It is to photography's credit that it has found beauty in the most humble places, and that it has ushered in a new democracy of vision. People from all walks of life are able to feast their eyes on subjects remote and grand. They are able to hold them in their hands. Perhaps most important, all people can see themselves and their private worlds in beautiful ways because, in the words of Susan Sontag, "To photograph is to confer importance." Photographs have given us visual proof that the world is grander than we imagined, that there is beauty, often overlooked, in nearly everything.

Ring the bells
that still can ring.
Forget your perfect offering.
There is a crack
in everything.
That's how the light gets in.

~ Leonard Cohen

Light

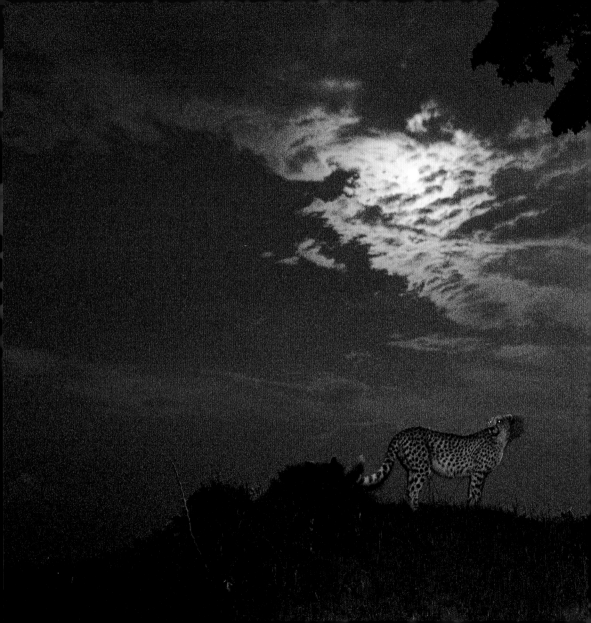

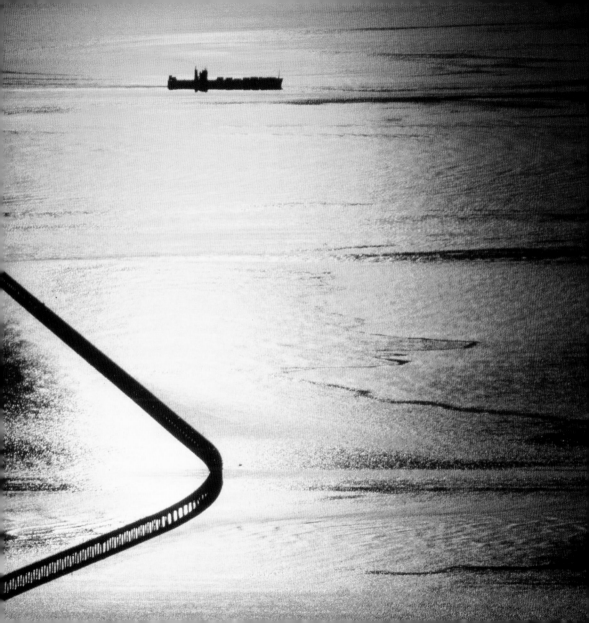

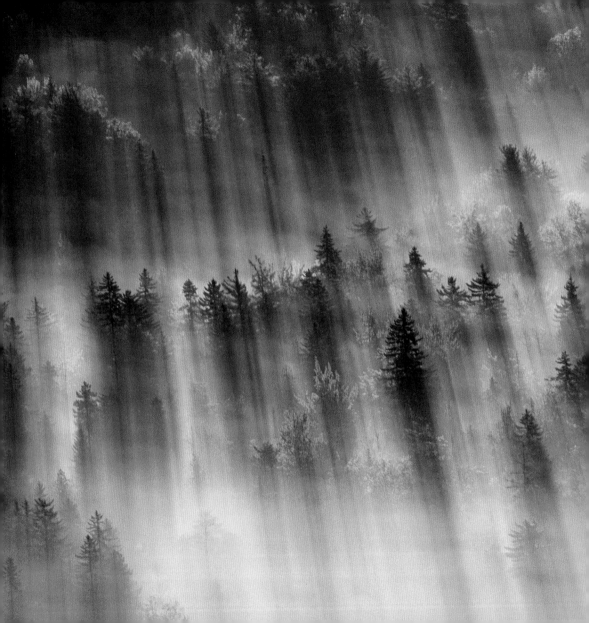

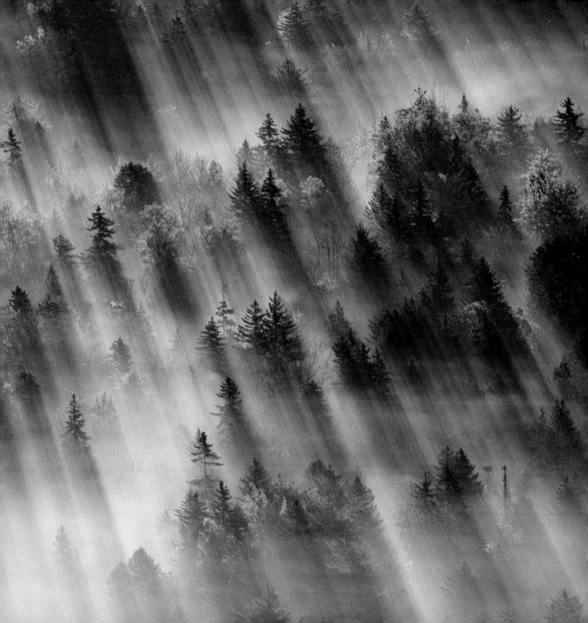

Light makes photography possible at the most basic level. Without light there is no sight, much less color or art or photography. It is the fragmentary reflection of light in the daily objects around us that allows all of us to see. In photography, light is the energy that allows any scene to imprint, on paper or glass or memory card. But light is so much more than a vehicle for sight. It comes to us in waves and bursts, and it touches, and profoundly affects our moods. Consider the comforting words we associate with light: nightlight, highlight, candlelight, lighthearted, enlightened. Likewise, it is the quality of light in a photograph that leads the heart as well as the eye. ☙ There simply aren't enough verbs to describe light. Light dances and illuminates and plays and washes and caresses and flows

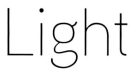

and ignites. More than any other aspect of a photograph, it is light that makes us gasp. It says to us *pay attention*. It can be as jarring as lightning or as discreet as a shadow. Light is the source of all color. It reveals form and texture and depth. Light is generous. We can see it only when it is gifted to us by reflection: light waves that return to us after bouncing off objects. The quantity of reflected light determines whether we see or we are blind. Infants respond to light in the womb. And even those who have been blind since birth are profoundly affected by light. It influences our moods and rallies our hormones. Light triggers our circadian rhythms. ☙ Yet, most people don't think much about light. We turn it on, we turn it off. We sometimes enjoy the beauty of a sunset. We may notice a pleasing play of light in a loved one's hair or a shaft of light through a stained-glass window. But mostly, we take the light of our days for granted—unless it is missing. Nearly everyone has a visceral response to total darkness. ☙ There is a moment in the life of most photographers when they first *see*

light—when they cross a threshold from measuring light merely by *quantity*—the amount that must be considered for exposure—to recognizing the *quality* of light in a photograph. My epiphany came as a young photojournalism student. I was photographing at sunrise on a rain-soaked golf course in St. Paul, Minnesota. As the sun inched over the horizon, its light was fractured by a million drops of mist—each an individual prism—and the scene was charged with light and energy. That recognition of the glory of light in a photograph changed the course of my life. I realized that the world was luminous and I wanted to photograph it. ❧ I soon discovered that, if we allow it, light can take us by the hand and help us compose photographs filled with energy and detail. Photographs are constructed directly from life, from reality. Unlike a painter, who can add dramatic elements or tidy up distracting flaws, a photographer is restricted by what reality offers. But light can take the real, the ordinary, and make it new, make it fresh, make it beautiful. Reality is the canvas, and light is the brush. ❧ Light in a photograph is like light on our faces. It can calm or burn, bless or agitate. Consider National Geographic photographer James Stanfield's image of Pope John Paul II on pages 60-61. The scene is washed in golden light, and it is the warmth and atmospheric quality of that light that confers holiness on His Holiness. Contrast this with the razor-sharp light that turns Gordon Gahan's photograph of a concrete tunnel (pages 44-45) into a thing of beauty, or the soft, plainspoken light that asks us to linger on the face of William Albert Allard's cowboy (page 70). Light sets the mood for all of these images. ❧ Light is dynamic. It moves. Some of the most intriguing days of shooting are stormy days, when the light changes constantly, revealing a new image of the same scene moment by moment. On bright days, at high noon, the light is harsh and high contrast. Many photographers

abhor this kind of light. Others find it their greatest inspiration. On cool, overcast days the light may be muted, but color is often richer and more detailed; mist fills the atmosphere with tiny particles that bend and enhance the light in a scene. 🖙 In portraiture, it is often light that reveals personality. High contrast or low light can make a subject look sinister or tragic. Backlight can make a figure appear angelic, or it can create a silhouette. A shaft of light can rivet attention on a single feature or gesture. Soft, diffused light allows the features on a face to read as a whole, without distortion or hard detail. Simply revealing the catchlight in a subject's eye will suggest intimacy and allow the viewer to connect on a more emotional level. 🖙 The physical photographic process is nothing more than the recording of a stable image generated by a ray of light. Light creates its own metaphor. Light is, literally, energy. The greatest source of light is our own sun, but light also comes to us from far greater distances. Although light travels at incredible speed—186,000 miles a second—it is humbling to note that the natural light that reaches us is older than we are, than our species is. Light is as old as the universe. 🖙 British mathematician and astronomer Sir John Herschel coined the word "photography" in 1839, based on the Greek words meaning to "draw with light." The very first photographer, Joseph Nicéphore Niépce, called his invention "heliography"—sun writing. In his essay on photography, author Graham Clark says, "If the word photograph is 'light-writing,' it is also our signature on the world." 🖙 Before the advent of photography, painters spent lifetimes trying to accurately reproduce light in their work. Dutch painter Rembrandt van Rijn, who painted his masterworks 200 years before the advent of photography, is still revered for the dramatic light in his work. Any artist knows the unique quality of "Rembrandt light." But it was only through the development of photography that

light and shadow were for the first time fully revealed. And what a revelation! Artists were captivated by the rich gradations of shadows, the animation of surfaces, and the depth of detail that light revealed in a photograph. In fact, during its infancy, photography was seen by many artists as simply a tool to help them improve the presence of light in their paintings. Others were threatened, fearing that this glorious new invention would make paintings obsolete. Fortunately, neither assessment was accurate. ❧ Impressionist painters found such inspiration in photographic light that they packed up their paints, left their studios, and headed outdoors to paint from reality—to harvest the natural light that had been revealed to them by photographs. Claude Monet led this movement, often returning to a place again and again to record a scene at different times of day, in different light. Monet was so enchanted by light that he sought to record every subtle sensation of reflected light with a touch of paint, a dash of color. His work inspired a whole new movement in art, defined by light. ❧ Likewise, the use of light in all genres of art, from painting to sculpture to dance, has always inspired photographers. The best photographers achieve visual literacy by feasting their eyes on the work of artists of all kinds. My work has been strongly influenced by dance—by the play of light and gesture I observe as the dancers move. Other photographers are inspired by paintings or sculpture or theater. One of the unsung joys of photography is that one never finishes observing light's influence on a subject. There is always the possibility of a new image, an expanded vision. We chase light the way we chase fireflies, furtive and enchanted. We return to subjects and places over and over again to find a new moment illuminated by the play of light. We want to capture it, hold it, revisit it, revel in it. As photographers, we are all hunters, seeking to capture visions of life made possible by light.

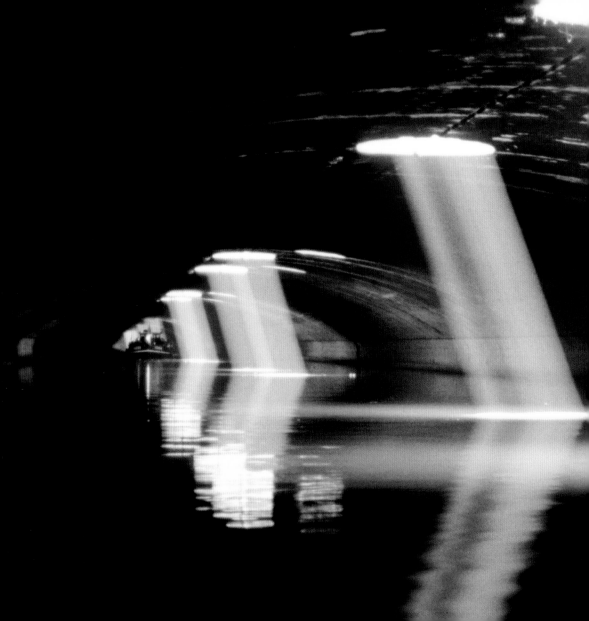

KAREN KASMAUSKI

Niger

A young girl smiles for an informal portrait

preceding pages (33-45)

SAM ABELL

Pleasant Hill, Kentucky

A Shaker hat hangs on a wall at Shaker Village
of Pleasant Hill

CHRIS JOHNS

Okavango Delta, Botswana

A young African cheetah prowls by the light
of the moon

LOWELL GEORGIA

Chesapeake Bay

A lone freighter navigates around the Bay Bridge
at the last light of the day

MICHAEL MELFORD

Acadia National Park, Maine

Autumn-colored trees pierce through the
morning fog

GORDON GAHAN

Paris, France

Sunlight descends through openings
in the Canal Saint Martin

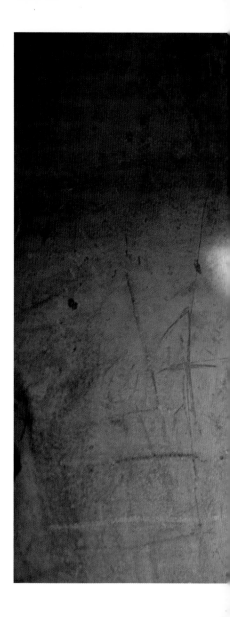

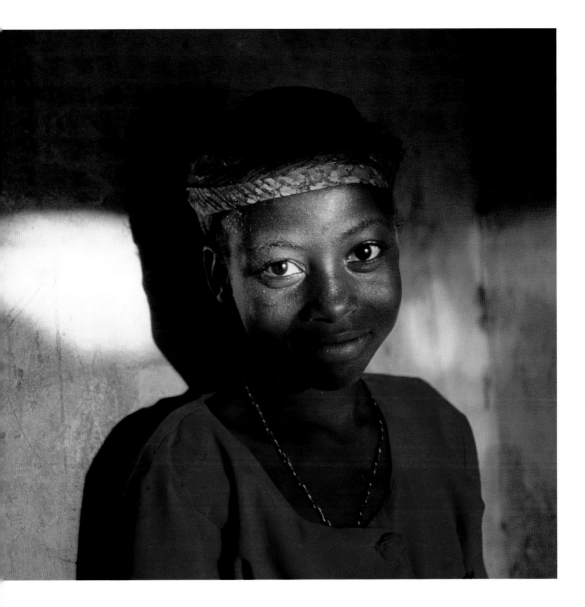

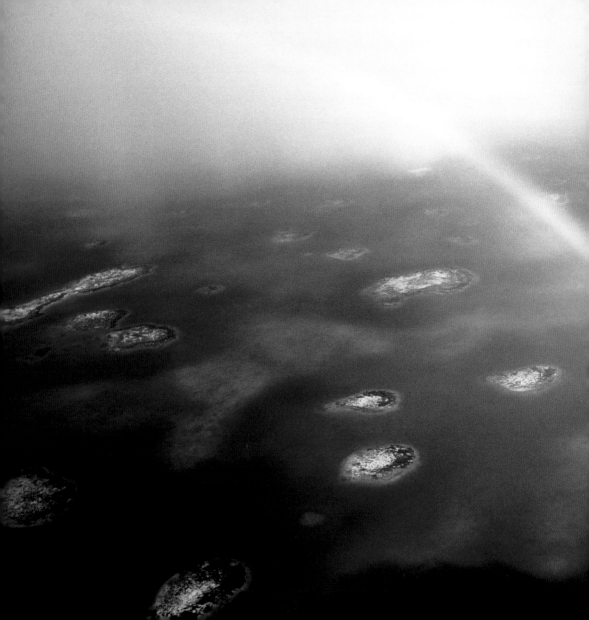

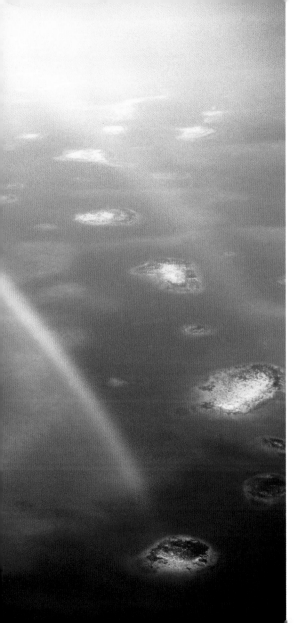

KENNETH GARRETT

Glover Reef, Caribbean Sea

A rainbow touches down on part of
the Yucatán Peninsula's reef system

following pages

WINFIELD PARKS

Istanbul, Turkey

Light streams into a Turkish bath
where men relax

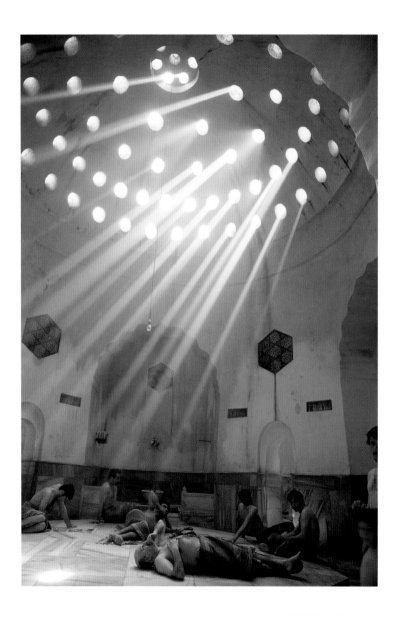

Light, when suddenly let in, dazzles and hurts and almost blinds us: but this soon passes away, and it seems to become the only element we can exist in.

~ Augustus William Hare

JAMES L. STANFIELD

Inner Mongolian Autonomous Region, China

Young members of the Bayan Obo People's
Commune prepare for the coming day

YVA MOMATIUK & JOHN EASTCOTT

Patagonia, Argentina

Evening light colors clouds hanging above
Argentina's Glacier National Park

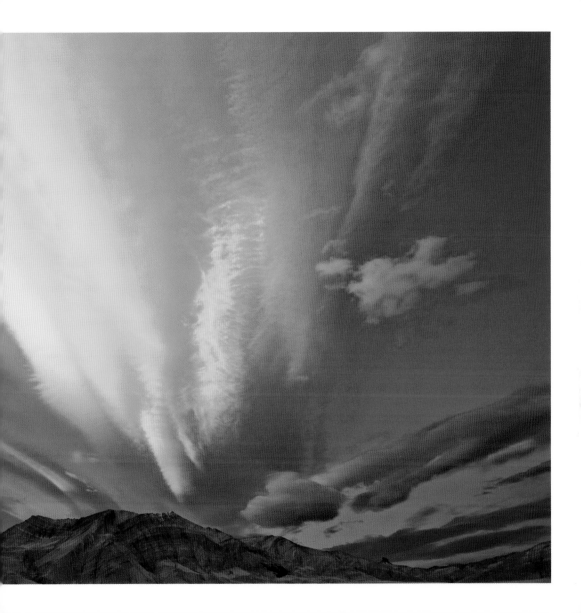

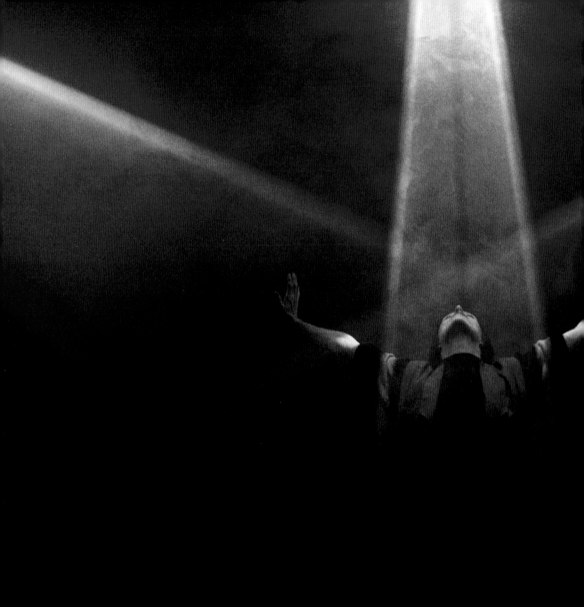

RAYMOND GEHMAN

Banff National Park, Alberta, Canada

Spotlights illuminate a dancer at the
Banff Centre

following pages

MICHAEL NICHOLS

Grand Canyon National Park, Arizona

A touch of light filters through the clouds
to illuminate a snow-covered landscape

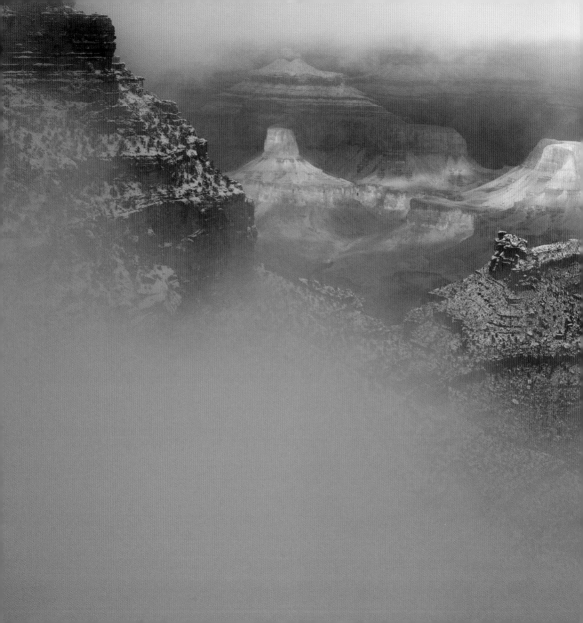

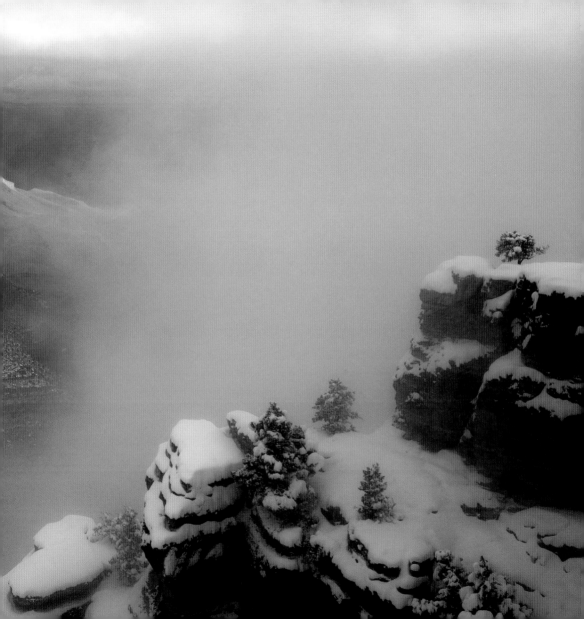

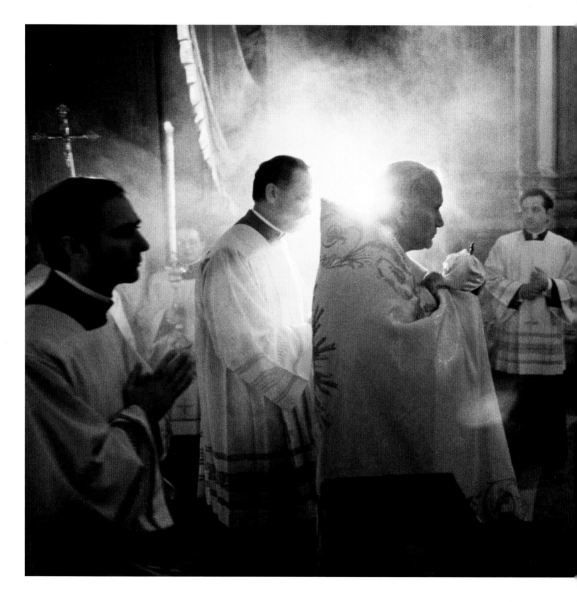

JAMES L. STANFIELD

Rome, Italy

Pope John Paul II celebrates Communion
prior to holding Mass

JAMES P. BLAIR
Dinaric Alps, Bosnia
A young man takes a break from work
on his family's farm to smile at the camera

following pages
JULES GERVAIS-COURTELLEMONT
Udaipur, Rajasthan, India
A man dressed in red looks out over a lake

ANNIE GRIFFITHS
Yellowstone National Park, Wyoming
Snow covers the Lower Geyser Basin

O. LOUIS MAZZATENTA
Near Beron De Astrada, Argentina
Gauchos race their horses through a lake

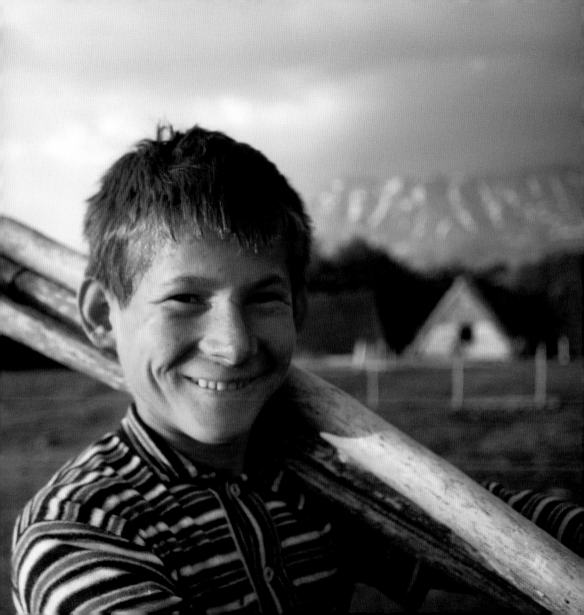

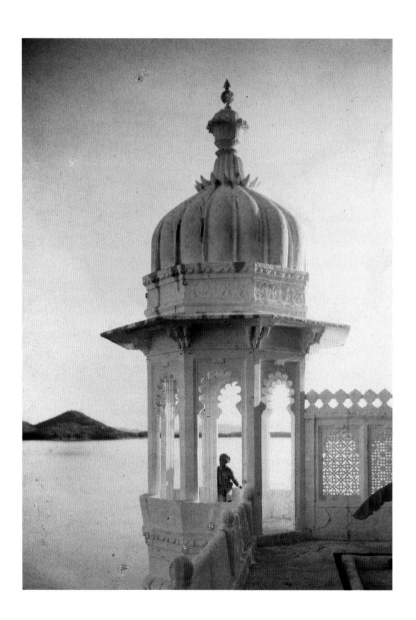

From within or from behind,

a light shines

through us upon things,

and makes us aware that

we are nothing,

but the light is all.

~ Ralph Waldo Emerson

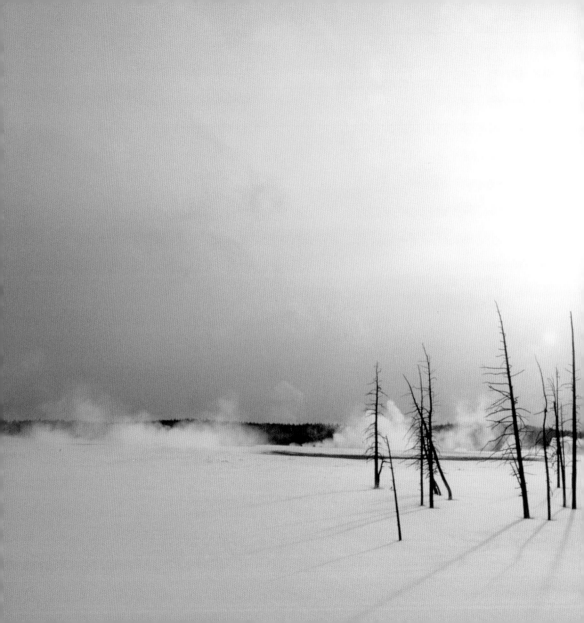

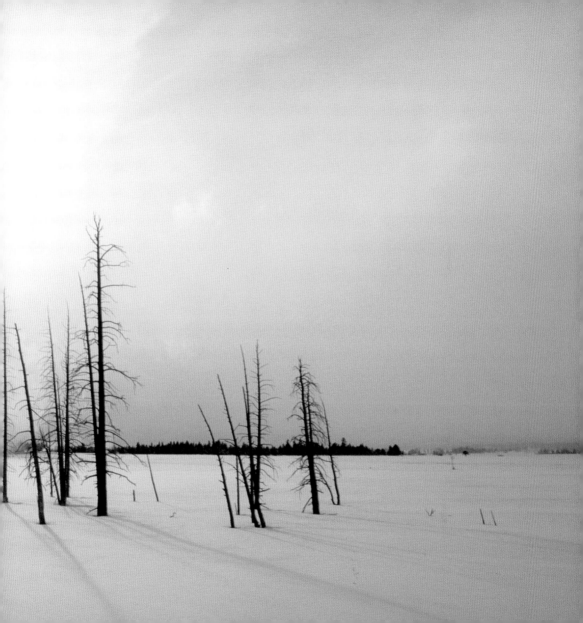

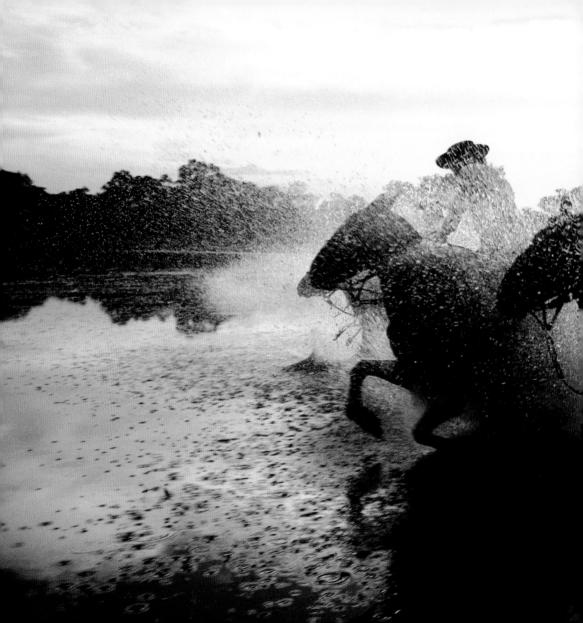

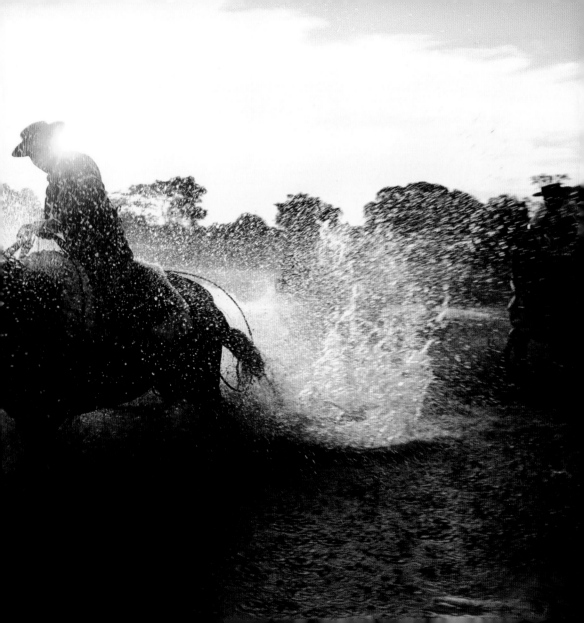

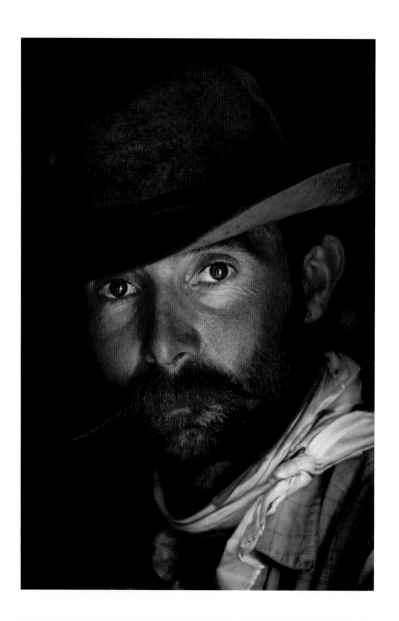

WILLIAM ALBERT ALLARD
Nevada
Cow boss Brian Morris poses for a picture

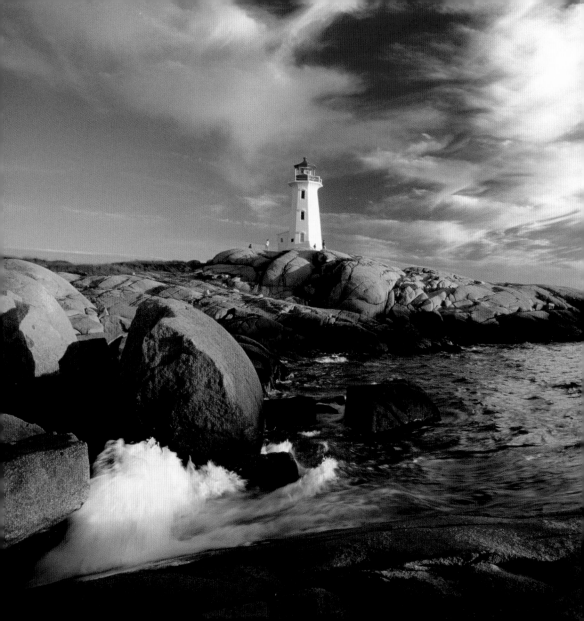

JAMES P. BLAIR
Peggy's Cove, Nova Scotia, Canada
Wispy clouds linger over a lone lighthouse

following pages
GORDON GAHAN
Anatolia, Turkey
A Turkish family peers out the window
of their train car

TIM LAMAN
Hokkaido Island, Japan
Cranes stand together in morning mist

Beauty is not in the face;

beauty is a light in

the heart.

~ Kahlil Gibran

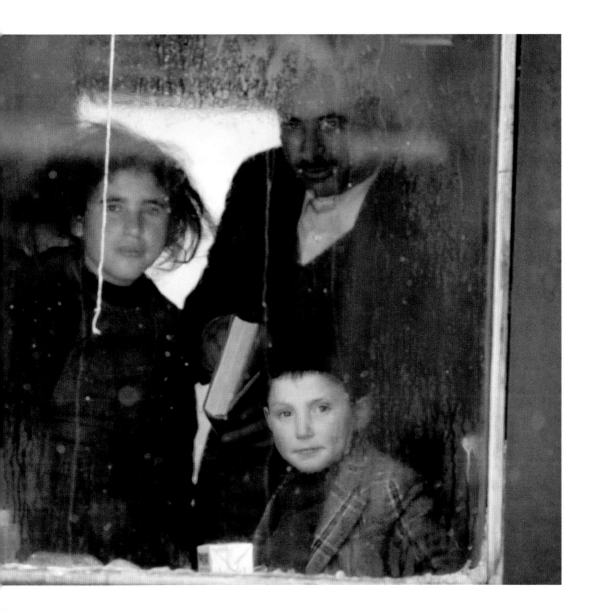

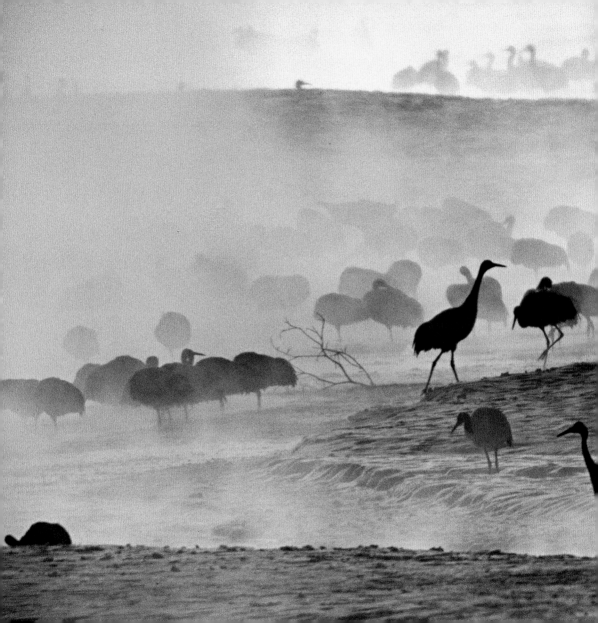

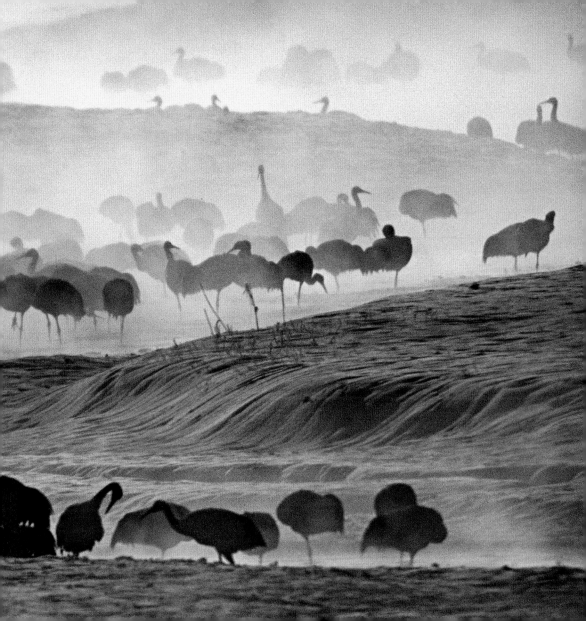

MELISSA FARLOW

New York City, New York

Light brushes the tips of trees in Central Park

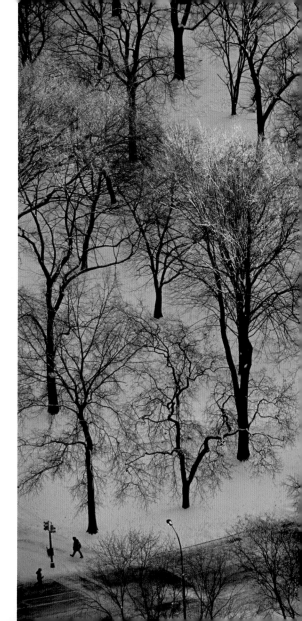

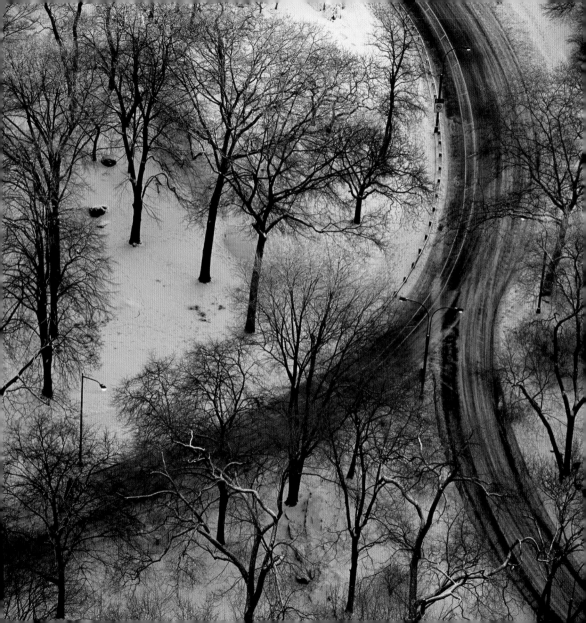

RICHARD NOWITZ

Jerusalem, Israel

Ballerinas from the Rubin Academy ready
themselves for a performance

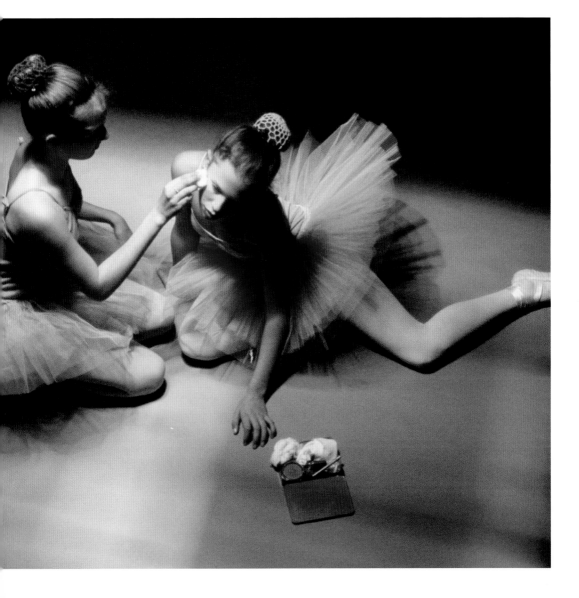

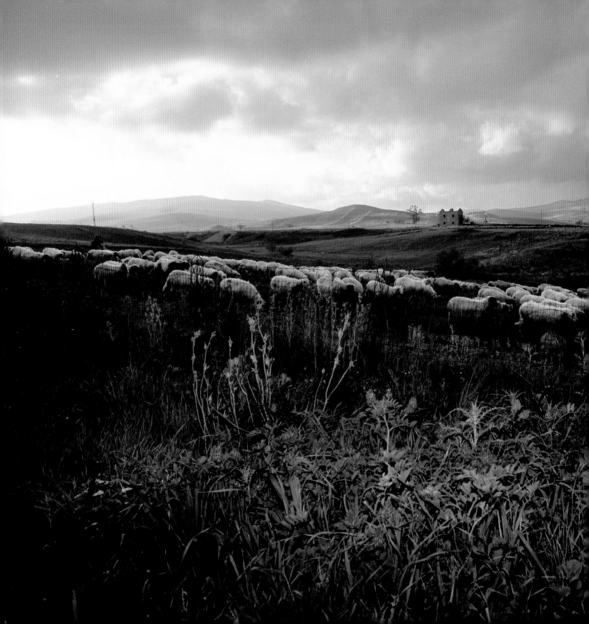

WILLIAM ALBERT ALLARD
Trapani, Sicily, Italy
Sheep cross a pastoral scene

following pages
DAVID EDWARDS
Bayan-Olgiy, Mongolia
A young Kazakh prays before slaughtering
a sheep

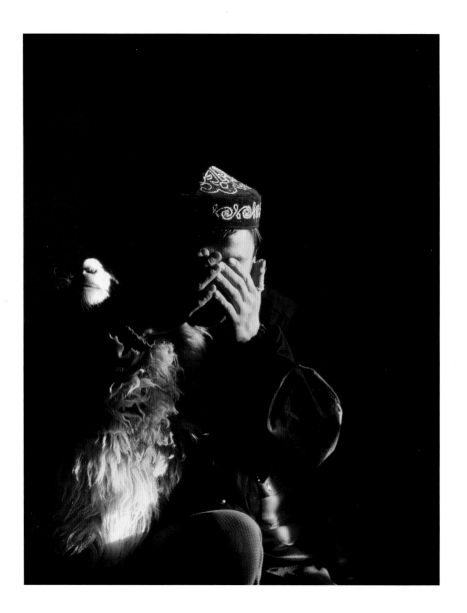

Light can be gentle, dangerous, dreamlike, bare, living, dead, misty, clear, hot, dark, violet, springlike, falling, straight, sensual, limited, poisonous, calm and soft.

~ Sven Nykvist

MARIA STENZEL

Las Vegas, Nevada

Lights project out of the tip
of the Luxor Hotel

following pages

RANDY OLSON

Al Kurru, Sudan

A man holds a light to illuminate
hieroglyphics inside the tomb
of a Nubian king

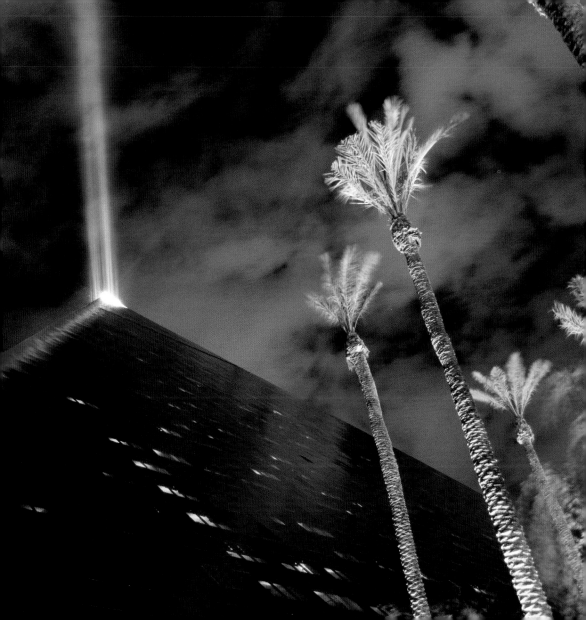

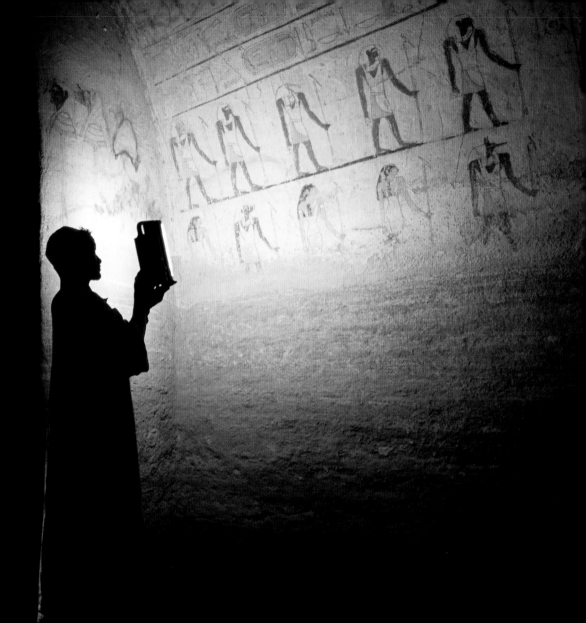

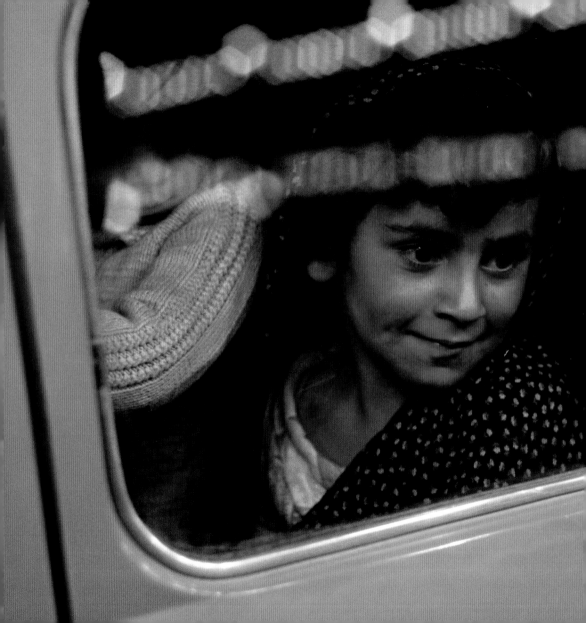

JAMES L. STANFIELD
Tehran, Iran
A young girl watches from a taxi as a street is decorated for a coronation

following pages
CLIFTON R. ADAMS
County Louth, Leinster, Ireland
Young faces smile happily at the camera in Drogheda

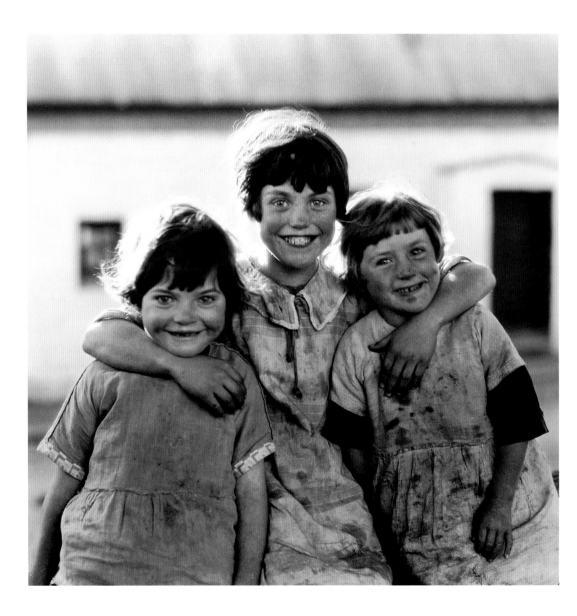

Light gives of itself freely, filling all available space. It does not seek anything in return; it asks not whether you are friend or foe. It gives of itself and is not thereby diminished.

~ Michael Strassfeld

MAYNARD OWEN WILLIAMS

Southern France

Dark clouds hover over deserted
rowboats on a beach

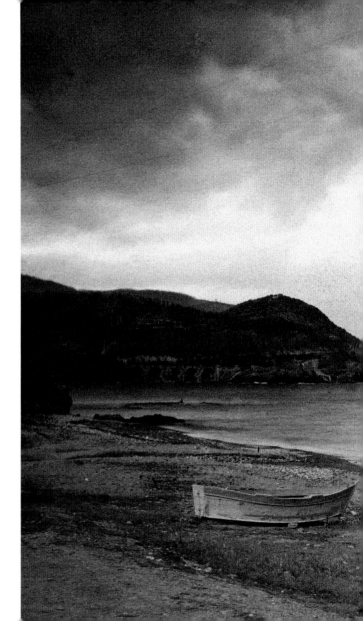

WILLIAM ALBERT ALLARD
Rondonia, Brazil
A malaria patient rests in a doorway

following pages
MICHAEL S. YAMASHITA
Japan
Leaves cover the path on Natagiri Pass

WINFIELD PARKS
Hunedoara, Romania
A young man walks under buckets
of iron ore being transported to
a steelworks

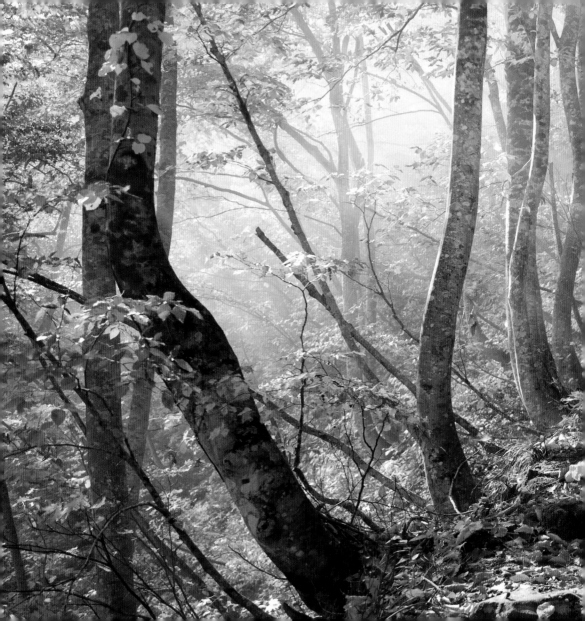

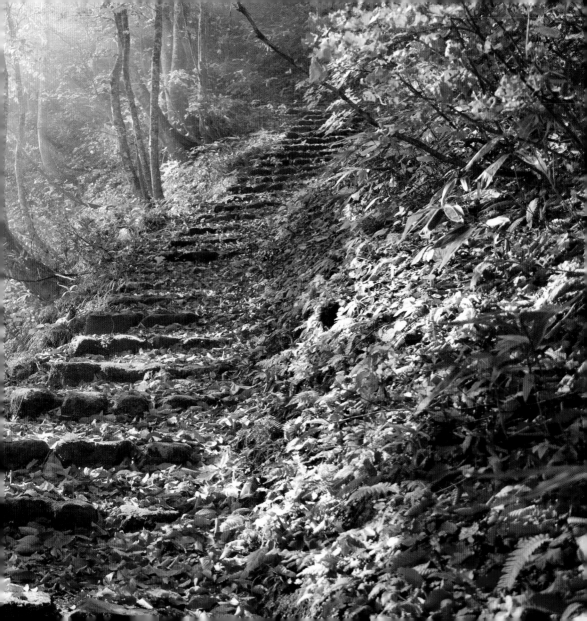

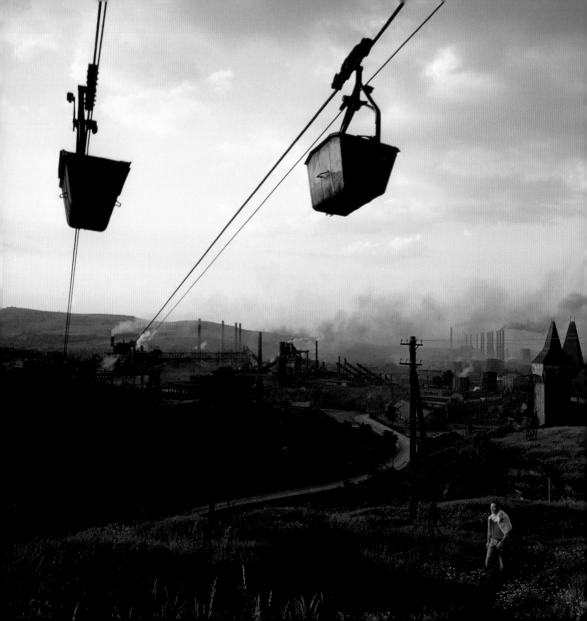

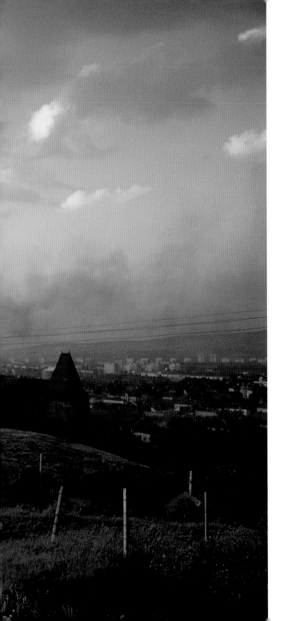

In the right light,

at the right time, everything is

extraordinary.

~ Aaron Rose

B. ANTHONY STEWART

Washington, D.C.

Prince Thondup of Sikkim and his fiancée
review an exhibition catalog

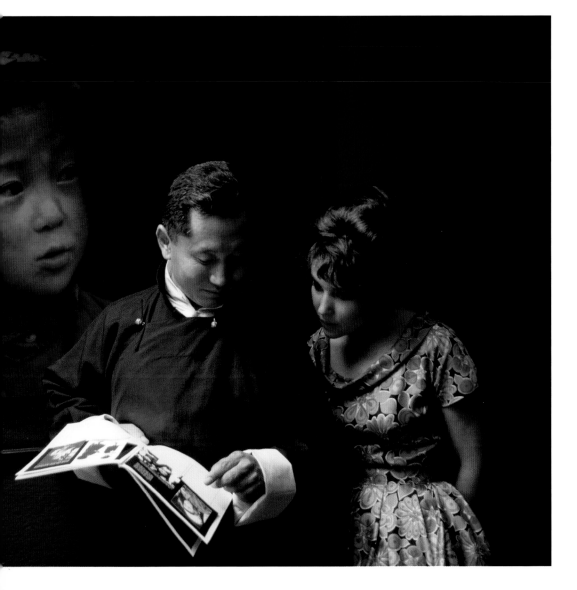

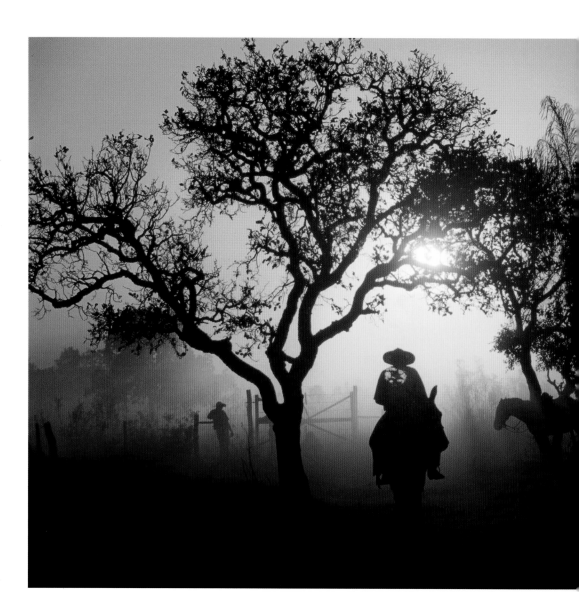

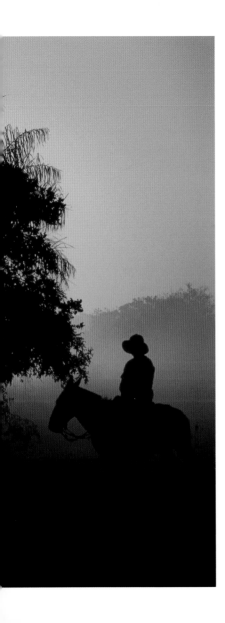

JOEL SARTORE

Pantanal, Brazil

The setting sun silhouettes gauchos
as they relax at the end of the day

following pages

PHIL SCHERMEISTER

Yosemite National Park, California

El Capitan's sunlit face is reflected
in the Merced River

Light comes to us unexpectedly and obliquely. Perhaps it amuses the gods to try us. They want to see whether we are asleep.

~ H. M. Tomlinson

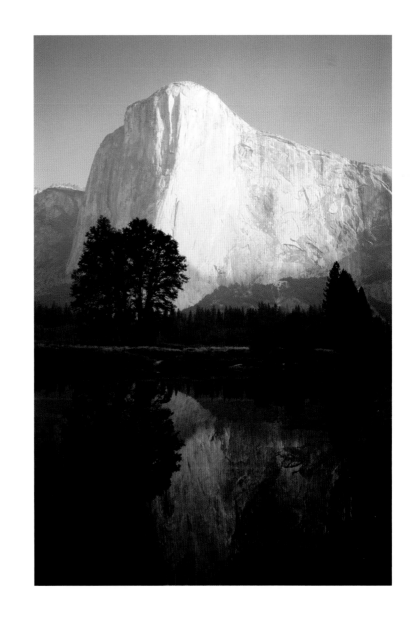

ANNIE GRIFFITHS

Cumberland Island, Georgia

With distinctive twisted branches, live oak trees
flourish on Cumberland Island

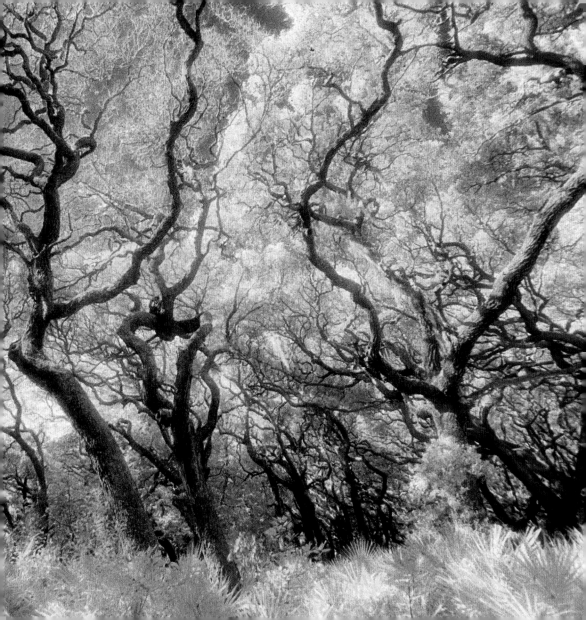

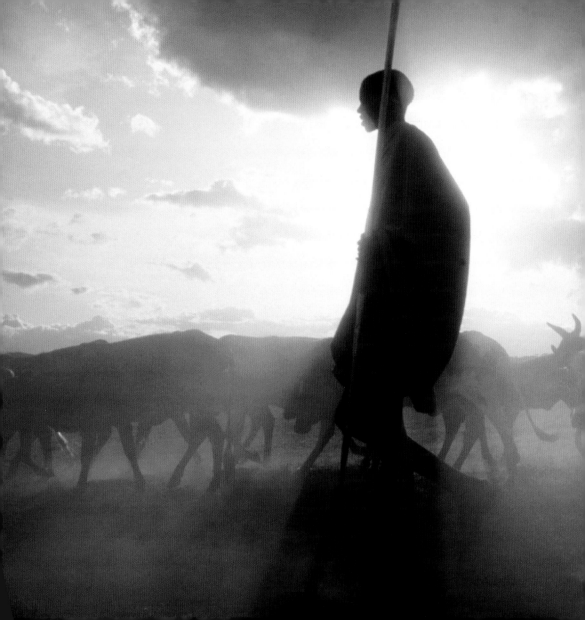

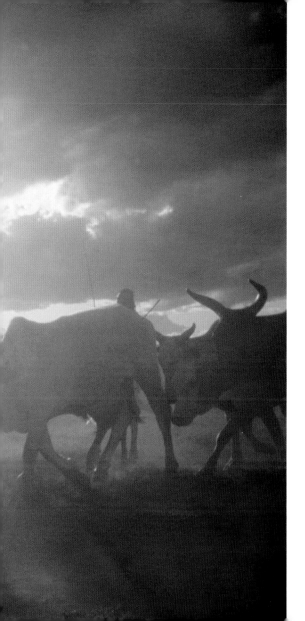

MITSUAKI IWAGO

East Africa

Light shines around a Maasai tribesman as he watches cattle

following pages

JAMES P. BLAIR

Louisiana

The delta duck potato thrives in the Atchafalaya National Wildlife Refuge

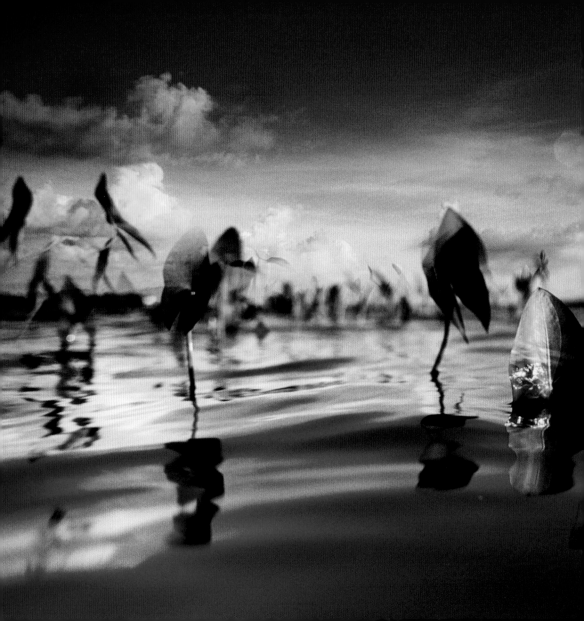

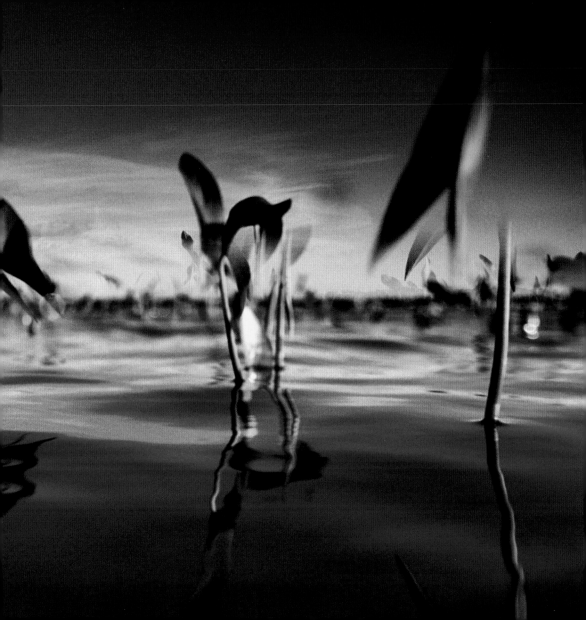

Photographers deal in
things which are continually
vanishing and when they
have vanished there is
no contrivance on earth
which can make them
come back again.

~ Henri Cartier-Bresson

Composition

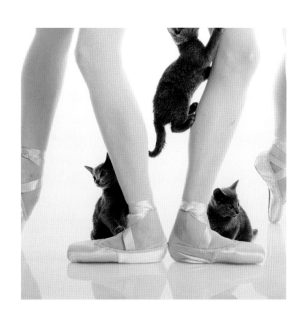

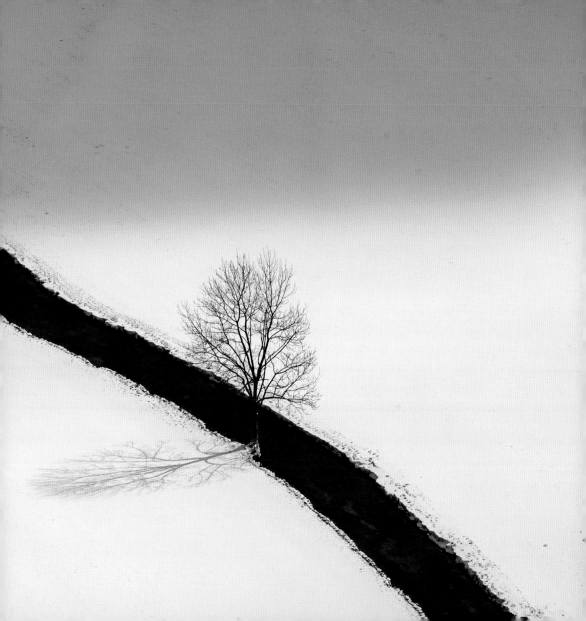

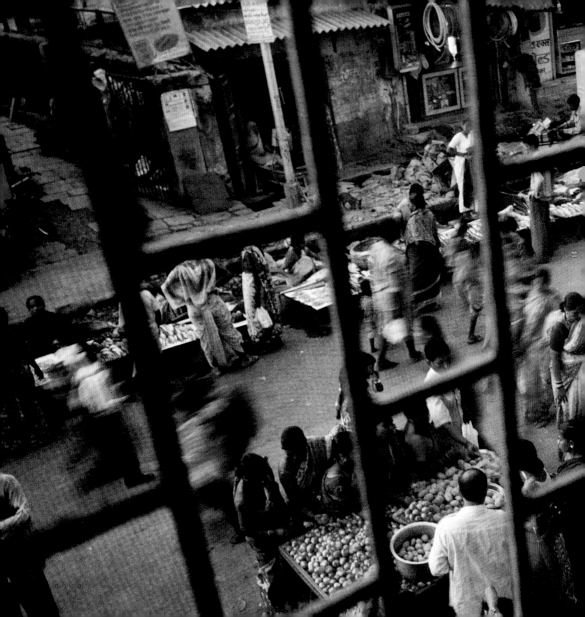

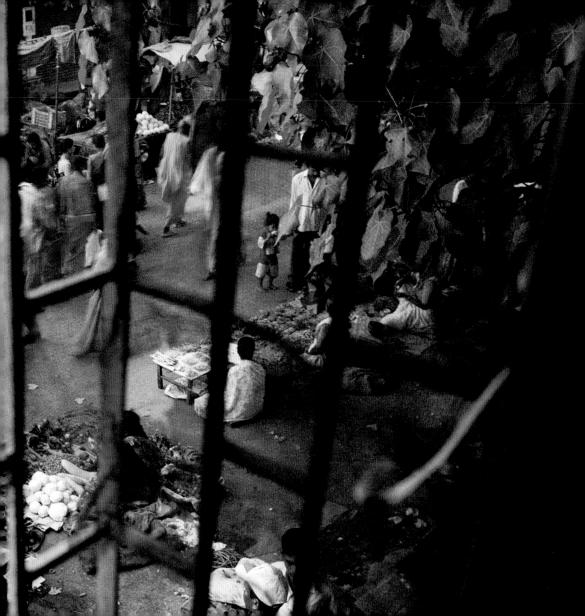

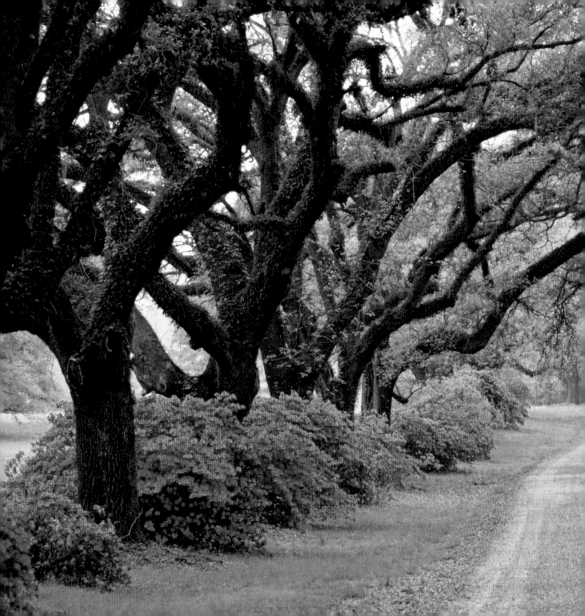

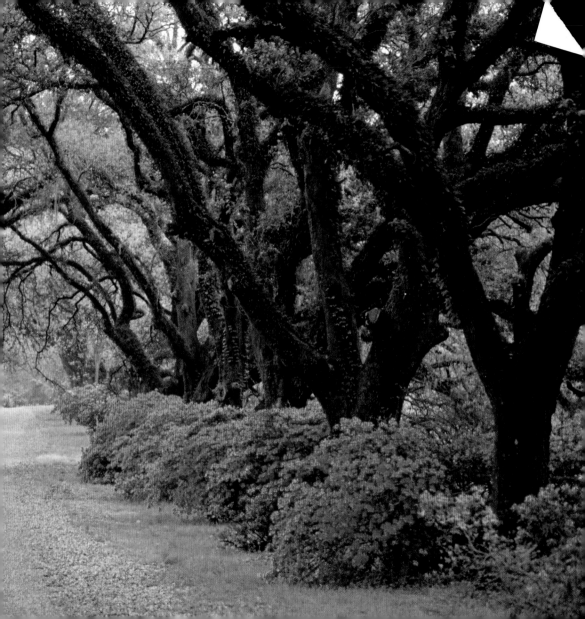

When we love a picture, we put a frame around it and hang it in a special place. The frame is both decoration and definition. A frame honors the image within, but it also separates the picture from all that is around it. It contains the image and helps us to see it without distraction. Photography is a constant attempt to put a frame around something pleasing or important, to pluck one meaningful instant from the river of life and isolate it for eternity. 🐦 Composition is nothing more than an arrangement of elements within a chosen frame. But it is a crucial structure that can allow us to see something for the first time or blind us with the obvious. Composition can turn familiar objects into abstract patterns, or draw attention to a single voice in a chaotic moment. Every element in a great photograph cooperates in the production of beauty with an architectural balance that is both pleasing and illuminating. It is composition that can create the illusion that a two-dimensional object, a photograph, is really three-

Composition

dimensional. 🐦 The instantaneous nature of photography is both a blessing and a curse. It appeals to the impatient, who often push the shutter button before actually considering the structure of the resulting photograph. The truth is that many of the stunning *instants* attained in great photography required hours and even days to capture. A photographer may return to a subject again and again, seeking a touch of light, a splash of color, a passing figure that completes the composition. 🐦 The best compositions lead us to every important part of an image. Some compositions are so complex and delightful that our eye is pulled to multiple images within the frame. National Geographic photographer and master "composer" William Albert Allard is known for the complex structure and balance

of his photographs. Take, for example, the photograph where Allard has cleverly used the sections of a window to create individual scenes along a street in Mumbai (pages 118-119). This is the kind of picture we return to again and again, often finding surprises we missed in earlier viewings. ᐧᐧ Other compositions ache with simplicity, framing one perfect element—a single tulip, a distant figure, folded hands. Photographs like these are studies in balance. Placement of the single element must balance with the space of the rest of the image. ᐧᐧ Often, what is left out of the frame is just as important as what is left in. A photographer's goal is to try to fill the frame, edge to edge, with elements that contribute to the whole picture, leaving out anything that distracts. In an active situation, the photographer may find himself focusing on a particular subject, but with radar awareness of what is happening in the background—an anticipation that something unpredictable will make or break this image. ᐧᐧ The undisputed compositional king of photography was the French photographer Henri Cartier-Bresson. Consumed with the pursuit of serendipitous composition, he haunted the streets of Paris looking for those perfect images of balance and surprise. It is Cartier-Bresson who coined the phrase "the decisive moment"—the exact instant when all elements come together to make an unforgettable composition. ᐧᐧ Allard explains in his book *The Photographic Essay*, "I think the best pictures are often on the edges of any situation, I don't find photographing the situation nearly as interesting as photographing the edges." So the framing in Allard's images is always interesting. There are often intriguing objects, partially in the frame, or the inclusion of a separate element that balances the main subject. ᐧᐧ What makes a picture aesthetically pleasing are its geometric proportions within the frame. The most common compositional rule that is taught to young photographers is

called the rule of thirds. Simply put, if you can imagine a tic-tac-toe grid placed over an image, the most important elements in a photograph (horizon, subject, strong color) should fall along those lines, rather than dead center in the frame. Like all rules, this one is meant to be broken, but it is true that placing strong elements in thirds allows an easy flow from foreground to background. It also creates balance in an image. ✍ The Greeks sought perfect proportion in art—the harmonious relation of parts to each other or to the whole. They believed that the two most important shapes in a picture were a long, serpentine line and triangular forms. These forms would appear in a balanced proportion they called the divine triangle, the divine proportion, or *phi*. Phi became the guideline that was used by classical artists to ensure that the composition of their paintings was pleasing to the eye. Phi is based on the idea that everything in nature, from the features of the human face to the spirals in a nautilus shell, can be broken down into a proportion of 1:1.618. Once the Greeks identified these common shapes and proportion, phi was used as the basis for such classical works as the Greek Parthenon. Centuries later Leonardo da Vinci used it to create the "Mona Lisa." ✍ One astonishing fact is that, without analyzing it, earlier cultures had used the same mathematics in constructing some of the wonders of the world. The Egyptians had used it in the construction of the great pyramids and in the design of hieroglyphs. Thousands of miles away, the ancients of Mexico employed it in building the Sun Pyramid at Teotihuacan. ✍ So how does this math relate to a beautiful photograph? Consider the image of a lone tree (pages 116-117) and note where the photographer chose to place the tree. Then notice how important the serpentine line of the road is in leading you through the image. The road leads the eye from one part of the picture to another. Now note how the leading line in this

photograph also divides the image into two triangular fields of snow. A leading line can take many compositional forms. It can be a curve, a figure eight, a triangle. Usually, the viewer is unaware of it, but in all strong compositions, it is there, providing rhythm and structure to the whole photograph. ☙ At first blush, it seems counterintuitive that geometry is so essential in art. We right-brainers are leery of those on the left. But it is true, when one looks at the most satisfying photographs, there often are serpentine lines and triangular arrangements within the composition. ☙ Geometry is very much a part of Henri Cartier-Bresson's "decisive moment" photographs. Cartier-Bresson searched for scenes of perfect composition, and then waited for some surprising element to happen. He took photographs "to find the structure of the world—to revel in the pure pleasure of form" and to reveal that "in all this chaos, there is order." Geometry in a beautiful photograph creates balance. It can be found in compositional elements such as the location of the horizon, the placement of color, or a beam of light. ☙ Cartier-Bresson describes the hunt for these images in his book *The Decisive Moment*: "You wait and wait, and then finally you press the button—and you depart with the feeling (though you don't know why) that you've really got something. Later, to substantiate this, you can take a print of this picture, trace on it the geometric figures which come up under analysis, and you'll observe that, if the shutter was released at the decisive moment, you have instantly fixed a geometric pattern without which the photograph would have been both formless and lifeless." ☙ A geometrically balanced composition can be enigmatic or crystal clear, witty or threatening, energizing or calming or tender. We make these compositional choices because it pleases our eye, it awakens our inner mathematician. We are moved by the geometry of perfection.

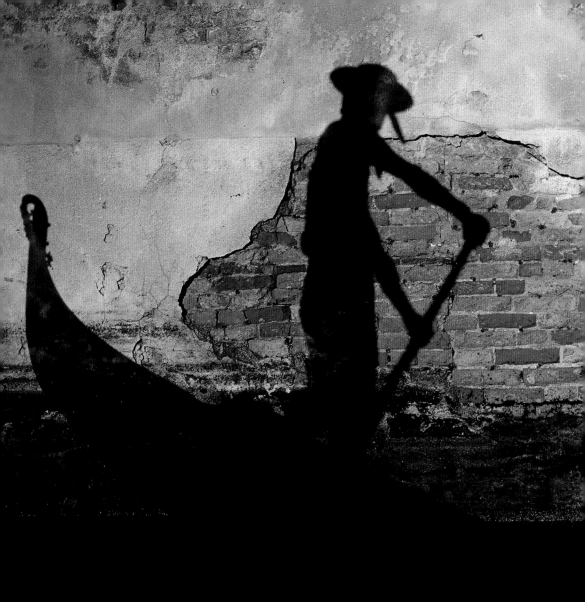

JAMES P. BLAIR

Hainan Island, China

A straw hat, straw baskets, and a red belt crowd
sparse hooks along a white wall

preceding pages (115-127)

KAREN KUEHN

Russian blue kittens play at the feet of ballerinas

NORBERT ROSING

Upper Danube River Valley Nature Park, Germany

The shadow of a bare tree breaks up the winter
stillness

WILLIAM ALBERT ALLARD

Mumbai, India

People move through a busy open-air market

SAM ABELL

Mississippi

Kinked limbs of trees intertwine over a dirt drive

WILLIAM ALBERT ALLARD

Venice, Italy

An old building hosts the shadow of a passing
gondolier

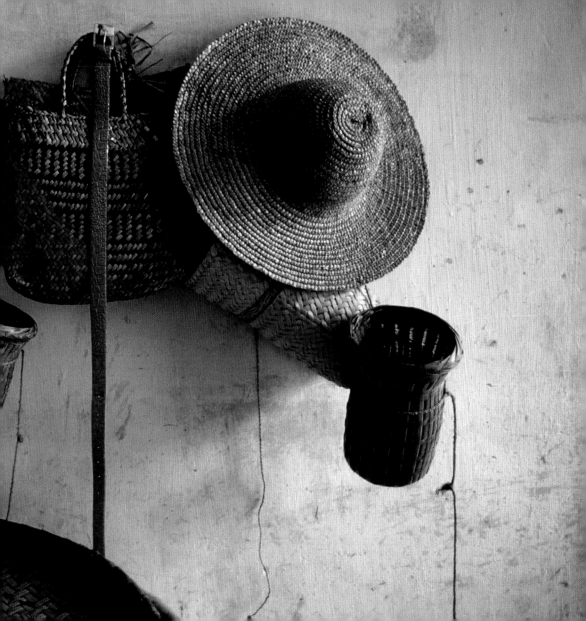

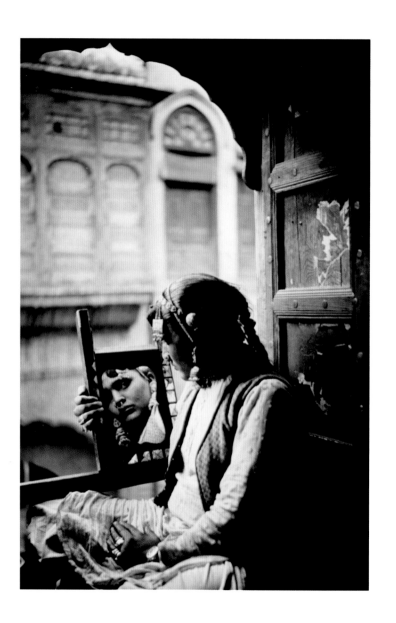

Beauty is eternity gazing at itself in a mirror.

~ Kahlil Gibran

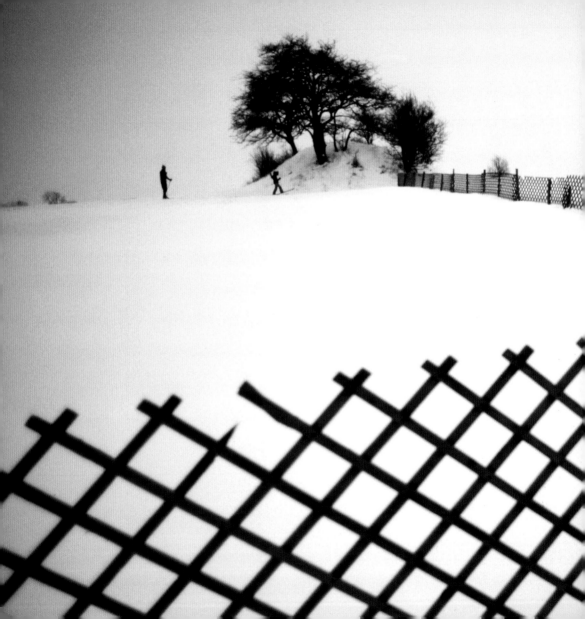

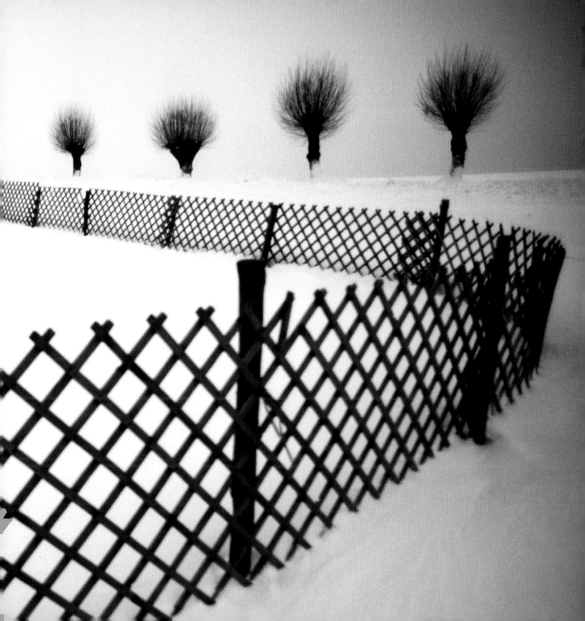

RAYMOND GEHMAN

Outside Beijing, China

Pale blossoms contrast with the shades
of red and brown on the wall behind them

preceding pages (130-133)

MAYNARD OWEN WILLIAMS

India

A woman regards herself by natural light

KEENPRESS

Elverhøj, Sjaelland, Denmark

Trees and a fence contrast with the bright snow
that surrounds a burial mound

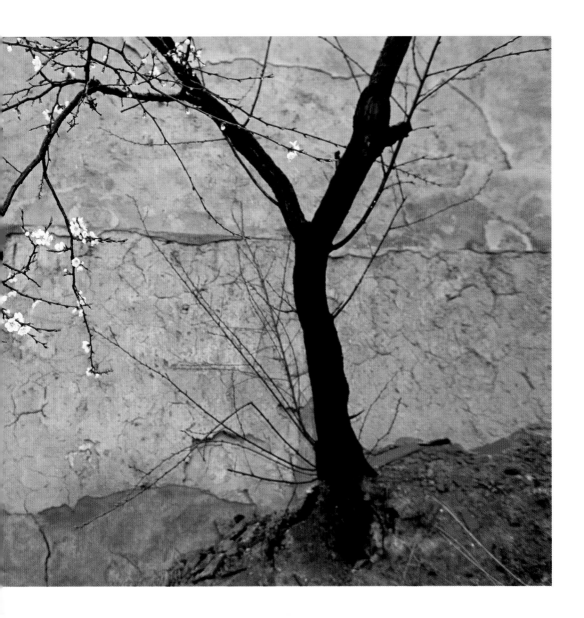

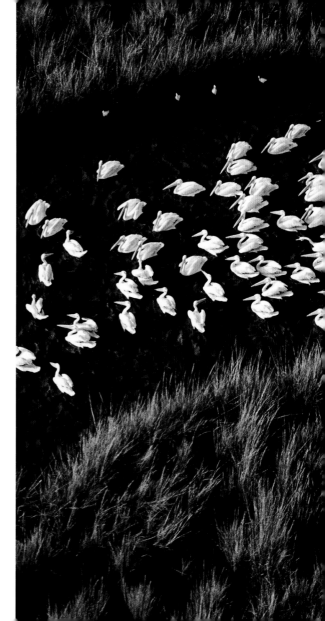

ANNIE GRIFFITHS
Mississippi Delta, Louisiana
White pelicans navigate a bend in the river

following pages
JIM RICHARDSON
La Crosse, Wisconsin
Fields and trees appear to float above
low-lying clouds

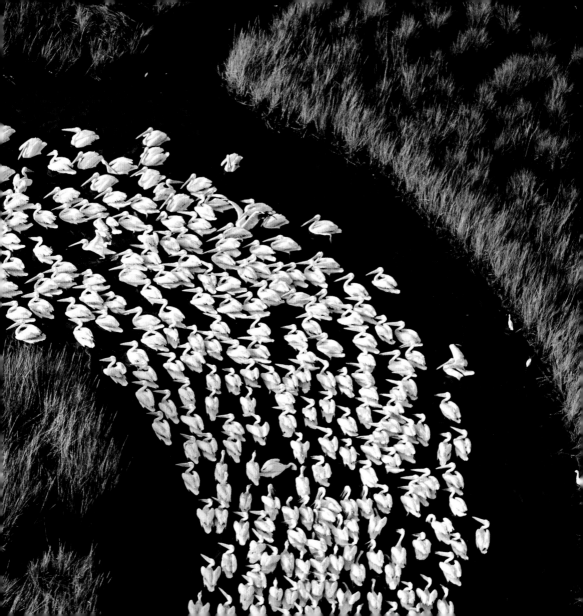

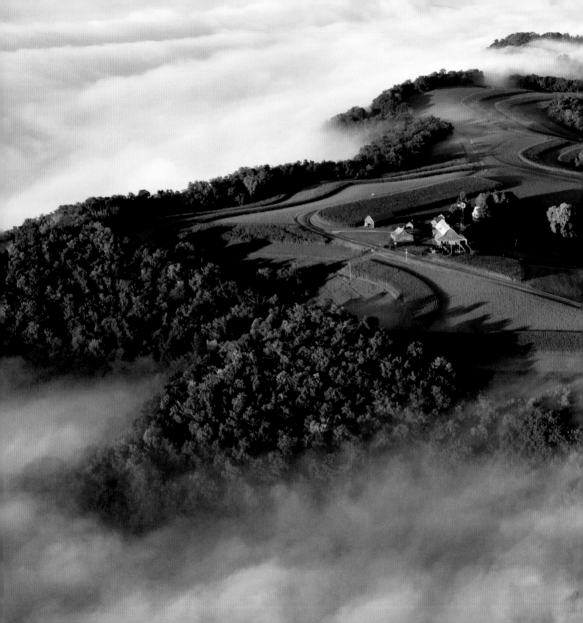

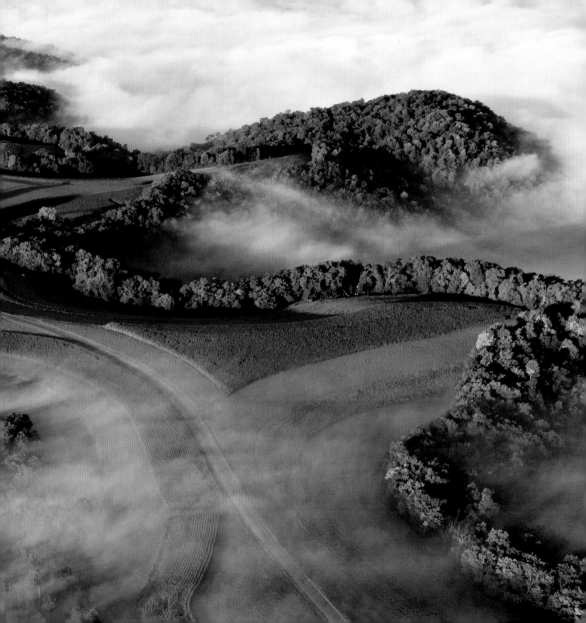

CARR CLIFTON

Organ Pipe Cactus National Monument, Arizona

Mexican golden poppies surround the remnants
of a cholla cactus

following pages

THOMAS J. ABERCROMBIE

Foroglio, Ticino Canton, Switzerland

An old chestnut tree drapes its branches
over stone-clad buildings

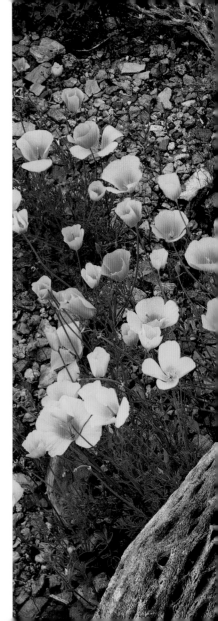

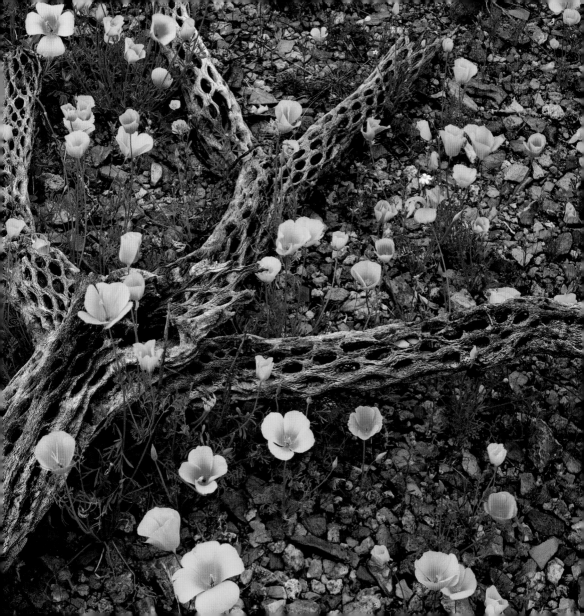

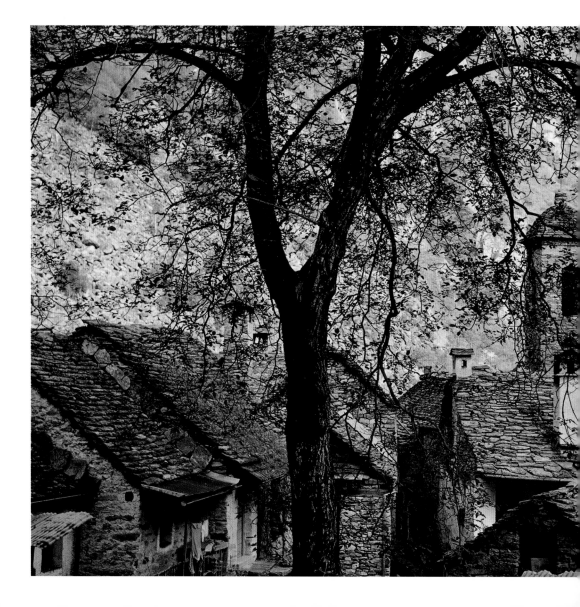

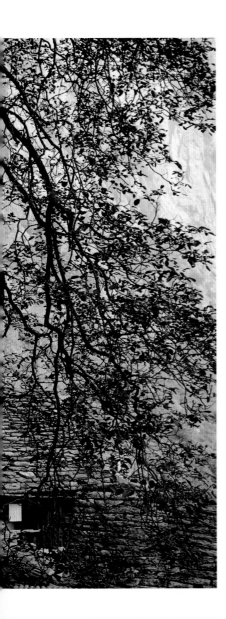

Now to consult the rules

of composition before

making a

picture is a little like

consulting the law of gravitation

before going for

a walk.

~ Edward Weston

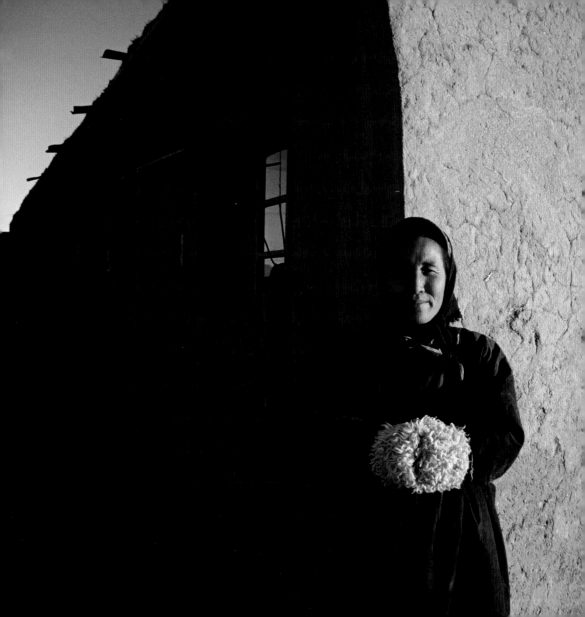

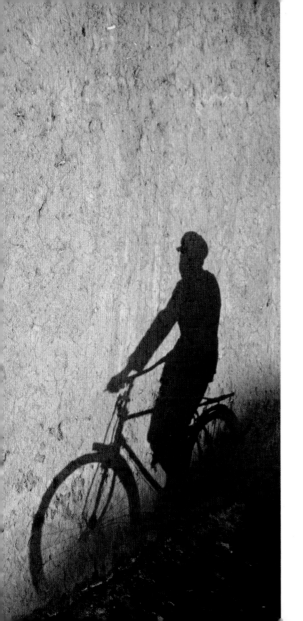

JAMES L. STANFIELD

Inner Mongolian Autonomous Region, China

Sun and shadows highlight people at the
Bayan Obo People's Commune

following pages

JIM BRANDENBURG

Minnesota

Adult American avocets sleep in a group

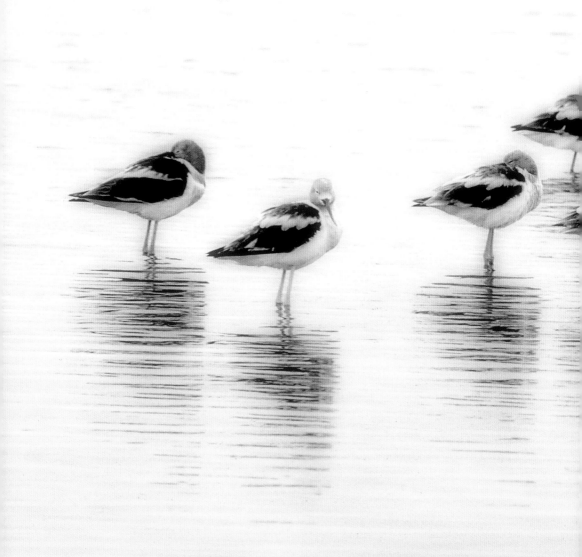

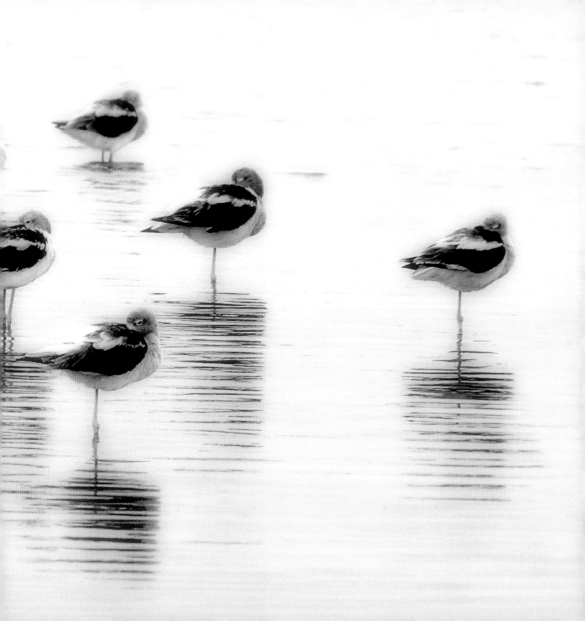

JODI COBB

London, England

Garden Party guests wait through drizzling rain
to see the Queen at Buckingham Palace

following pages

BILL CURTSINGER

Yarmouth, Maine

A dog looks curiously at an unexpected visitor

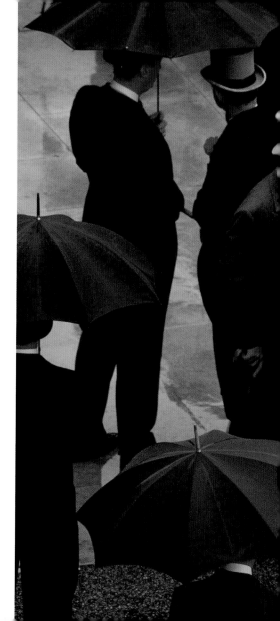

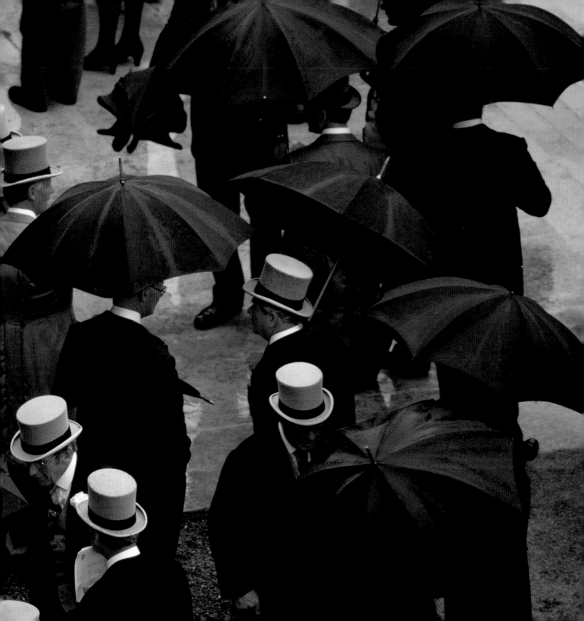

There is one thing the photograph must contain, the humanity of the moment.

~ Robert Capa

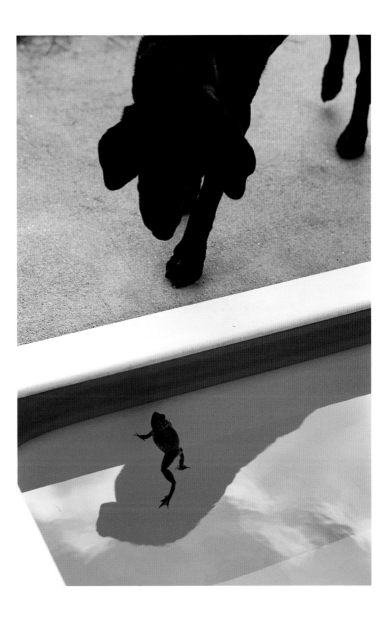

MICHAEL NICHOLS

Samburu National Park, Kenya

A rainbow graces the cloudy sky as a lone elephant
treks through the African countryside

following pages

JAMES L. STANFIELD

Mali

A man smiles from under his woven hat

DONALD McLEISH

Giza, Egypt

An observer admires the worn stone
of the Sphinx

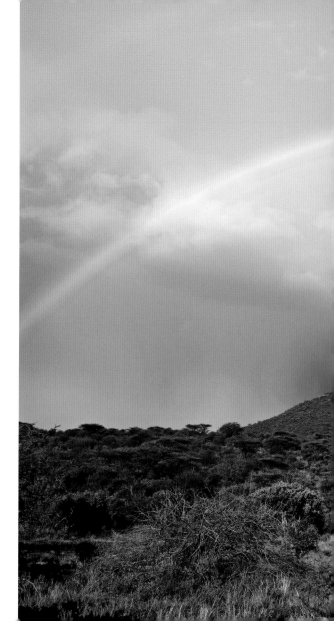

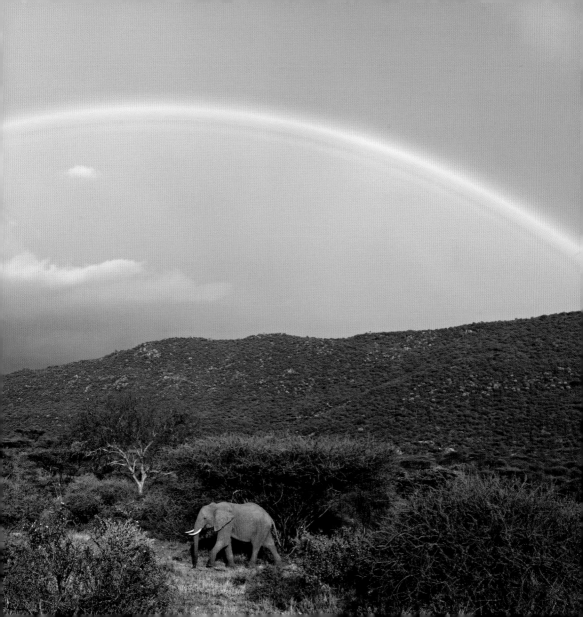

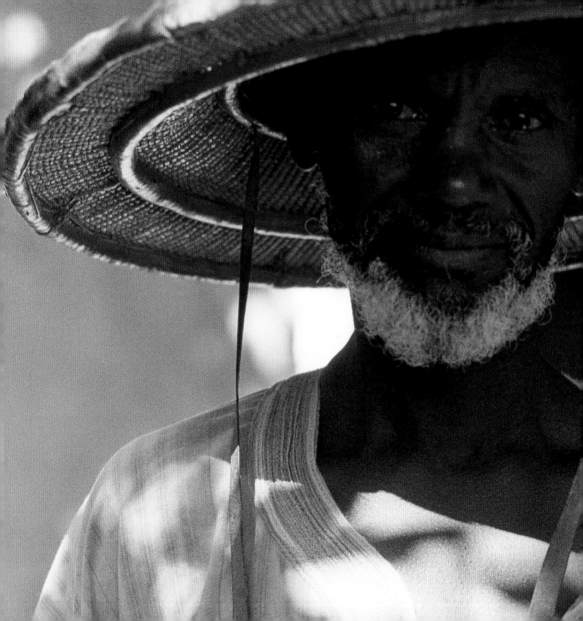

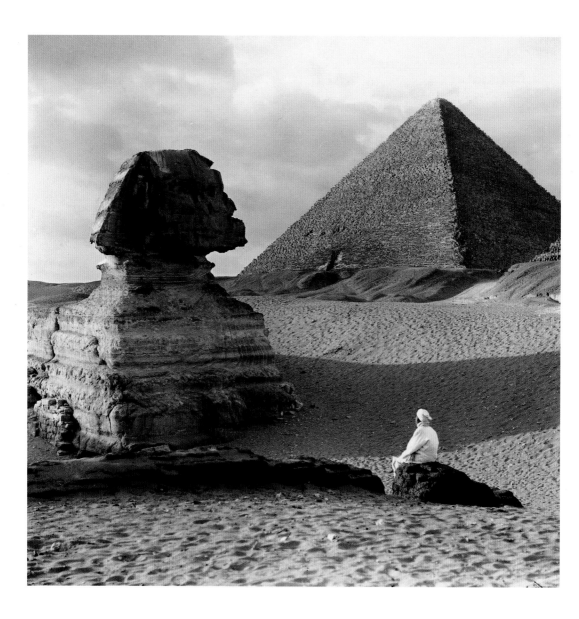

It is in the light of these sparks that the first photographs emerge so beautifully, so unapproachably from the darkness of our grandfathers' days.

~ Walter Benjamin

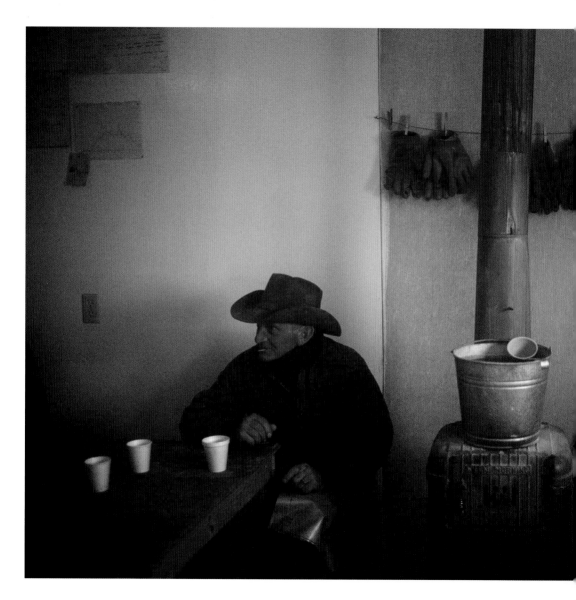

WILLIAM ALBERT ALLARD

Montana

An old cowboy drinks coffee in a calving shed

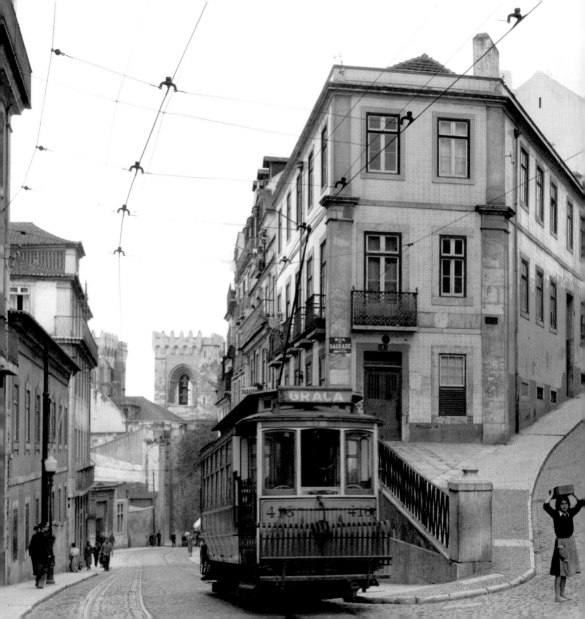

W. ROBERT MOORE

Lisbon, Portugal

A tramcar climbs a hill on a narrow street

ANNIE GRIFFITHS

Bakewell, England

Rabbits hang above a fruit display
at an English market

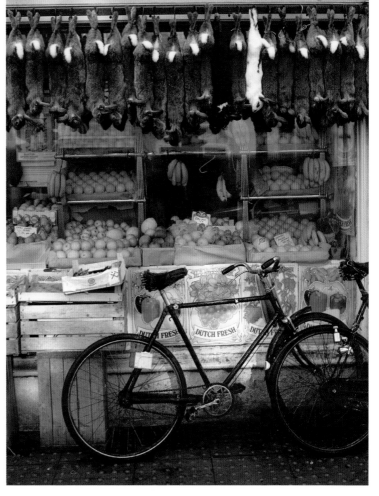

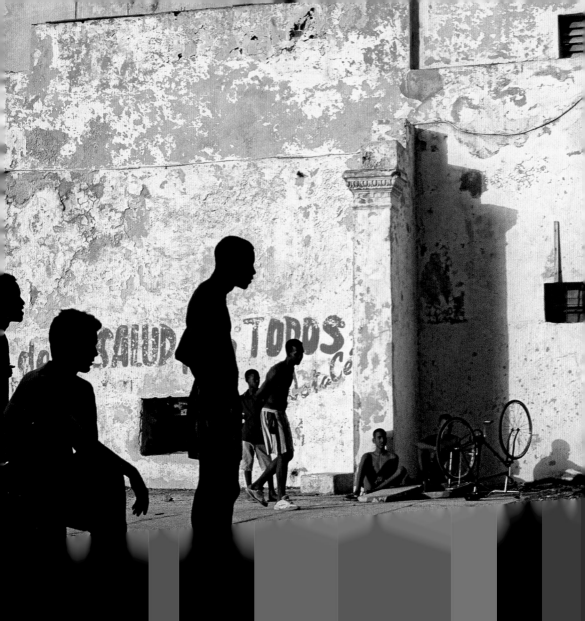

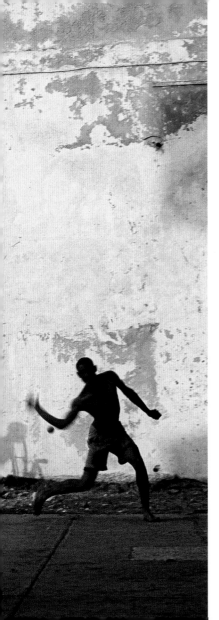

DAVID ALAN HARVEY

Havana, Cuba

Young men enjoy a pickup baseball game
in the city, in spite of not having a bat

following pages

JIM BRANDENBURG

Minnesota

A trio of tundra swans grace a cloudy sky

JULES GERVAIS-COURTELLEMONT

Egypt

A young Nubian girl leans against a wall

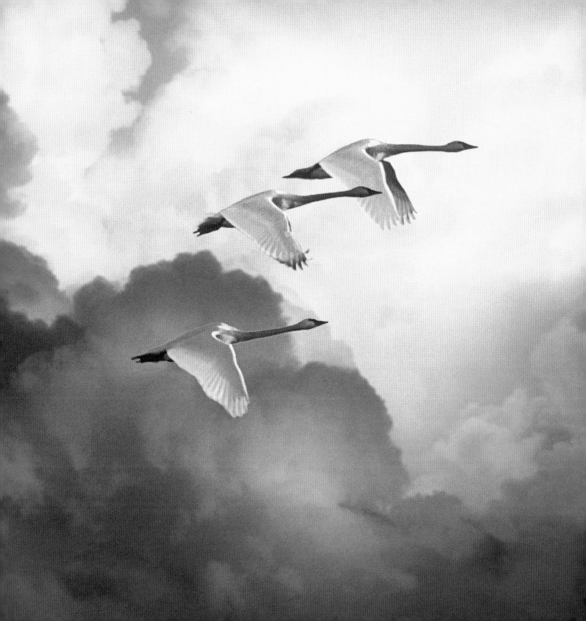

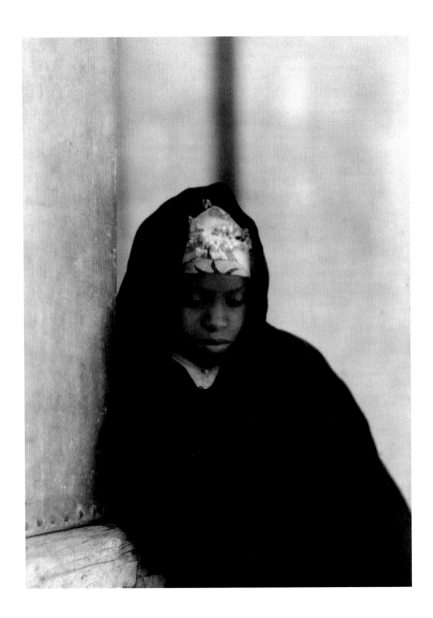

A man's work is nothing but this slow trek to rediscover, through the detours of art, those two or three great and simple images in whose presence his heart first opened.

~ Albert Camus

GEORGE F. MOBLEY

New Mexico

The painter Georgia O'Keeffe sits beside
one of her creations

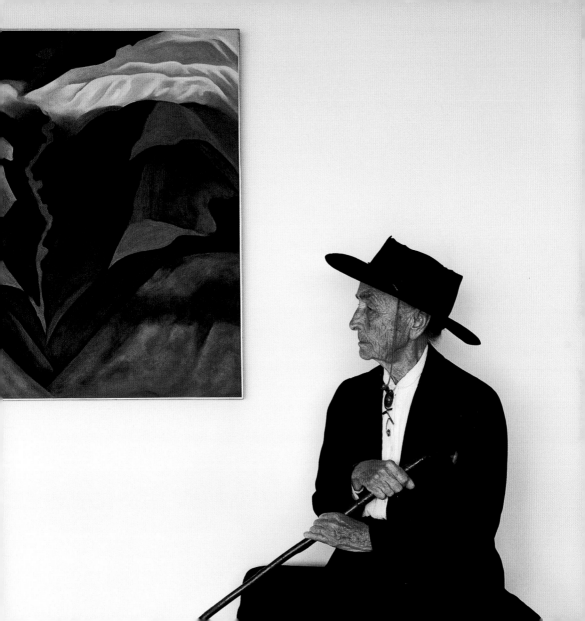

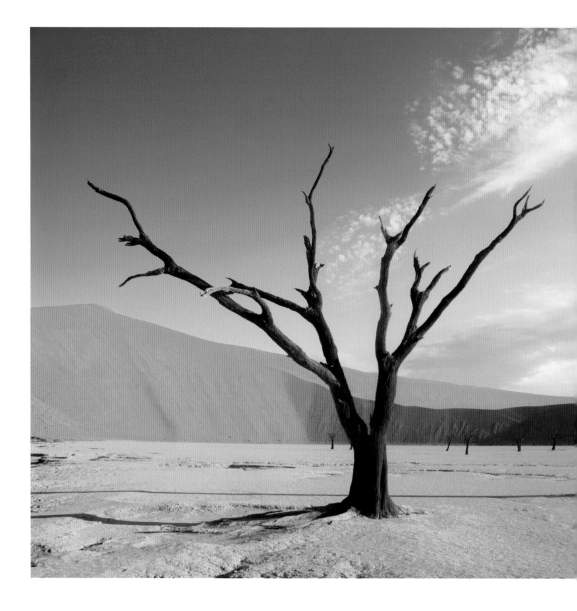

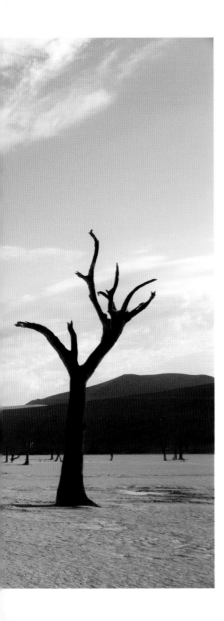

ANNIE GRIFFITHS
Sossusvlei, Namibia
Ancient acacia trees persist despite
encroaching sand dunes

following pages
W. E. GARRETT
Pak-Ou, Laos
A woman prays in a sacred cave along
the Mekong River

HARRY OGLOFF
Alberta, Canada
Still water reflects the face of Mount Kidd

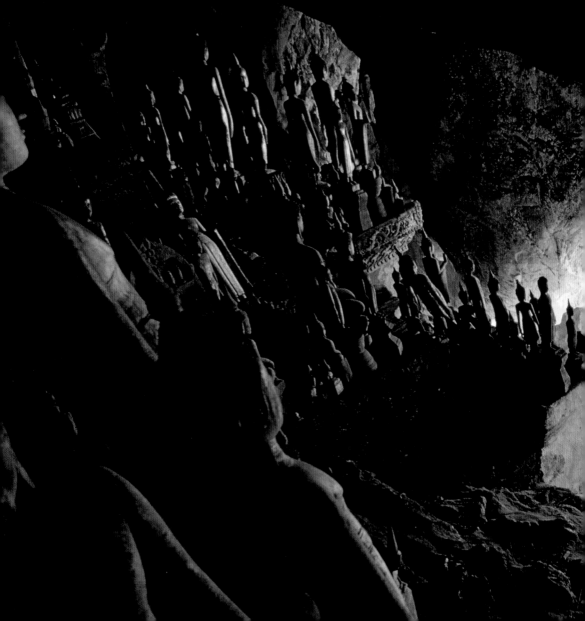

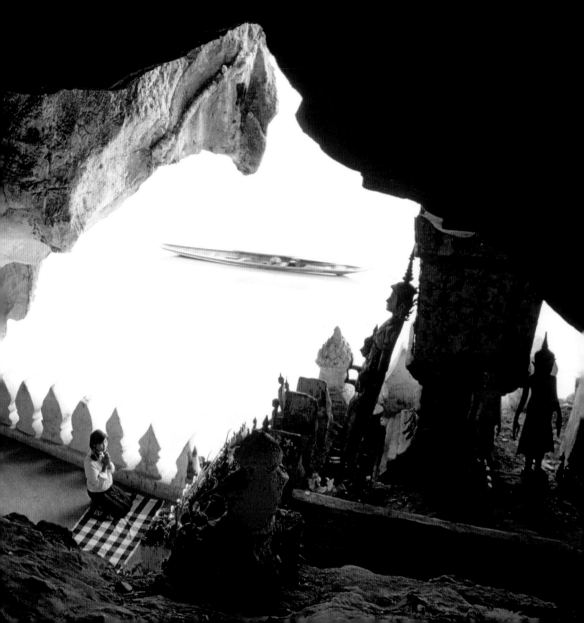

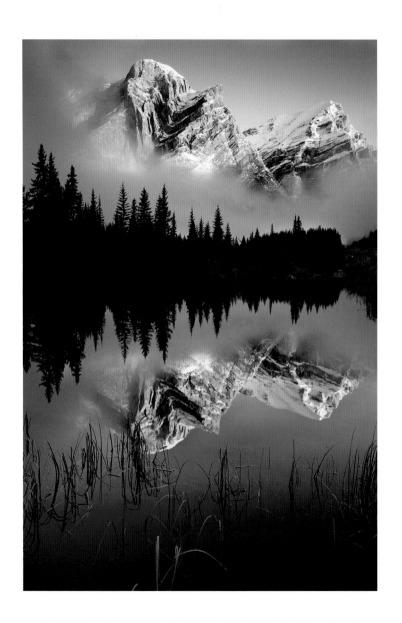

Beauty is a
form of genius—

is higher, indeed, than genius,

as it needs no

explanation.

~ Oscar Wilde

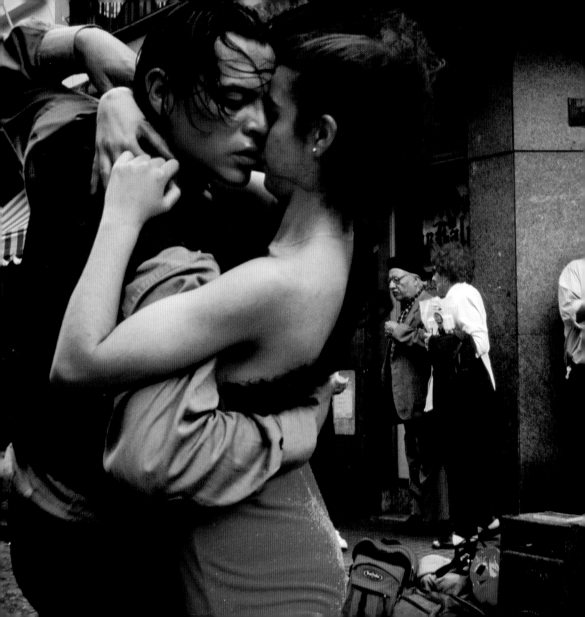

PABLO CORRAL VEGA
Buenos Aires, Argentina
A couple dances on a busy street corner

LUIS MARDEN

Esteli, Nicaragua

Riders tie up their horses' tails in order
to keep them out of the mud

following pages

JAMES P. BLAIR

Virginia

A sika deer wades in Black Duck Pond
at Chincoteague National Wildlife Refuge

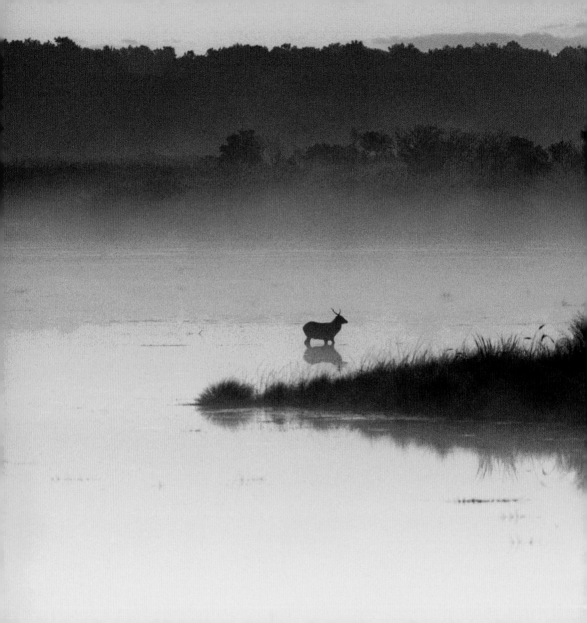

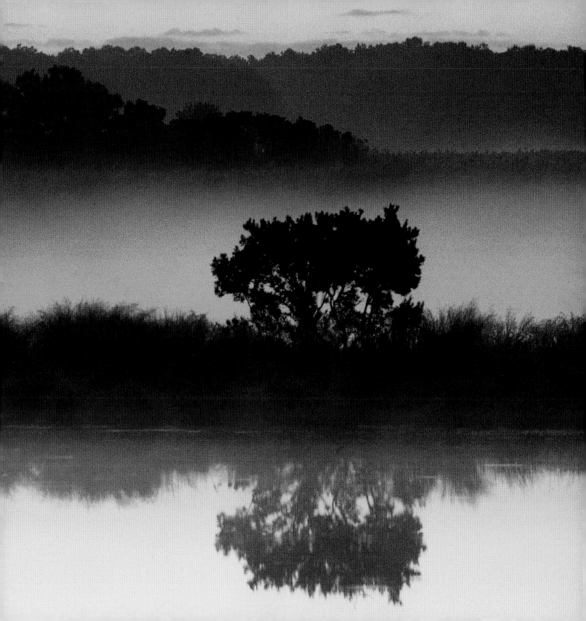

JAMES L. STANFIELD

Richnava, Slovakia

Roma children look out the window of their shanty

following pages

PHIL SCHERMEISTER

Yosemite National Park, California

Green moss distinguishes large trunks
in the Tuolumne Grove

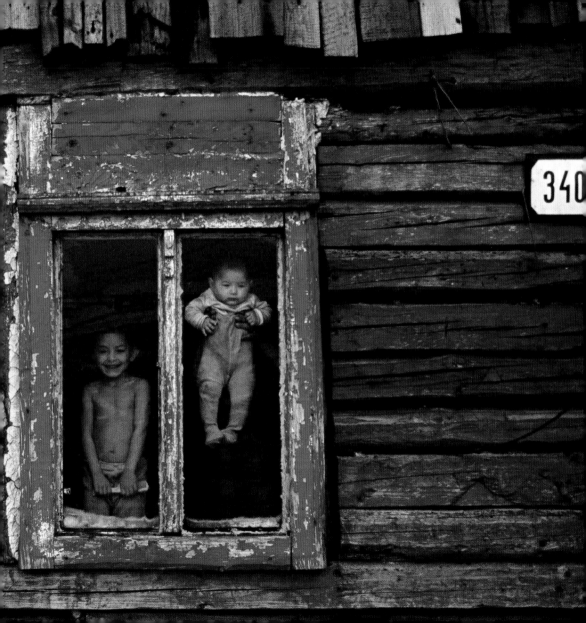

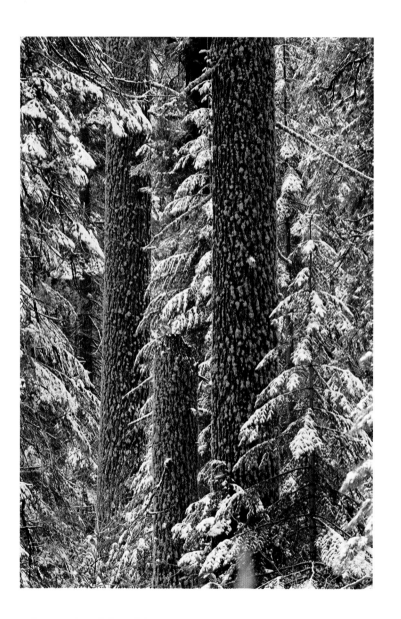

Art consists of limitation. The most beautiful part of every picture is the frame.

~ G. K. Chesterton

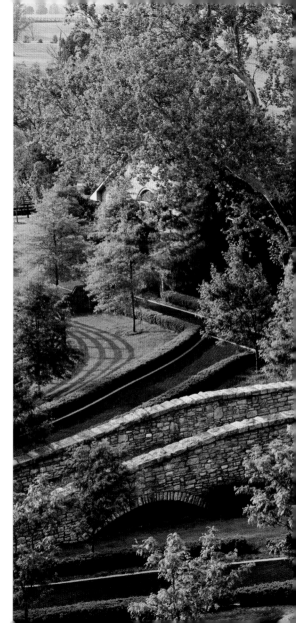

MELISSA FARLOW

Versailles, Kentucky

A horse is walked past barns on the grounds
of Ashford Stud

following pages
JAMES L. STANFIELD

Mozambique Island, Mozambique

Fishermen prepare for the day as the sun rises

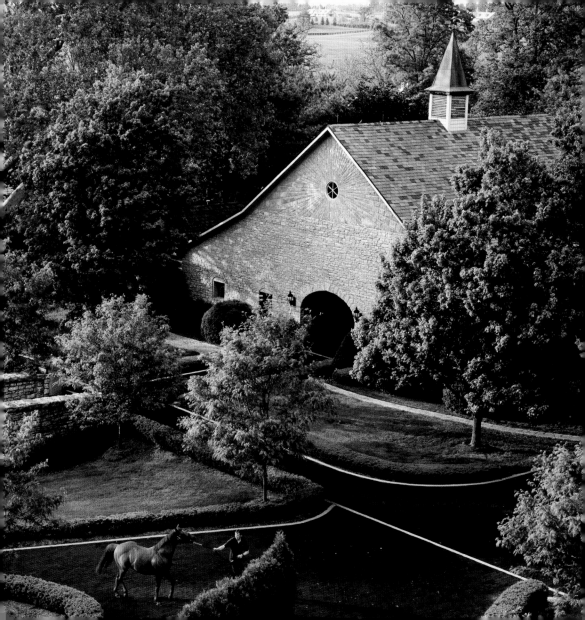

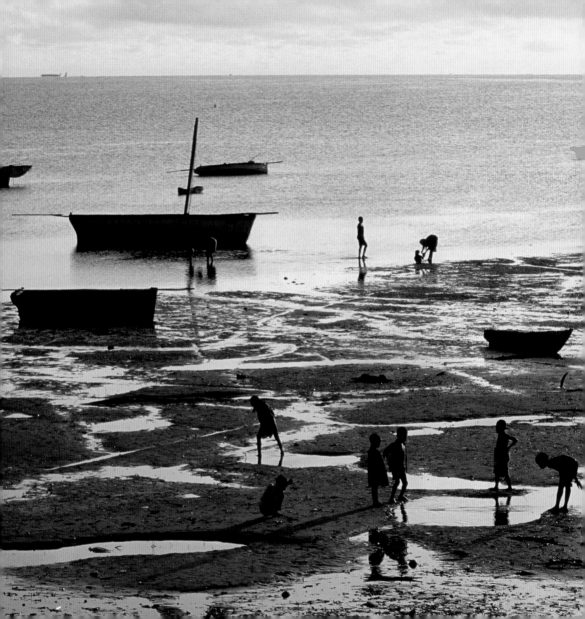

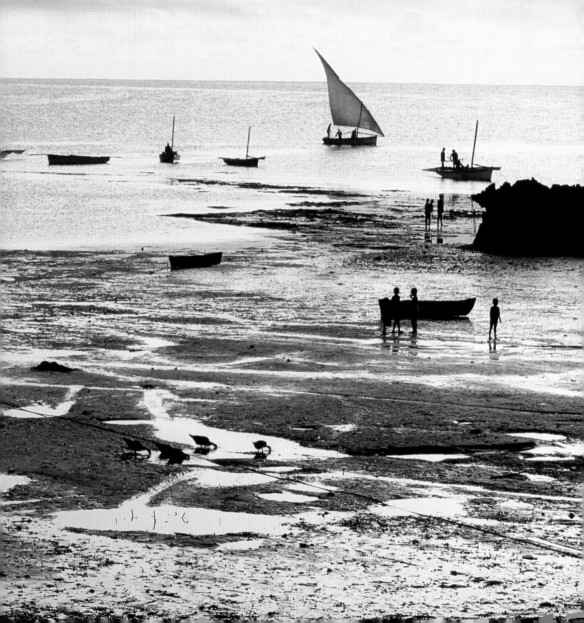

GORDON GAHAN
Tahiti
A dancer is covered with coconut oil before
a performance

following pages
EDWIN L. WISHERD
New Orleans, Louisiana
A woman poses against the door of a theater
in the old French Quarter

JULES GERVAIS-COURTELLEMONT
Île-de-France, France
A woman carrying a wicker dosser walks past
a medieval wall

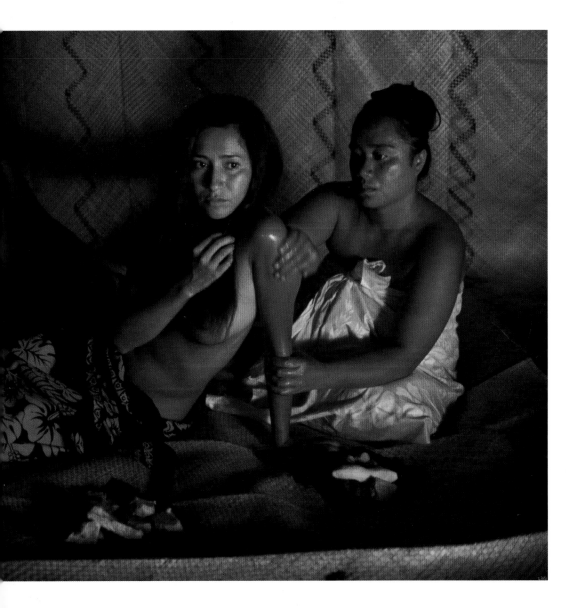

The news that

the camera

could lie

made getting photographed

much more popular.

~ Susan Sontag

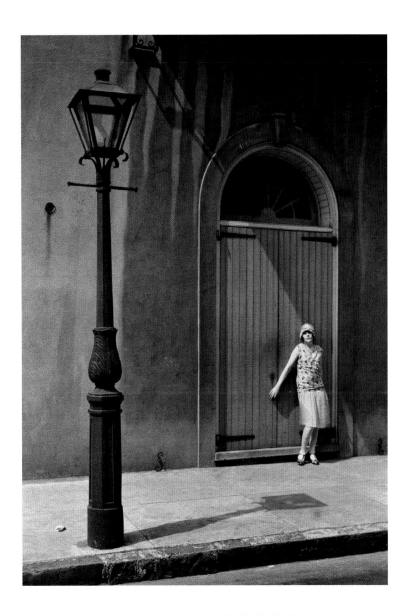

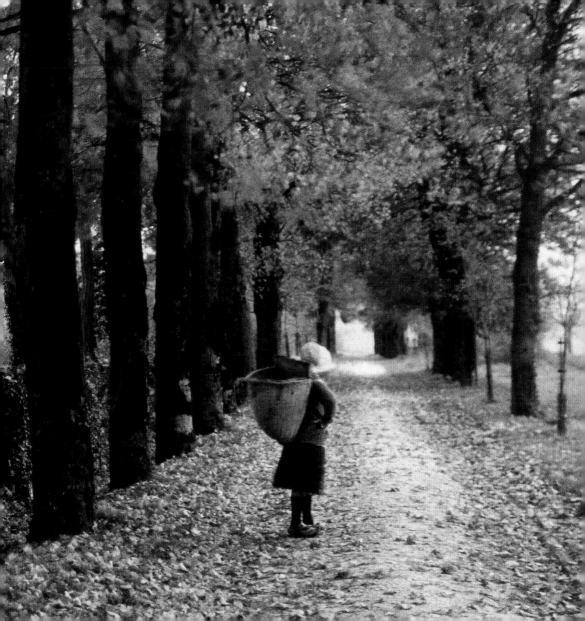

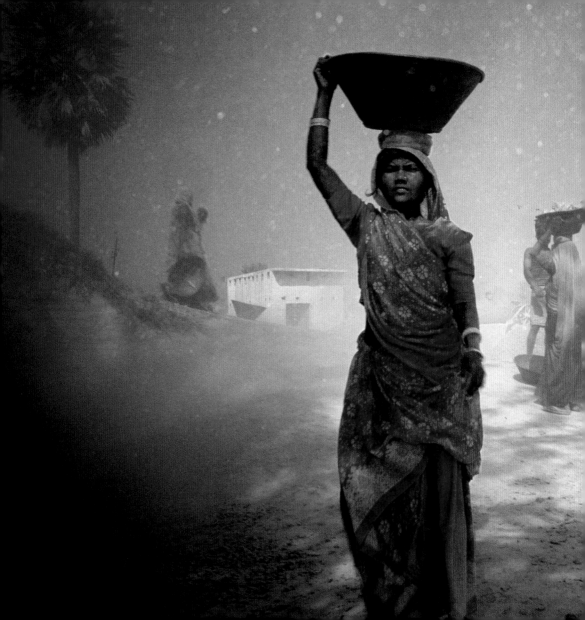

WILLIAM ALBERT ALLARD

Bihar, India

A woman carries a basket filled with
crushed rock on her head

following pages

PAUL NICKLEN

Northwest Territories, Canada

A white gull lands on a piece of sea ice
in Lancaster Sound

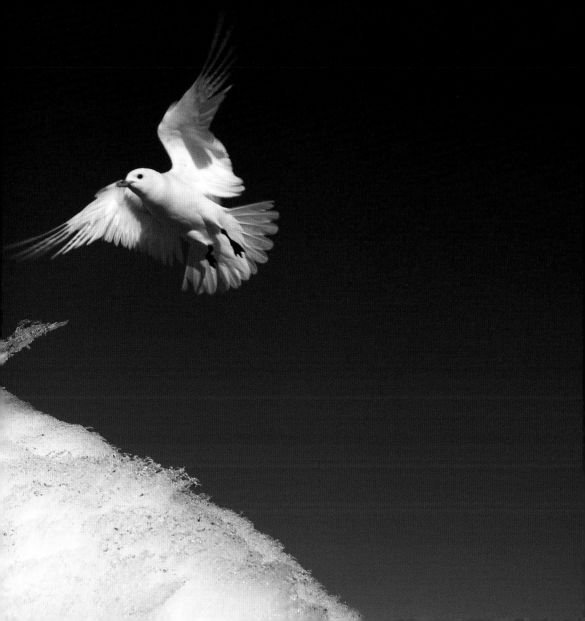

Photography affects us
like a phenomenon in nature,
like a flower or a snowflake
whose vegetable or earthly
origins are an inseparable
part of their beauty.

~ André Bazin

Moment

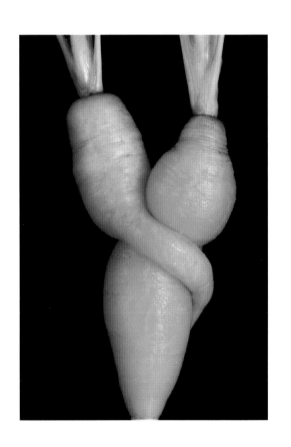

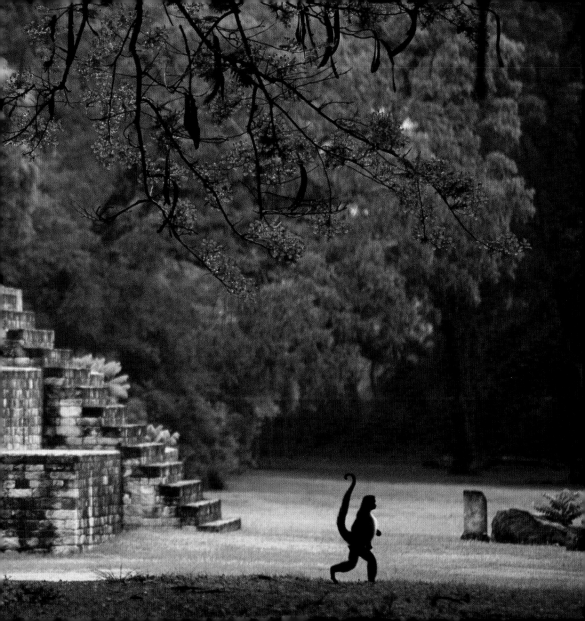

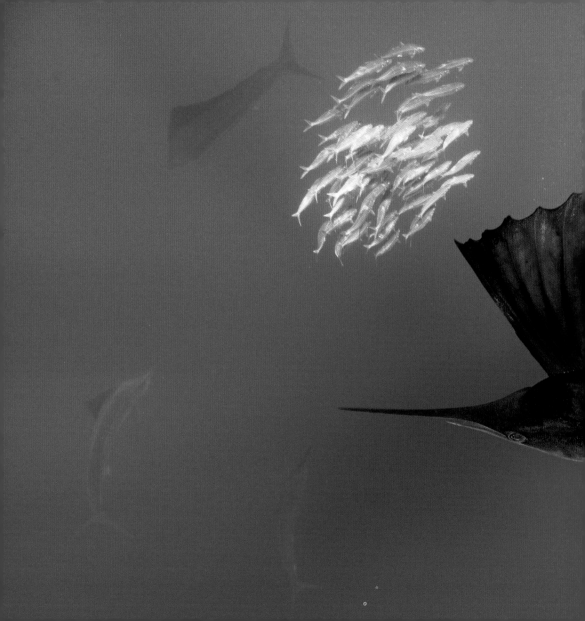

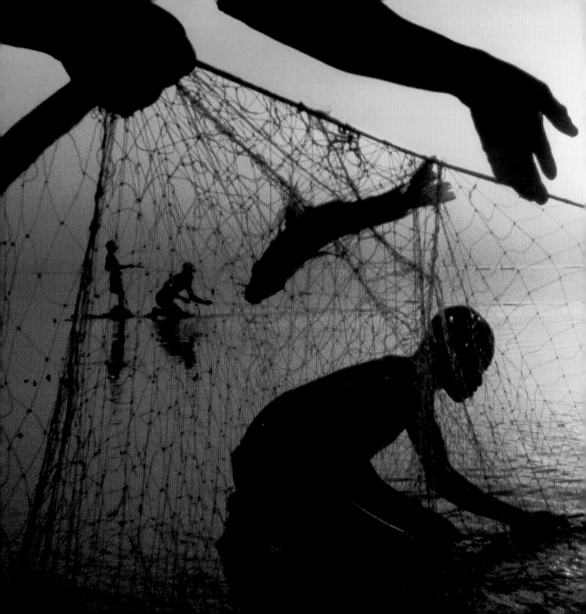

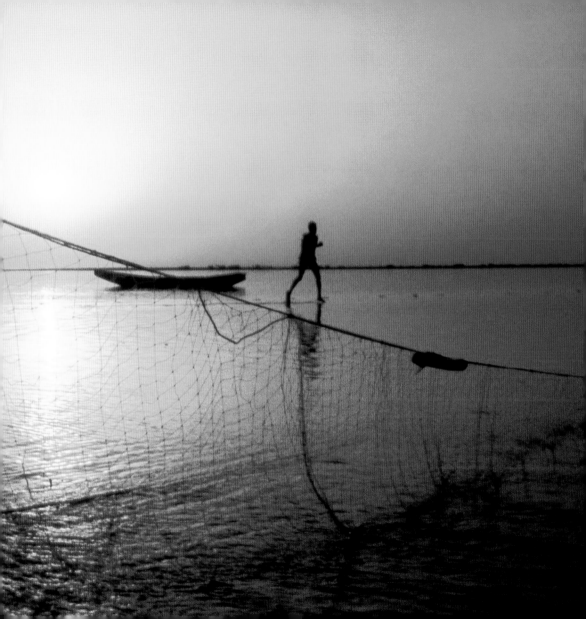

Quickly—recall three photographs that you will never forget—that have had an emotional impact on you. Don't intellectualize. Just let them come to you: Your grandparents' wedding portrait or the sonogram of a child growing inside you; your toddler's first step or that of Neil Armstrong on the moon; the American flag being raised on Iwo Jima; the plane that landed safely on the Hudson River; the seaman kissing a nurse in Times Square. Whether part of history or of our own lives, the moments captured in photographs stay with us like favorite smells. Chances are, most of them capture an indelible moment in our lives or in the lives of others. ∂ So what is a "moment" in photography? It refers to the precise instant when visual elements come together to make a photograph compelling:

Moment

a touch of light or of comfort, a glance, a benediction, a smirk, a caress, a moment of tension or illumination or enlighten-ment or grace or empathy or despair or rapture. Photogra-phers dream of such moments—when a picture is almost

perfect, and then the flag flutters, the hands touch, the sun ignites, the baseball is struck. It can be a moment that involves light or composition or revelation, and it will be over in an instant. Miss it, and it is gone forever. ∂ Consider photographer Ken Garrett's photograph of the Maya pyramid in Copán, Honduras (pages 204-205). The scene is interesting. The composition and light and color are lovely. A monkey walks through the scene, making it better. Then the monkey's tail goes up. Bam! A photograph is born. Composition, light, color, and moment have come together to make a great photograph. ∂ The best moments happen when subjects become so comfortable with the photographer that they forget his or her presence, and return to the life they lead, with no

self-consciousness at all. We see this in photographer Michael Christopher Brown's image of a woman and her horse (pages 230-231). Who knows how many pictures were taken that day, but it is the instant when the woman buries her face against the horse's neck, and the horse's eyes close, that reveals intimacy. We are privileged to witness such a private moment. Some photographers strive for compositions where all the visual elements are enhanced by an unpredictable moment. Consider Randy Olson's wonderful view of an Amish family sprawled on a hay wagon (pages 234-235). The photographer had clearly earned the trust of these notoriously camera-shy people. The composition is so engaging—the body language of each family member so natural—and then the cat walks through. Perfection. Light and gesture come together miraculously in Mitsuaki Iwago's photograph of a lioness and her cub (pages 246-247). We are immediately drawn to the gesture of the lion cub with its paw on the mother's neck. Even the lions' pose, looking away, adds to a sense of intimacy. And the soft beauty of the light completes the image, blesses the gesture, and makes it unforgettable. In order to capture such moments, the photographer must work to become invisible, so that the scene unfolds naturally. Wildlife photographers have no choice but to accept that they are guests in the subject's world, and must abide by the animal's way of doing things. They must earn the pictures by being as unintimidating as possible. These same rules also apply to photographs of the human animal. The best photographers have an ability to listen on many levels—to body language, to facial expressions, to behavior—so that they are prepared for what may happen, and they never intrude on a moment. Photographers must be humble and instinctive and excruciatingly patient as they anticipate the unknown. They must put their subjects at ease as quickly and as completely

as possible. 🙠 When I am on assignment, I do many things to appear nonthreatening. I carry very little gear: one small camera and a backpack. I never hover above people when shooting, but rather try to be physically at their level or below them. I spend a lot of time on my knees. We don't think about it often, but humans, too, have an ingrained sense of dominant or submissive behavior. Submissive body language will always put the rest of the species at ease. And that's when real moments happen. 🙠 On the best days, the photographer becomes completely lost in the scene before him, anticipating the unknown with an ever attentive eye. Most of the time he has no idea what he is waiting for. The lack of control is exhilarating. The moment may or may not happen. But when it does—magic! 🙠 In 1871, only a few decades after the invention of photography, an article in *Macmillan's Magazine* in London stated, "Any one who knows what the worth of family affection is among the lower classes, and who has seen the array of little portraits stuck over a labourer's fireplace . . . will perhaps feel with me that . . . the sixpenny photograph is doing more for the poor than all the philanthropists in the world." 🙠 Prior to this time, only the wealthy could afford to have paintings made of their families. And those paintings were expensive and representational, often idealized. With photographs came the small imperfections of loved ones' lives—the untied shoe, the smudged cheek, the unruly curls—things a painter would have tamed. Painted portraits tended to represent the subject in general, through a series of sittings, rather than at one moment in time. Photographs were far more specific. They captured a person in one instant, warts and all. And these photographs were affordable. Imagine what that meant to the vast majority of people in the late 1800s, who had never possessed a likeness of any loved one, much less a photograph revealing that person,

exactly as they looked at that special moment in time. ⌘ As photographic technology improved, allowing for shorter exposures on more sensitive film, photographic moments became more and more instantaneous. Photographs could freeze action and vibrancy and gesture. Because still images have always had to communicate without sound or smell or motion, gesture has become one of the most compelling indicators of a moment frozen in time. This is true even with inanimate objects. Consider the way a tulip nods coyly (page 256), or the wit of the carrots' embrace (page 203). These images touch us because they imitate a gesture that we understand on an emotional level, and it is our emotional connection to a photograph that makes it memorable. ⌘ Some moments seem to become more beautiful or poignant with the passage of time. We are delighted by old pictures that remind us of the styles and events and priorities of the past. Time can turn even sad moments into objects of tender regard. I was ten years old when John F. Kennedy was assassinated. I recall days of news coverage, of tragic video, and of a nation grieving. But of all the images from that dramatic event, it is the simple, beautiful gesture of a three-year-old attempting to salute his father's casket that I and my generation will cherish forever. ⌘ Other moments are beautiful because they are a revelation. We wonder at the paternal birth of a seahorse, shiver at the sight of a BASE jumper flinging himself off a tower in Dubai, and are humbled by the kindness in the eyes of Nelson Mandela. Photographic moments inform us about things we can't imagine, help us to care, and create a record of what was. Master photographer and teacher Aaron Siskind said, "Photography is a way of feeling, of touching, of loving. What you have caught on film is captured forever . . . it remembers little things, long after you have forgotten everything."

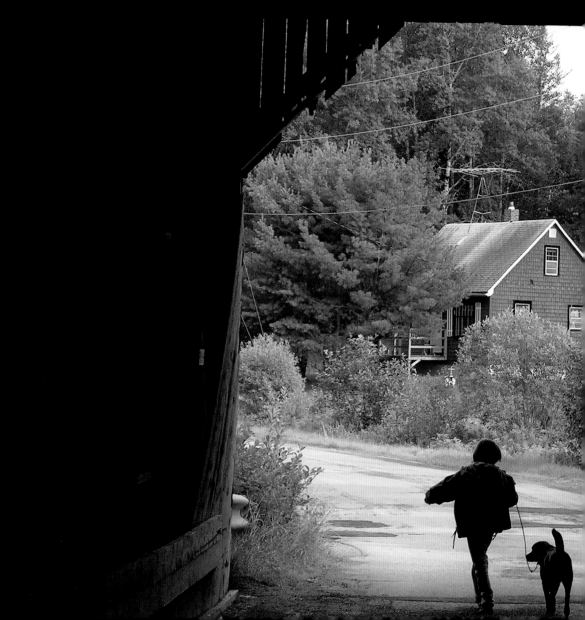

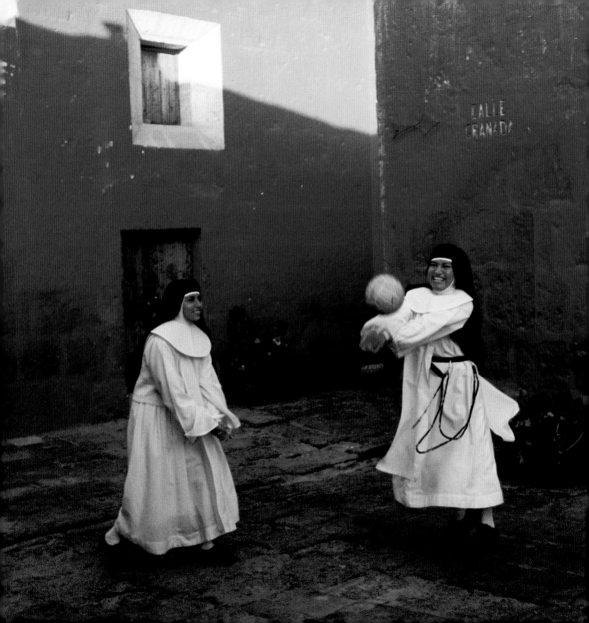

MELISSA FARLOW

Arequipa, Peru

Young nuns play volleyball at the Santa
Catalina Monastery

preceding pages (203-215)

RICH REID

Oak View, California

Carrots grow twisted together

KENNETH GARRETT

Copán, Honduras

A spider monkey walks past a Maya ruin

PAUL NICKLEN

Isla Mujeres, Mexico

A sailfish gracefully rounds up sardines

GORDON GAHAN

Lake Chad, Chad

Fishermen haul in a net at the end
of the day

BRUCE DALE

New Brunswick, Canada

A child walks a dog through
a covered bridge

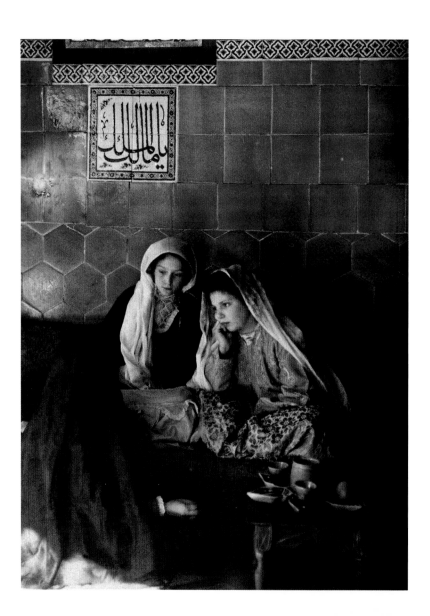

Beauty comes as much from the mind as from the eye.

~ Grey Livingston

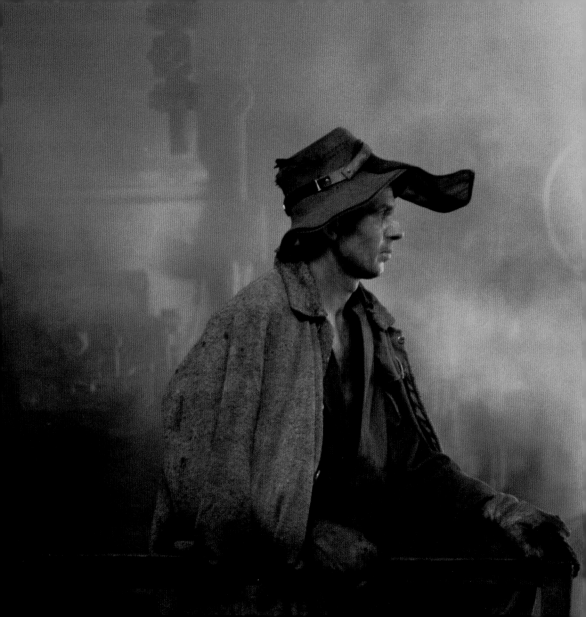

JAMES P. BLAIR
Kosice, Slovakia
A steelworker tends a blast furnace

preceding pages (218-221)
JULES GERVAIS-COURTELLEMONT
Bursa, Turkey
Young women share tea in a brightly
tiled room

PAUL NICKLEN
Lancaster Sound, Nunavut, Canada
A pod of narwhals disappear into
the depths of the Arctic Ocean

GORDON GAHAN

Near Wismar, Germany

Women share a laugh while harvesting sugar beets

following pages

JOEL SARTORE

Bioko Island, Equatorial Guinea

A young drill monkey covers its mouth with its hand

BRUCE DALE

Tidore Island, Indonesia

A young boy balances while drinking from
a freshwater pool

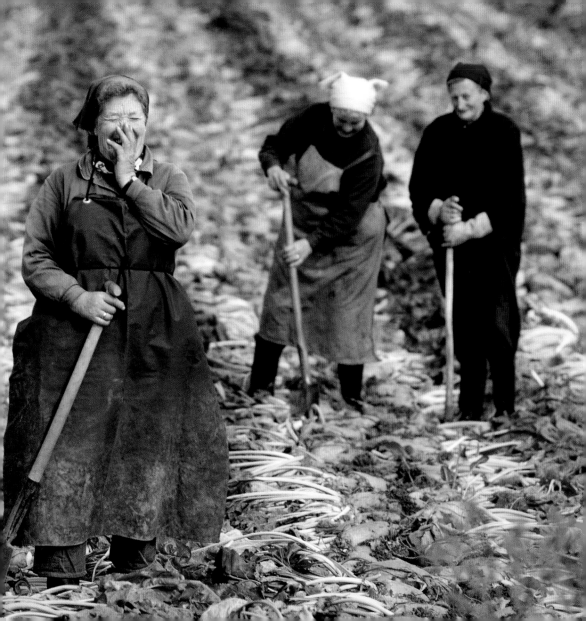

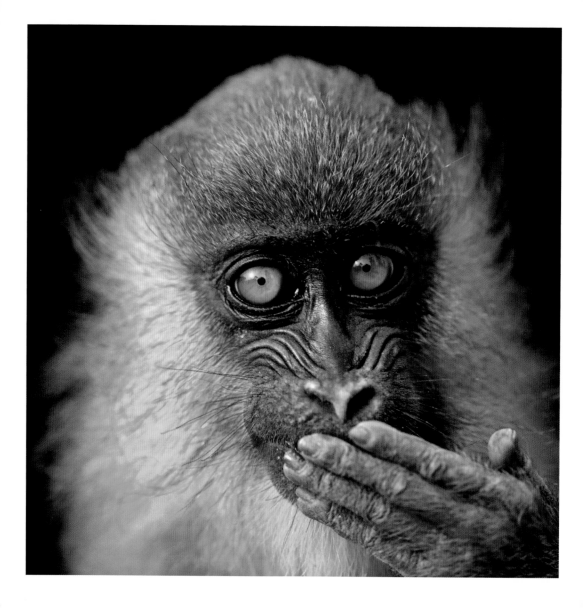

Of which beauty will you

speak? There are many. . .

~ Eugène Delacroix

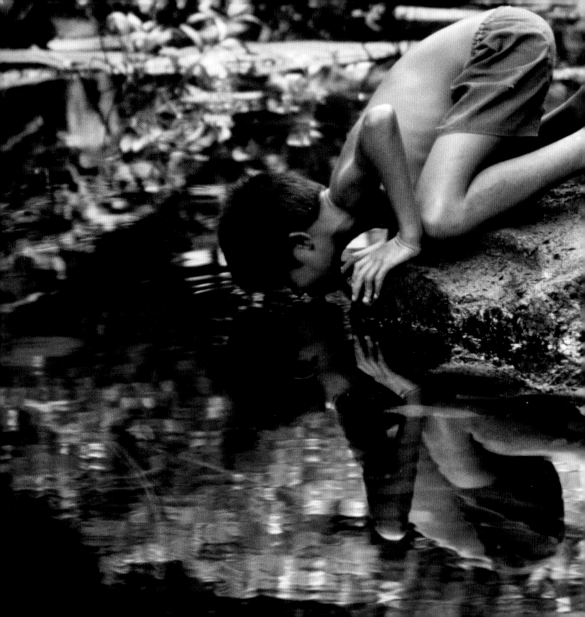

MICHAEL CHRISTOPHER BROWN

British Columbia, Canada

A rider pats her horse during a rest stop
in the Muskwa-Kechika Management Area

following pages

JAMES L. STANFIELD

Akko, Israel

Dancers from the Inbal troupe combine Yemeni
and Jewish rhythms

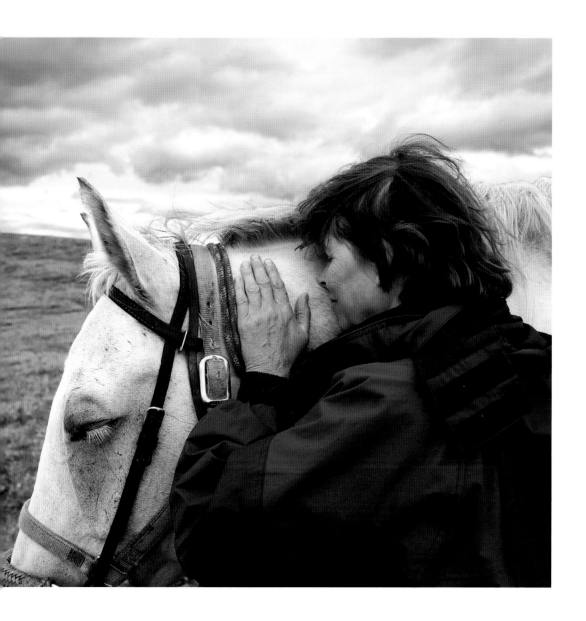

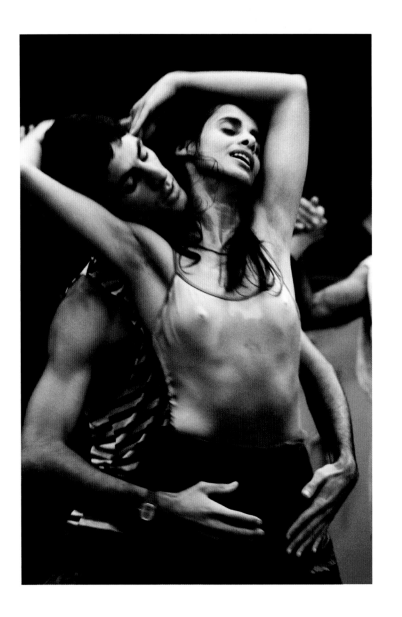

In every man's heart there is a secret nerve that answers to the vibrations of beauty.

~ Christopher Morley

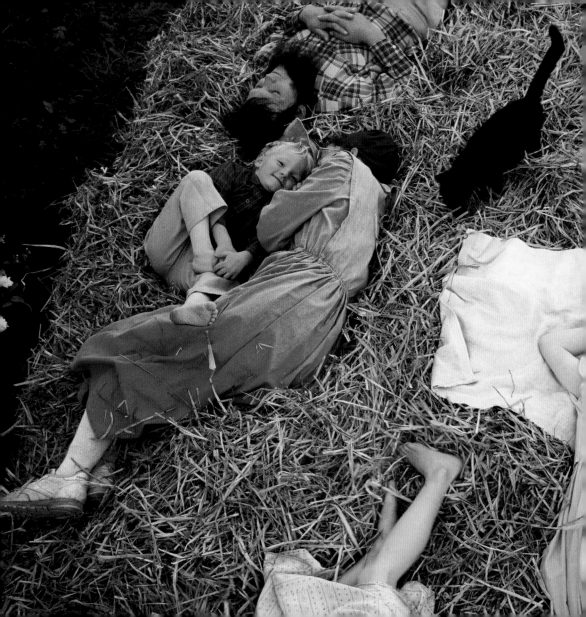

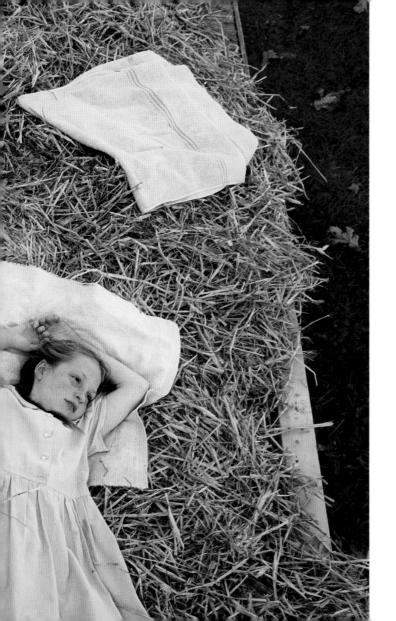

RANDY OLSON

Peace Valley, Missouri

An Amish family rests in a full hay cart

following pages

FLIP NICKLIN

South Island, New Zealand

The tail of a sperm whale arches out
of the water as the animal dives

IAN NICHOLS

Democratic Republic of the Congo

A silverback gorilla soaks in a swamp
while munching on water plants

235

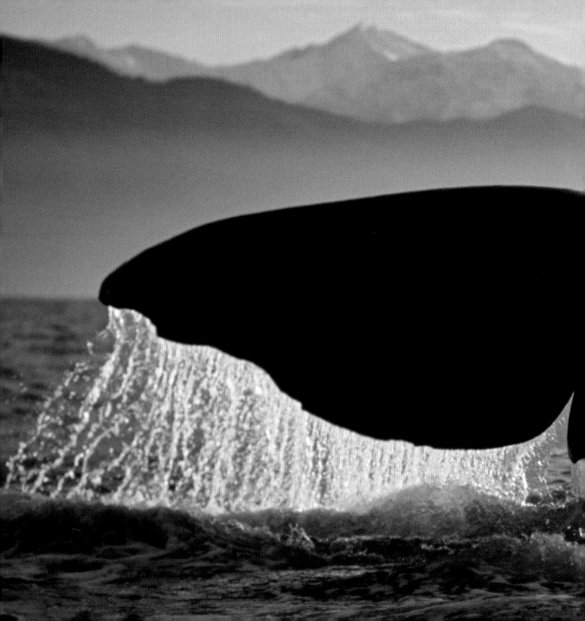

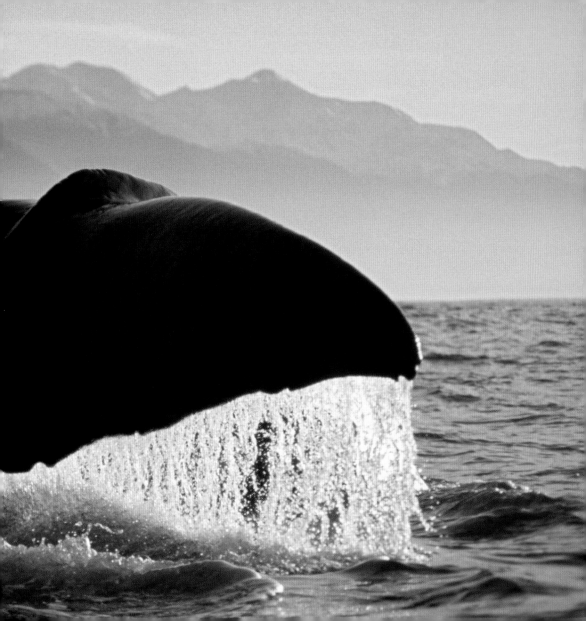

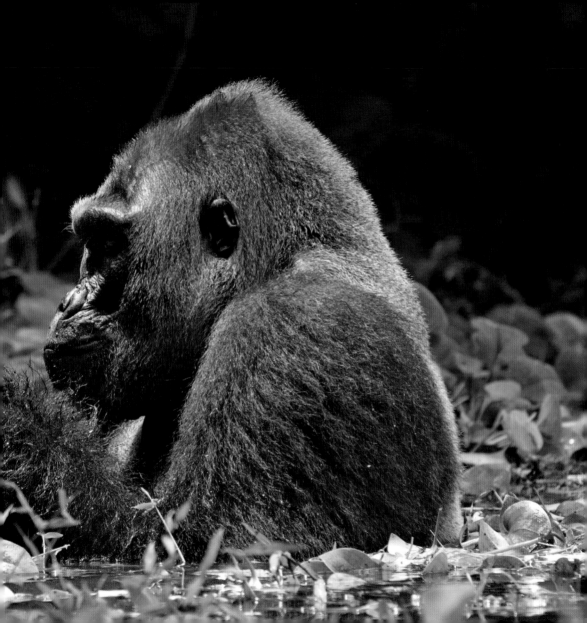

SISSE BRIMBERG

St. Petersburg, Russia

A proud mother smiles at her sleeping baby
in Tauride Garden

following pages

WINFIELD PARKS

Mila 23, Romania

Smiles crease the faces of a Romanian couple

JULES GERVAIS-COURTELLEMONT

Near Beaulieu, France

Artists paint along the banks of the Dordogne River

The really original artist does not try to find a substitute for boy meets girl, but creates the illusion that no boy ever met a girl before.

~ A. Hyatt Mayor

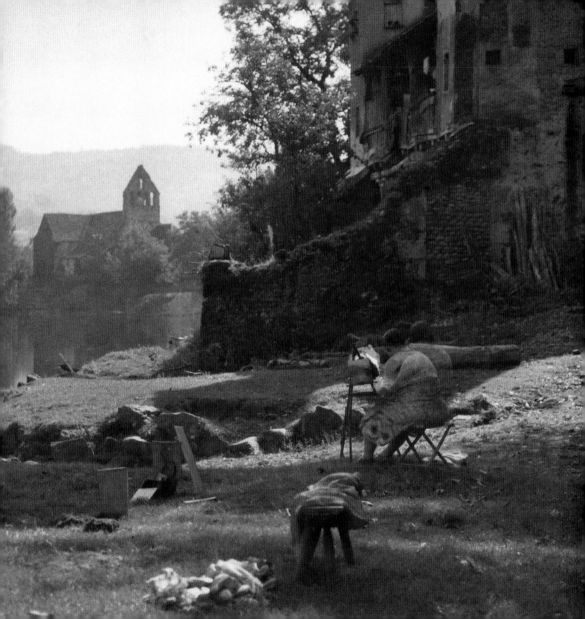

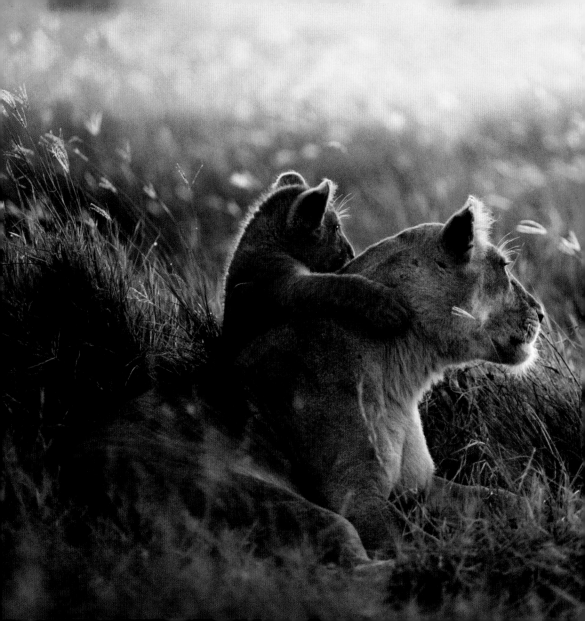

MITSUAKI IWAGO

Serengeti National Park, Tanzania

A mother and cub stare off into the distance as sun reflects off the grasses

following pages

JAMES P. BLAIR

West of Dacca, Bangladesh

A young herder uses a water buffalo as a platform from which to do a backflip

JAMES L. STANFIELD

Mongolia

An affectionate mother holds her baby

GORDON WILTSIE

Darhad Valley, Mongolia

Colorfully clad children race horses across a valley

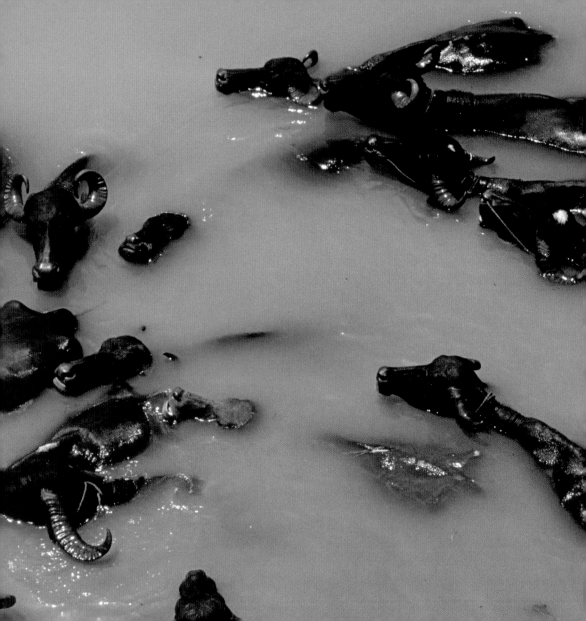

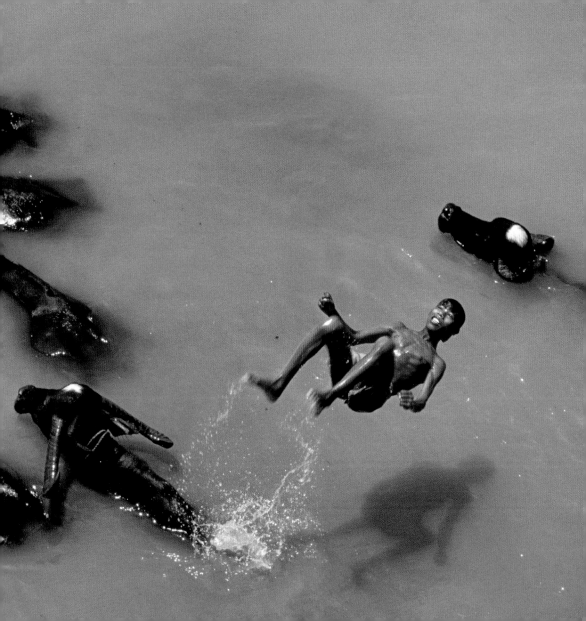

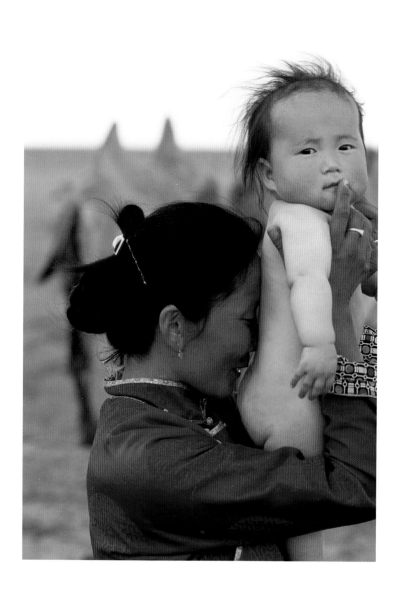

Wisdom is the abstract of the past, but beauty is the promise of the future.

~ Oliver Wendell Holmes

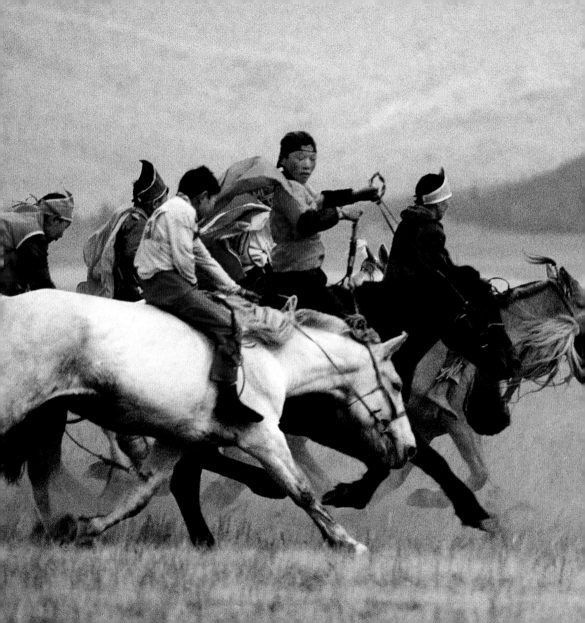

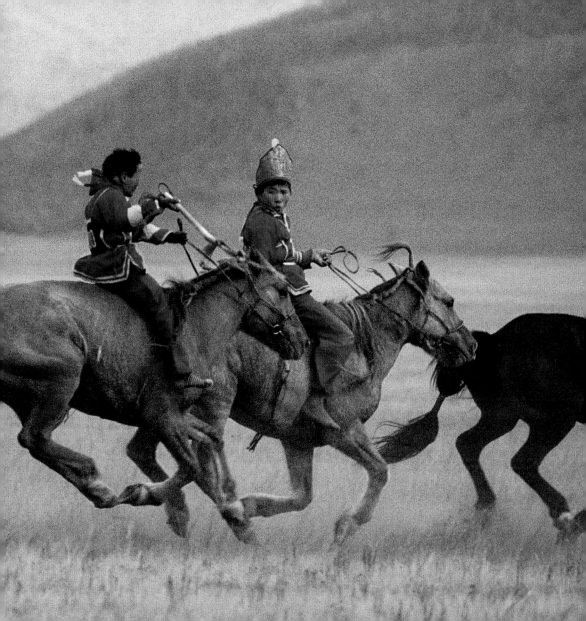

RANDY OLSON
Lorman, Mississippi
A man eats on the front porch of an old store

following pages
WENDY LONGO
New York
Tulips approach blossom

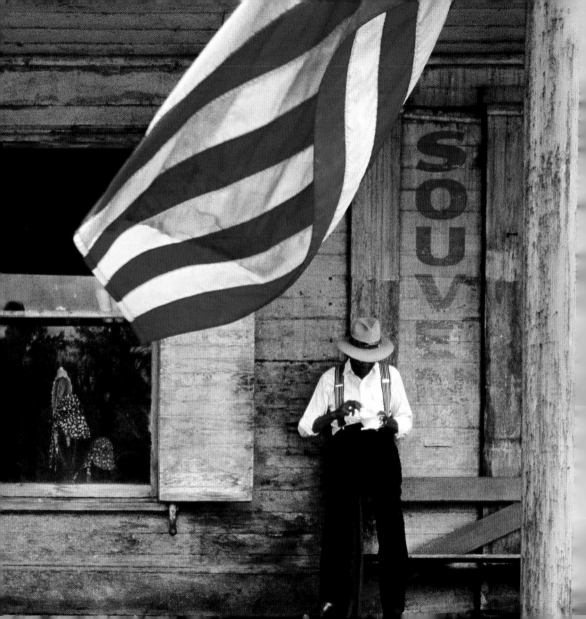

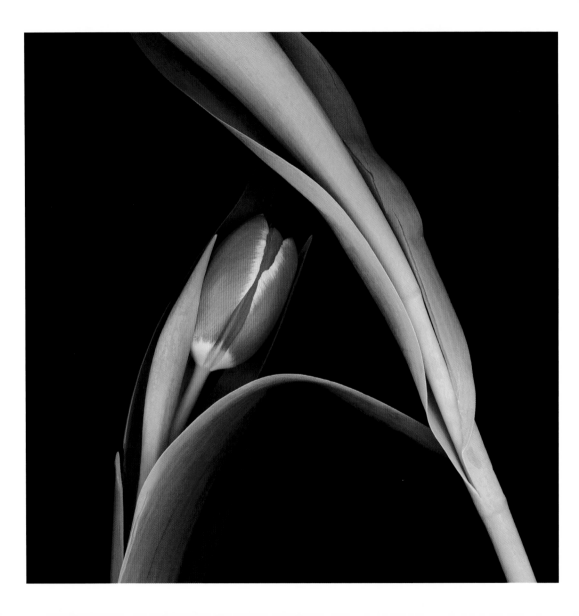

The possession
of knowledge
does not kill the sense of wonder
and mystery. There is always
more mystery.

~ Anaïs Nin

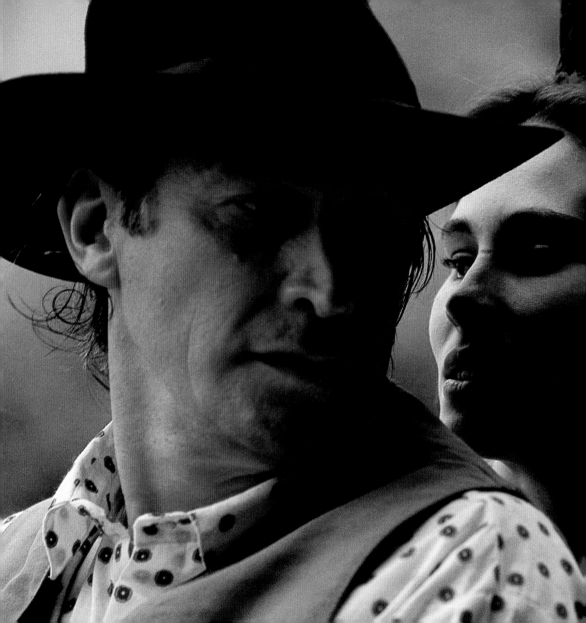

JAMES L. STANFIELD

Provence, France

A couple converses quietly while attending
a local festival

KAREN KASMAUSKI

Honshu Island, Japan

A girl carries a miniature version of her
grandmother's harvest basket

following pages

JAMES L. STANFIELD

Berkshire, England

A coach passes in front of Windsor Castle
on a snowy day

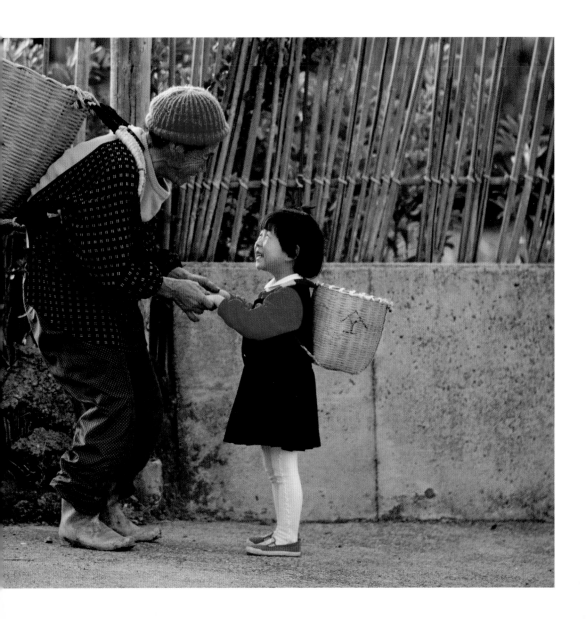

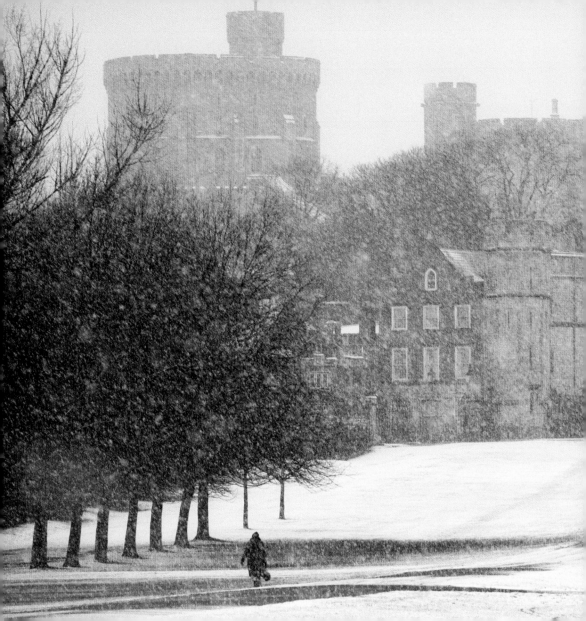

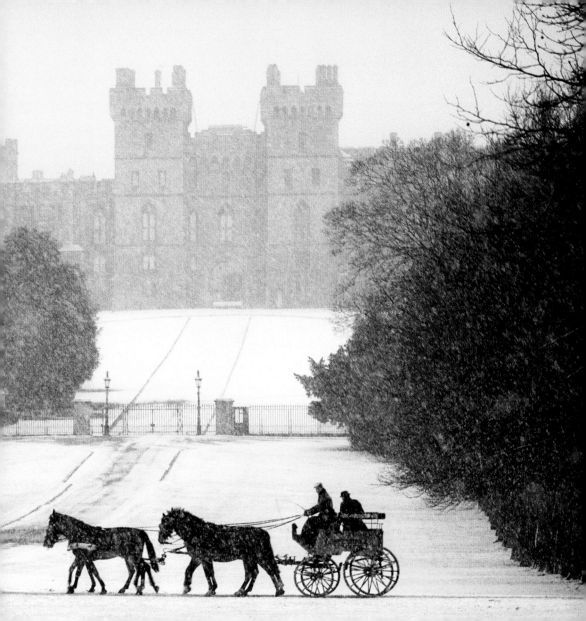

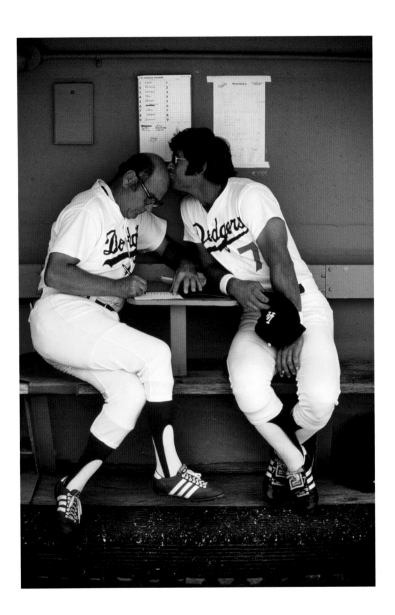

JODI COBB

Los Angeles, California

Steve Yeager jokes around with Monty
Basgall before a game at Dodger Stadium

following pages

JAMES L. STANFIELD

Havana, Cuba

Ballerina Alicia Alonso rehearses at the
Gran Teatro de La Habana

STEVE RAYMER

Vietnam

An elderly woman in a traditional hat
smiles for the camera

An artist is a dreamer consenting to dream of the actual world.

~ George Santayana

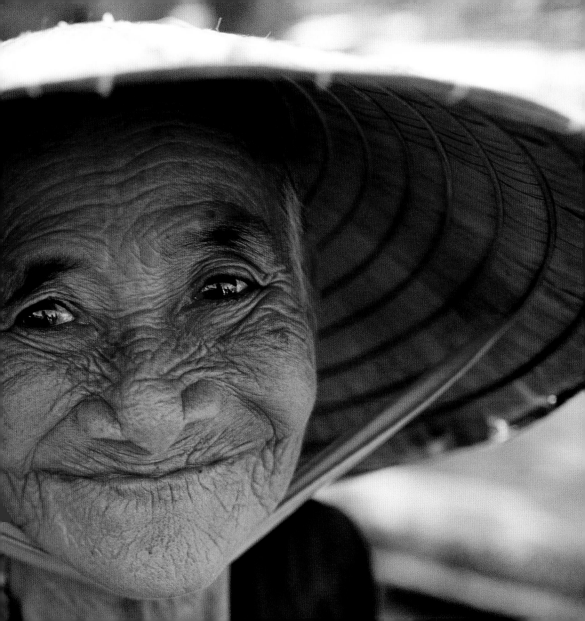

PAUL NICKLEN

Churchill, Manitoba, Canada

A polar bear cub snuggles up to its mother

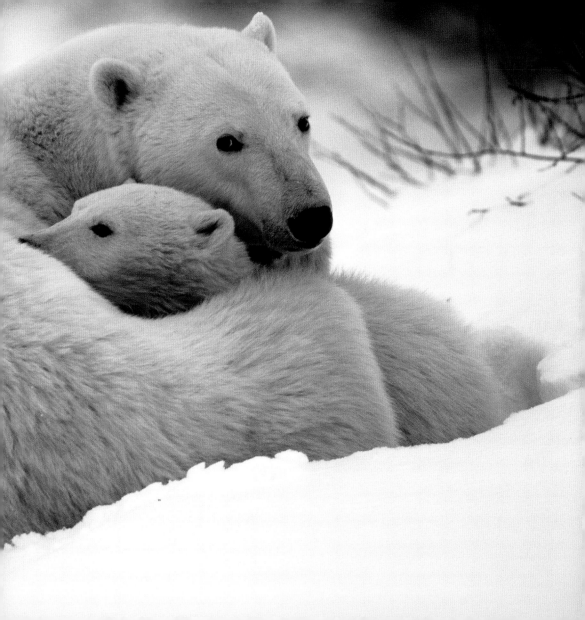

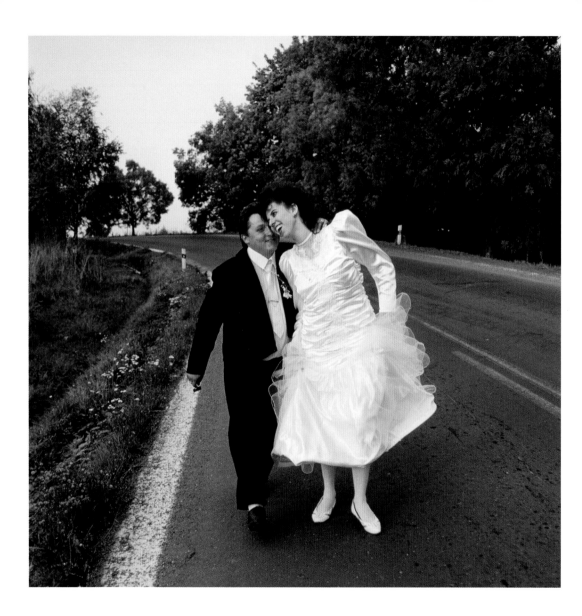

JAMES L. STANFIELD

Bilcice, Czech Republic

A newly wed couple walks home after
their wedding

following pages

ANNIE GRIFFITHS

Victoria Falls, Zambia

A swimmer stands at the edge of the falls

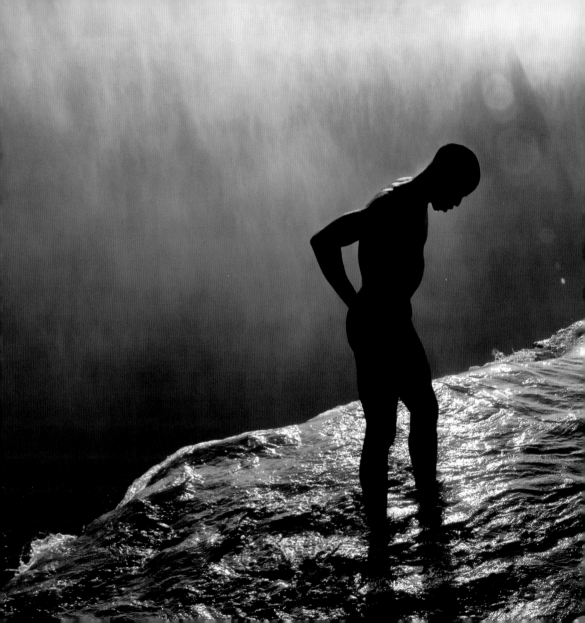

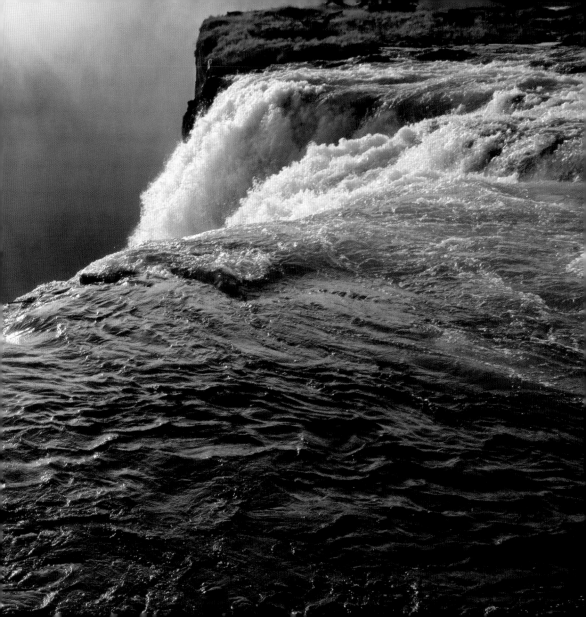

No matter how slow
the film, Spirit always
stands still long enough
for the photographer
It has chosen.

~ Minor White

Time

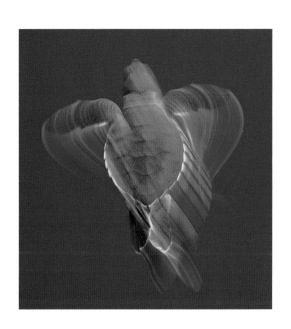

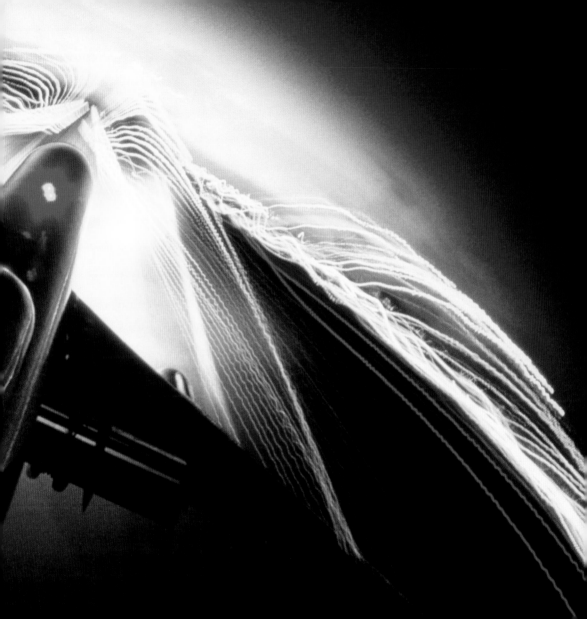

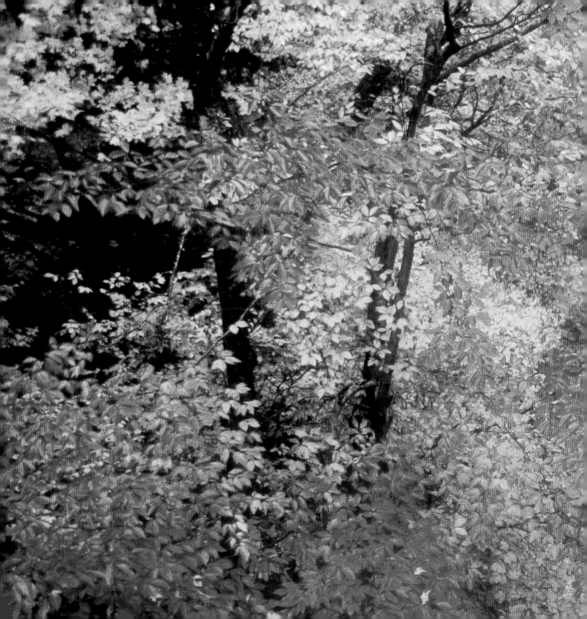

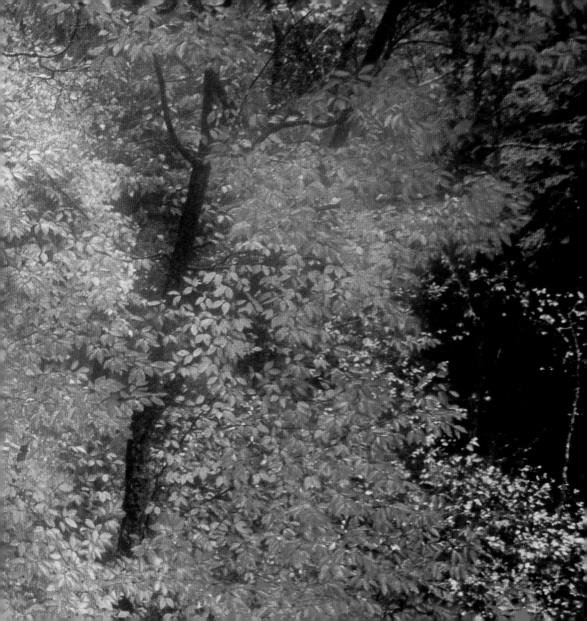

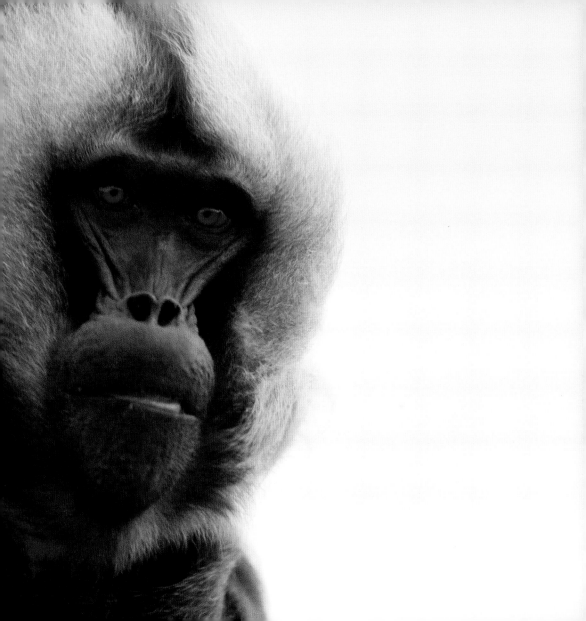

In 1826, when French scientist Joseph Nicéphore Niépce uncapped the lens of his latest invention to capture the view from the window of his country estate, time stood still for the first time in history. Granted, the exposure was eight hours long, but his was the first permanent, direct positive picture ever made. Until the camera seized it, time was an unstoppable traveler. Specific moments in time could only be called from memory, sometimes clear, often clouded. Those memories could be described or painted or set to music, but the gift of a visual memory, frozen in time, was beyond most people's dreams. ☙ Time is perhaps the least understood tool in the photographic camera bag. The truth is that *all* photographs are time exposures—some instantaneous, some painstakingly long.

Time

The look and feel of a photograph can be profoundly changed by how long the shutter is open. For example, the same bird in flight can be captured with such speed that we see details we have never known, or so slowly that the movement of flight becomes an abstract blur. Yet most amateur photographers, by relying on automatic settings, let the camera make that decision for them, not realizing what joy there is in playing creatively with the elements of time and motion in photography. Time can reveal, in a photograph, a fourth dimension. In addition to the height, breadth, and depth captured in an image, a time exposure allows us to see the blurring of time or a moment that happens faster than the human eye can see. ☙ A time exposure can literally stop a bullet in midair or allow a breeze to paint the mundane into a wash of color. It can call attention to one still figure in a chaotic scene or reveal to us for the first time things the eye literally cannot isolate on its own. Time can be abstract or profound, poignant or startling. It is a photographic

gift that allows us to see the familiar in entirely new ways. If we think of still images as notes, the passage of time allows them to become a melody. ❧ A photographic image is recorded when light hits the sensitive photographic emulsion or sensor long enough to leave an impression. And although early photographers were delighted with most aspects of photography, they were frustrated by the length of time it took to register an image. Subjects held poses for seconds and sometimes minutes, to prevent a picture from blurring. Yet, when we look back on these photographs, we often find the imperfection of movement within the frame charming—and far more revealing than a stagnant pose. ❧ But at the time, innovative photographers thought only of the multitude of subjects that were impossible to hold—dance, sport, the night sky, anything that moved. Part of the quest to improve photography really amounted to the quest to capture speed. Because speedy exposures required both sensitive emulsions and bright light, inventors turned to more light-sensitive alchemy in photographic emulsions, and, eventually, to that artificially created sunlight: flash. ❧ En route, photography excited not only the artistic community but also the scientific one, and led to discoveries that affected millions. As early as 1859, author Oliver Wendell Holmes realized, through a series of stop-action photographs, that the movements of people walking differed greatly from what physicians of the time thought. On the grounds of his photographic observations, Holmes was able to recommend to physicians an artificial leg far more practical than the one being used by amputee Civil War veterans. Likewise, the stop-action of photography revealed that painters had portrayed galloping horses incorrectly for centuries. ❧ When we look at a photograph, we are seeing something that no longer exists. Creatively holding that moment with time exposure allows it to become a literal record. The

human eye is magnificent, but it can process motion only at a certain speed, and that speed is far slower than what a camera can record. For example, the reason that film or television appears to be continuous is that the images move at only 24 frames per second, whereas our brains must process images at 50 to 60 per second. So, when we watch a movie, we are actually watching a blank screen for about half the time. Likewise, we are incapable of isolating the positions of rapidly moving subjects in life. ∽ Photographers began to use time exposures more creatively, discovering that there was beauty in the fragmenting of time, in recording the unseen. They experimented with following motion in a time exposure, called "panning," or simply letting the motion blur into abstraction. It was liberating to know that with time exposure, everything can move, or nothing can move. ∽ In the words of author Susan Sontag, "The force of a photograph is that it keeps open to scrutiny instants which the normal flow of time immediately replaces. This freezing of time—the insolent, poignant stasis of each photograph—has produced new and more inclusive canons of beauty." ∽ In photography, creation is a quick business. Master photographer Ernst Haas called himself "a painter in a hurry." Photographers wander and prowl and then react, snatching images in midair, fragmenting time or allowing it to flow. At times, the beauty of one of these flowing photos has little to do with the actual subject, and more to do with the pattern created by time. Notice the stunning image at the beginning of this chapter (page 277). The subject is one little turtle, but time has allowed it to evolve into an abstract of energy and beauty. ∽ Once the possibility of speed arrived in the form of film and smaller, quicker cameras, photographers began to find joy in the imperfect, in accidental juxtapositions and fabulous coincidences. Portrait photography became far more interesting when personality could be captured.

With the onset of flash photography, time could be arrested at unheard-of speed, providing both art and science with vast amounts of material that had never been seen. ✑ The precarious adventure of flash photography began with bursts of flash powder, which worked but periodically caused serious disasters. Early documentary photographer Jacob Riis, who championed the plight of the poor in New York in the late 1800s, is said to have accidentally set fire to a building while using flash powder. Such hazards eventually led to the inventions in the 1920s of flashbulbs and the electronic flash. Then, photographers were able to literally stop the world. ✑ And just when it seemed that time served only two photographic masters—those who strove to freeze moving objects and those who allowed movement to trace new patterns—along came photographers who decided to combine both in a single frame. Consider the astonishing photograph of technical genius and longtime National Geographic staff photographer Bruce Dale, who combined the instantaneous power of flash with a time exposure long enough to bring us an image of something never seen before. He persuaded an airline to let him strap a camera to the tail of a Lockheed TriStar and created a time exposure of the craft coming in for a landing (pages 278-279). The resulting image was both a cover and a three-page pullout in *National Geographic* magazine, thrilling more than 40 million readers. ✑ Time in photography continues to amaze. Who knew we could capture fireflies, or record the beauty of a comet? Who could have imagined, one hundred years ago, a great white shark cruising the bottom of the sea, a cheetah in mid-flight, or a bird's-eye view of Tibet from a speeding plane? Photographers have become choreographers, using available light and flash and the endlessly flexible tool of time exposure to add energy and life to their photographs. The still image is no longer still.

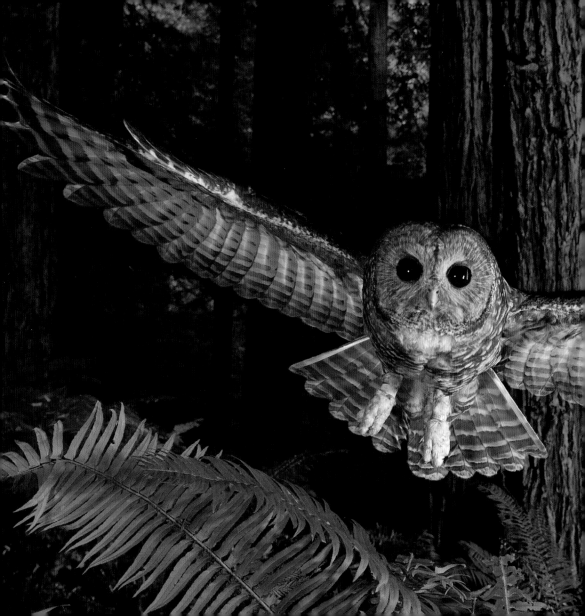

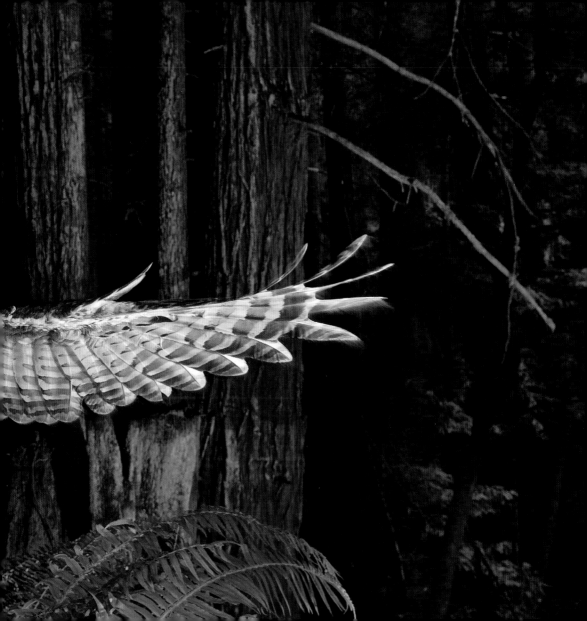

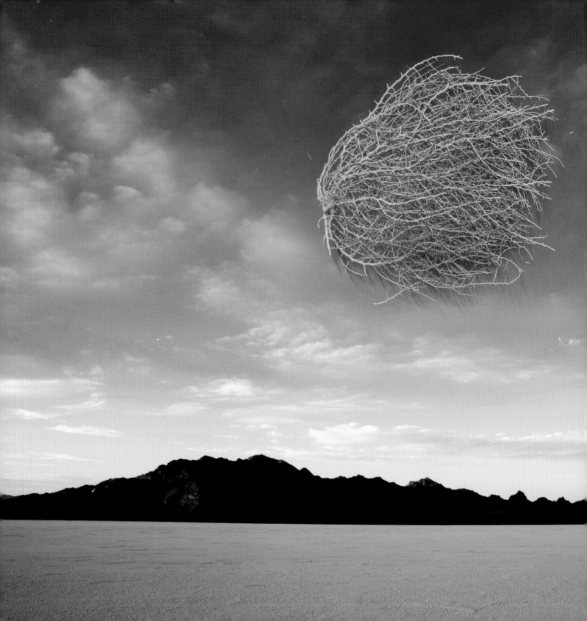

JOHN BURCHAM
Bonneville Salt Flats, Utah
A blowing tumbleweed is captured in midair

preceding pages (277-289)
BILL CURTSINGER
Michoacán, Mexico
A turtle swims through the deep blue
Pacific Ocean

BRUCE DALE
Palmdale, California
A camera affixed to the tail of a landing
plane captures the runway lights

RAYMOND GEHMAN
Monongahela National Forest, West Virginia
Bright beech tree leaves shine through
the rain

MICHAEL NICHOLS
Simien Mountains National Park, Ethiopia
A male gelada baboon poses for a portrait

MICHAEL NICHOLS
California
A northern spotted owl flies among
redwood trees

RICHARD DU TOIT

Sabi Sand Game Reserve, South Africa

Two female leopards fight

following pages

JOE PETERSBURGER

Labod, Hungary

A kingfisher diving into the water meets
its reflection

KONRAD WOTHE

Germany

A time exposure swirls autumn gold
around a European beech tree

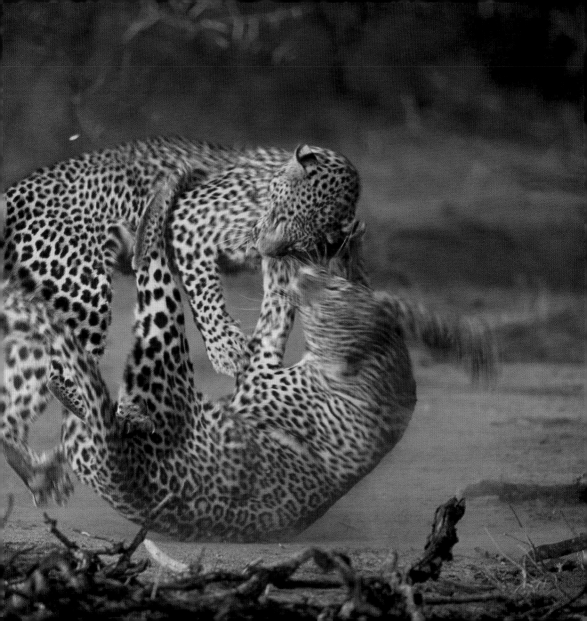

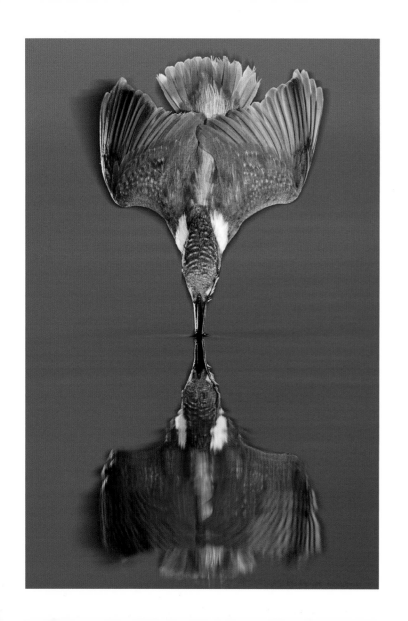

Beauty always contains

an element
of wonder.

~ Charles Baudelaire

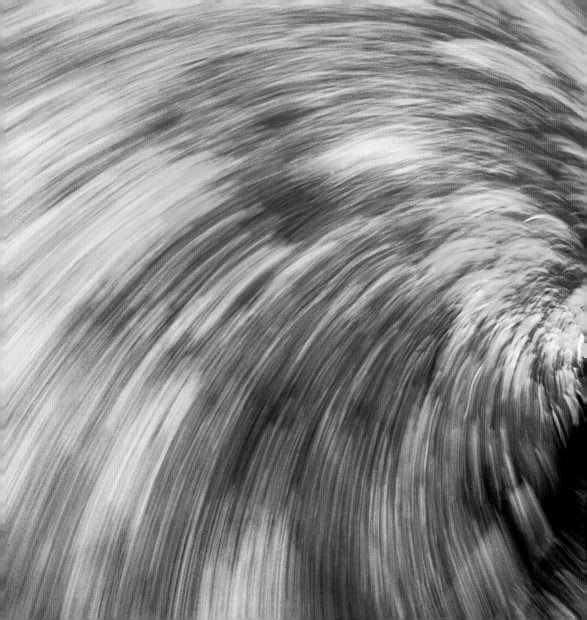

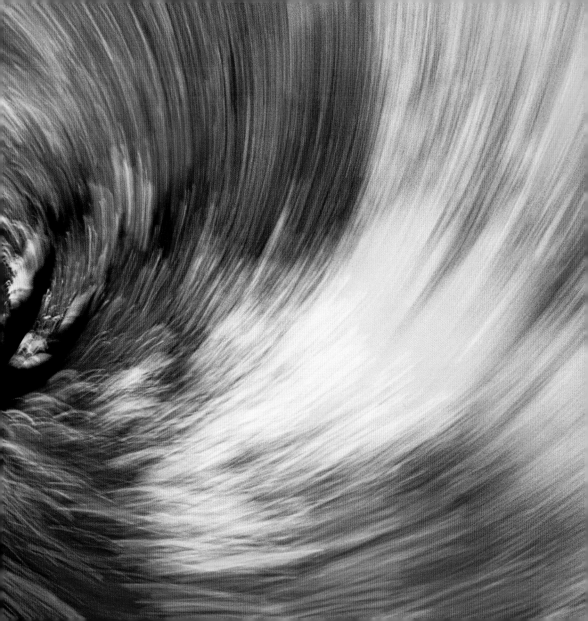

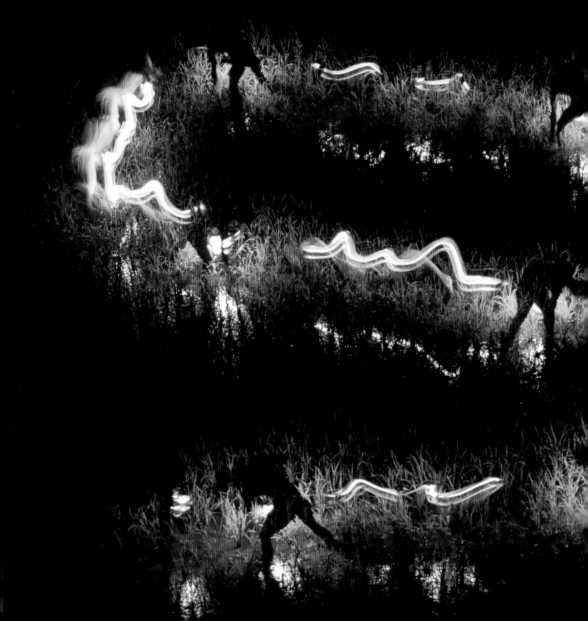

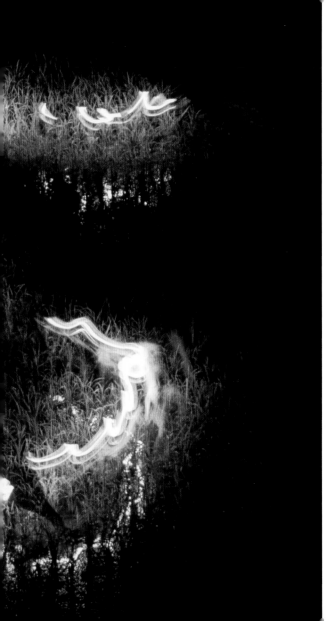

DONNA K. & GILBERT M. GROSVENOR

Bali, Indonesia

In this time exposure, a farmer stalks eels
in a rice paddy by lantern light

ANNIE GRIFFITHS

Yellowstone National Park, Wyoming

An American bison braves a winter blizzard

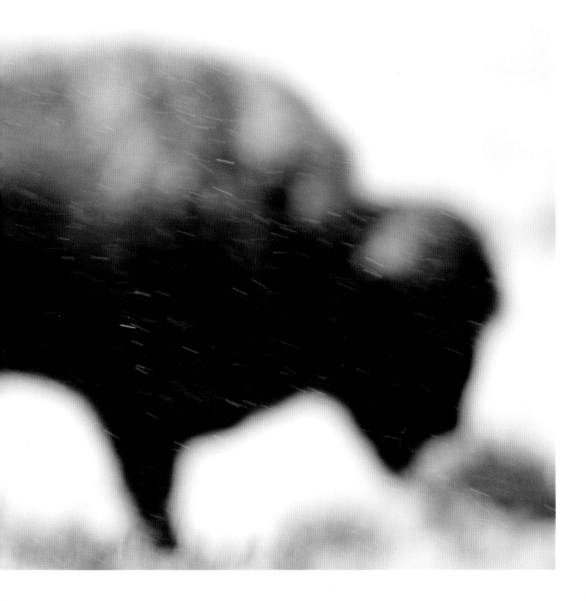

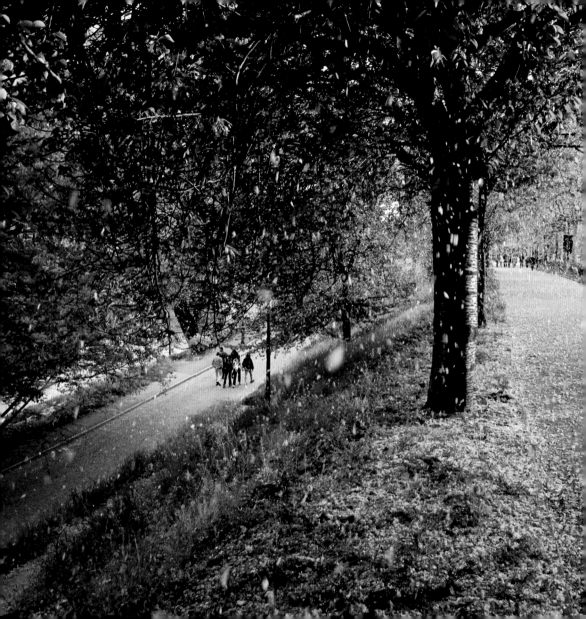

WILLIAM ALBERT ALLARD
Turin, Italy
Apricot blossoms sprinkle over a path in
Valentino Park

following pages
YVA MOMATIUK & JOHN EASTCOTT
Fifteen Mile Herd Management Area, Wyoming
Wild mustangs run through the desert

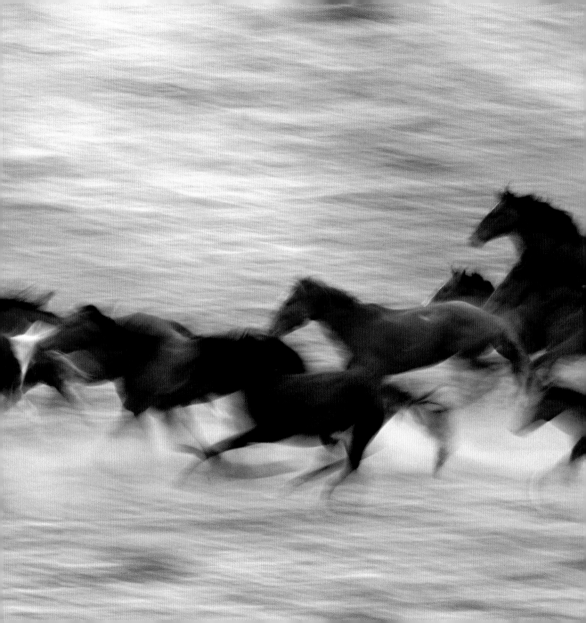

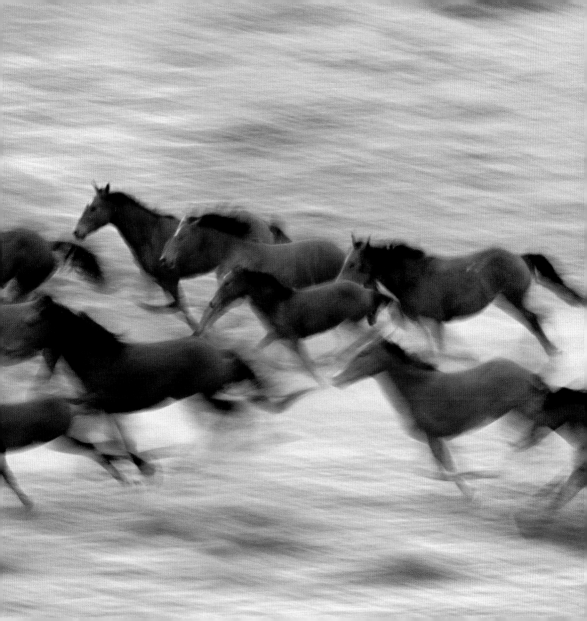

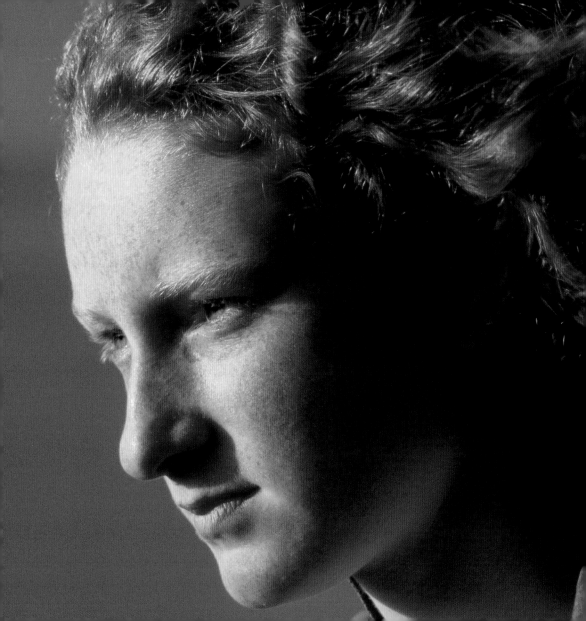

SUSIE POST RUST

Inisheer, Aran Islands, Ireland

Her Irish heritage evident, a girl faces
into the sun

following pages

KEES BASTMEIJER

An adult mute swan preens white feathers

What was any art but a mould

in which to imprison for a moment

the shining elusive

element which is

life itself—life hurrying past us

and running away, too strong to stop,

too sweet to lose.

~ Willa Cather

PHIL SCHERMEISTER

Yosemite National Park, California

Water cascades over rocks as the sun sets

following pages

MATTIAS KLUM

Borneo, Malaysia

Mist covers mountains in the Santubong area

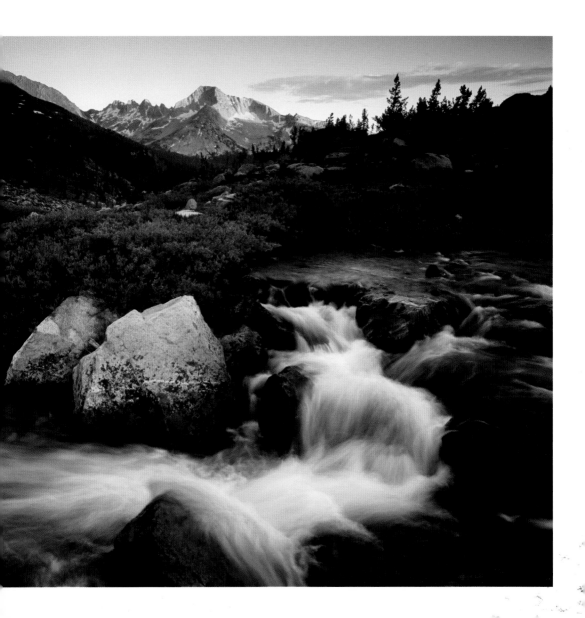

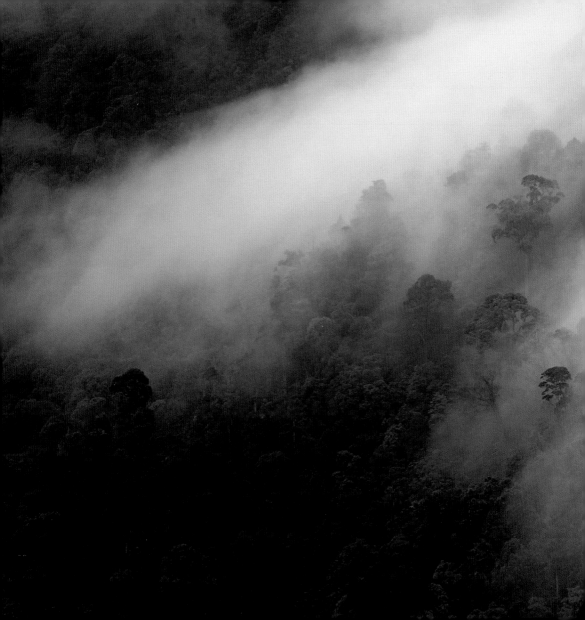

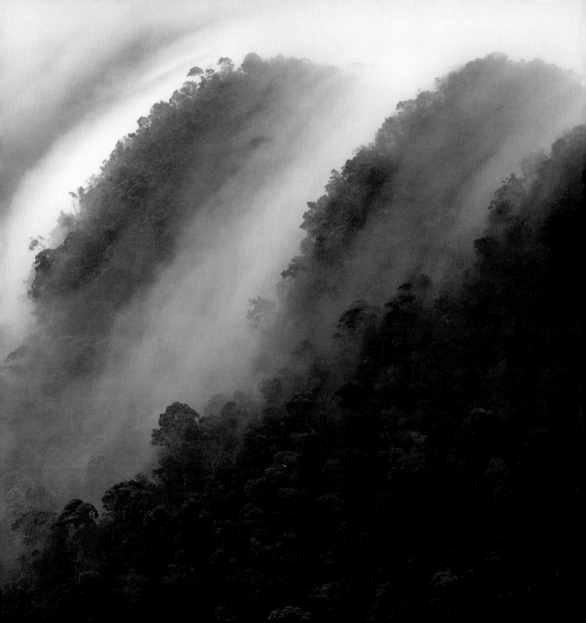

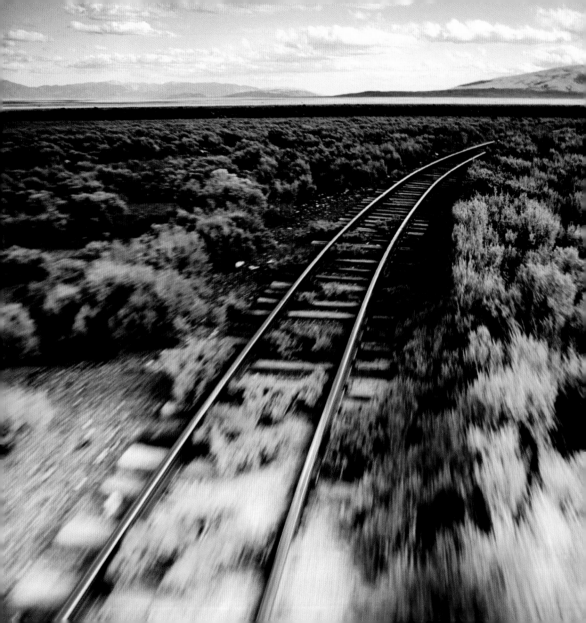

BRUCE DALE
New Mexico–Colorado Border
Train tracks stretch ahead of a moving train

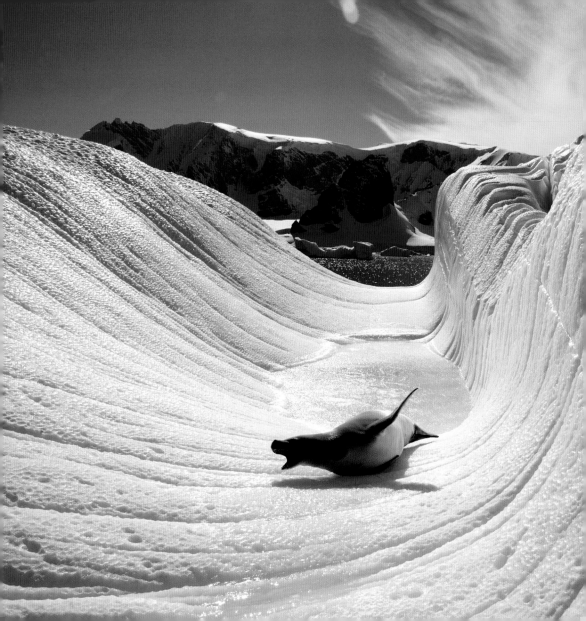

PAUL NICKLEN
Antarctica
A crabeater seal rests on an iceberg

following pages
MICHAEL S. YAMASHITA
Fukushima, Japan
A bright maple leaf is safe from
rushing water

MICHAEL MELFORD
Bangkok, Thailand
A flower vendor paddles a floating market

PAUL NICKLEN
Sechelt Rapids, British Columbia
A paddler surfs the waves

The moment one gives close attention to anything, even a blade of grass, it becomes a mysterious, awesome, indescribably magnificent world in itself.

~ Henry Miller

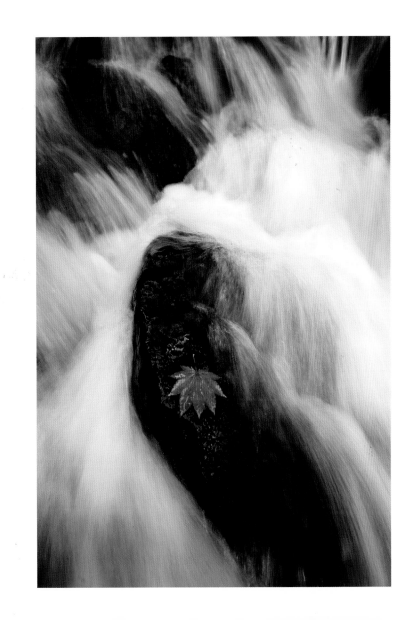

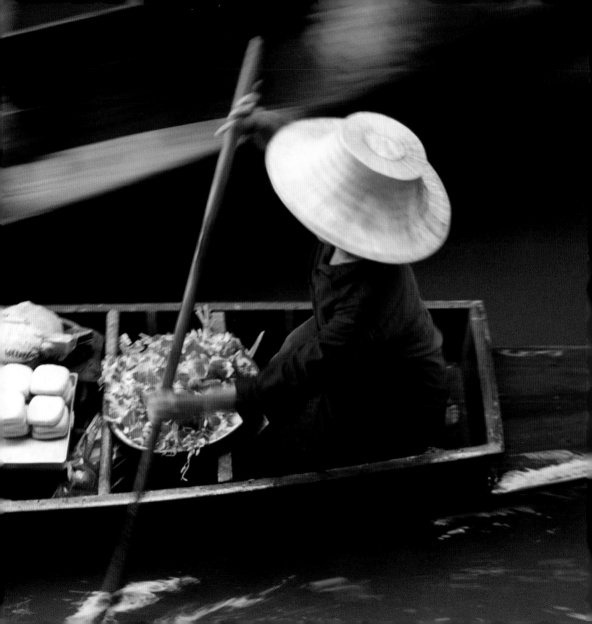

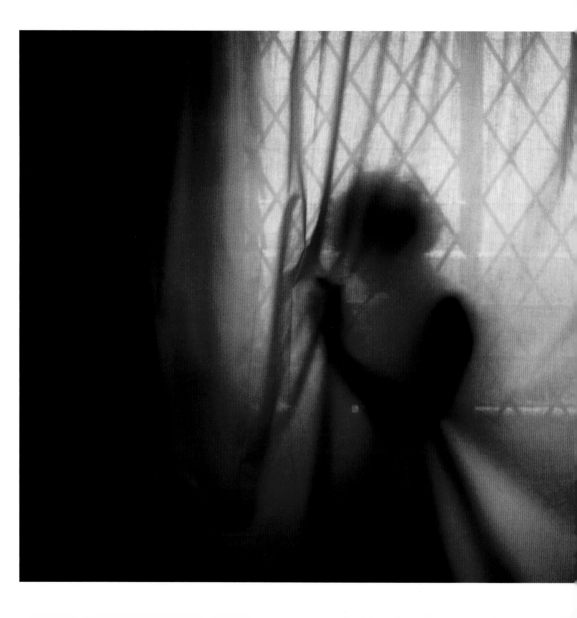

MICHAEL NICHOLS

Port of Spain, Trinadad

A woman hides in the curtains
of a hotel room

following pages

MICHAEL NICHOLS

Loango National Park, Gabon

A juvenile Nile crocodile takes a swim

You can't depend on your

eyes when your imagination

is out of focus.

~ Mark Twain

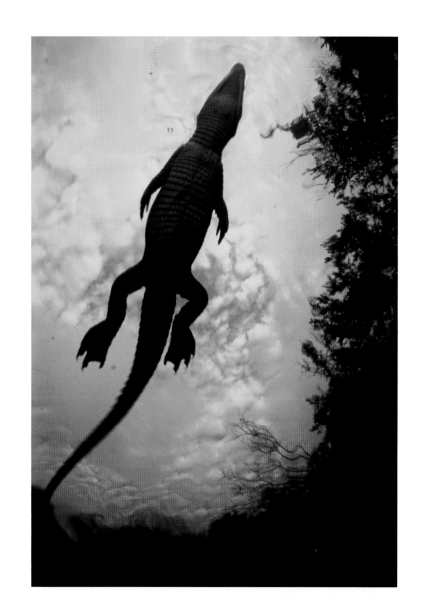

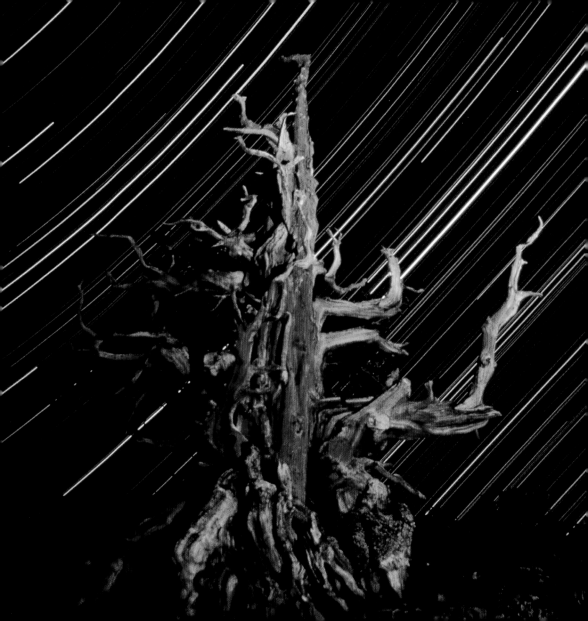

PAUL CHESLEY

Inyo National Forest, California

Stars seem to streak past a bristlecone
pine in a time exposure of the night sky

following pages

ANNIE GRIFFITHS

South Dakota

Grasses bend in a breeze in Buffalo Gap
National Grassland

CHRIS JOHNS

Okavango Delta, Botswana

An impala leaps its way through dry
grasslands

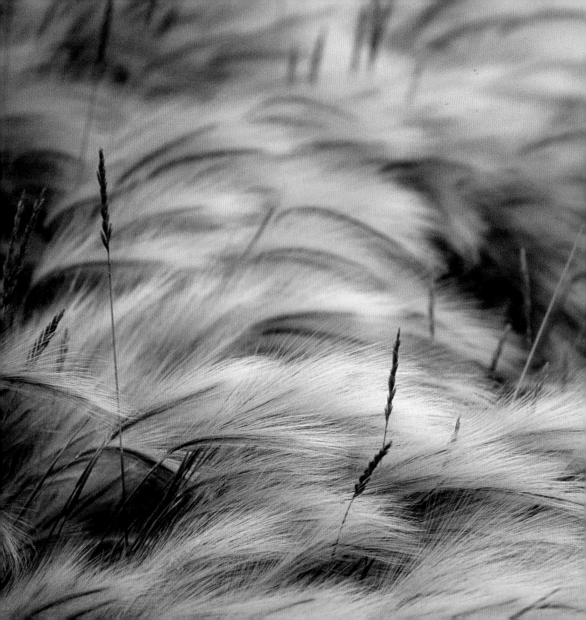

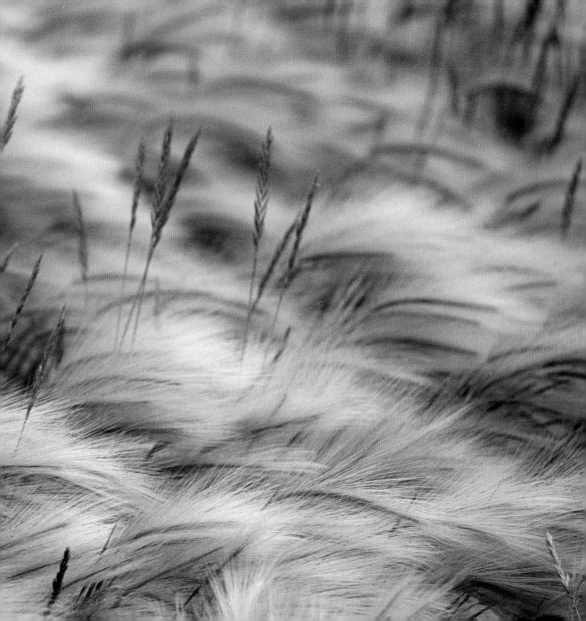

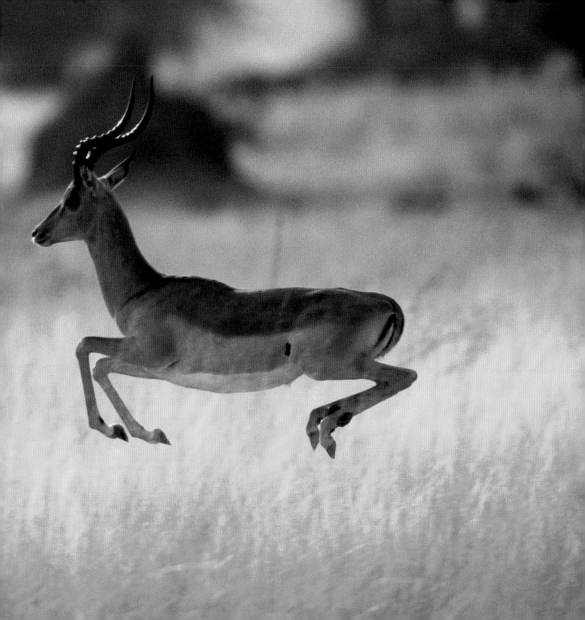

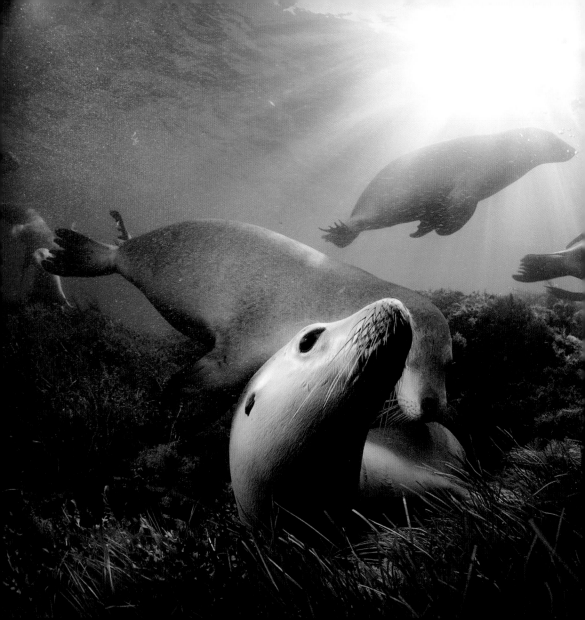

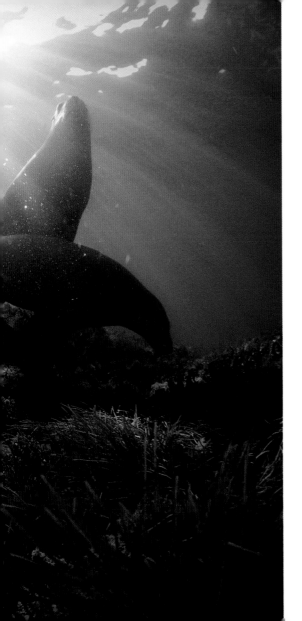

DAVID DOUBILET

Indian Ocean, Australia Coast

A group of sea lions swim in the waters off Hopkins Island

HEATHER PERRY
Rome, Italy
Lights shine from the Colosseum

following pages
PABLO CORRAL VEGA
South America
A couple dances the tango

JOE PETERSBURGER
Sarand, Hungry
A bee-eater bird takes flight, while another
keeps its perch

MICHAEL NICHOLS
Loango National Park, Gabon
Sun-burnished waters pour across sand flats

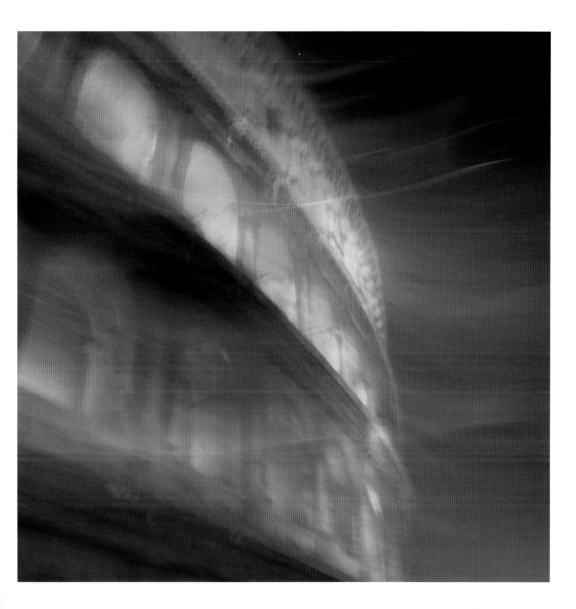

Photography to me is

catching a

moment which

is passing, and which

is true.

~ Jacques-Henri Lartigue

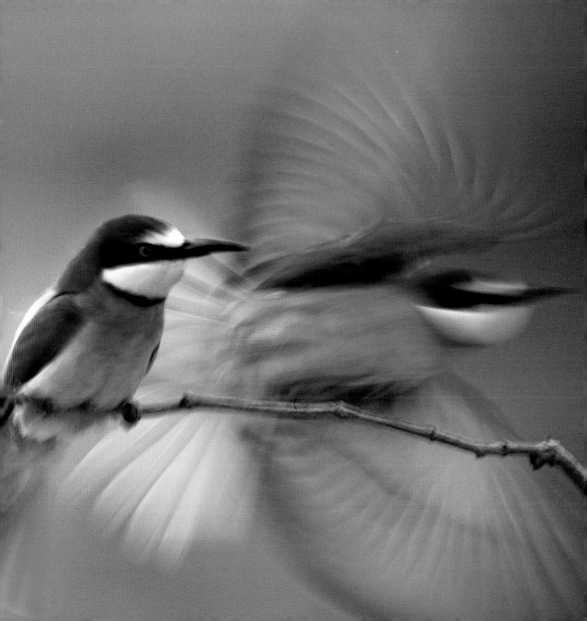

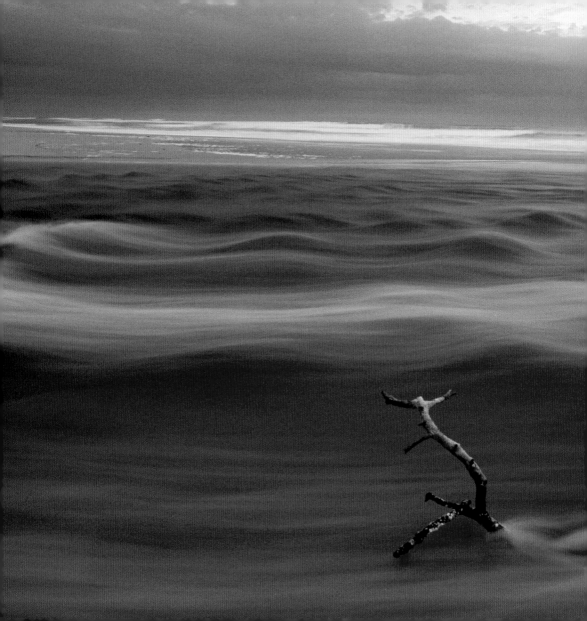

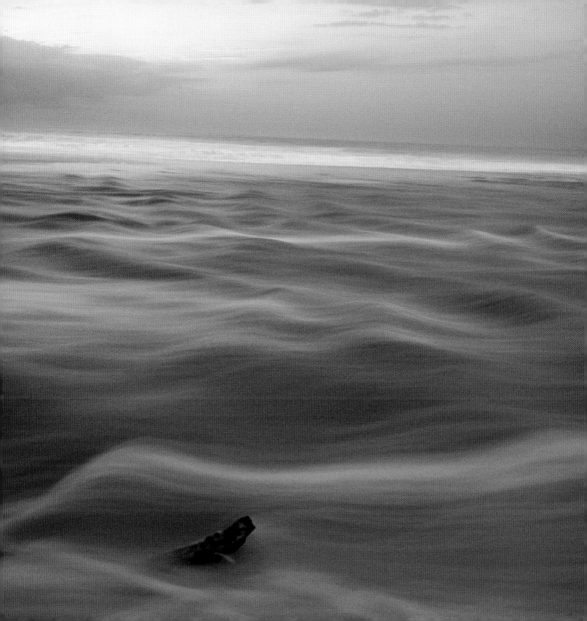

I found I could say things
with color and shapes
that I couldn't say
any other way—
things I had no words for.

~ Georgia O'Keeffe

Palette

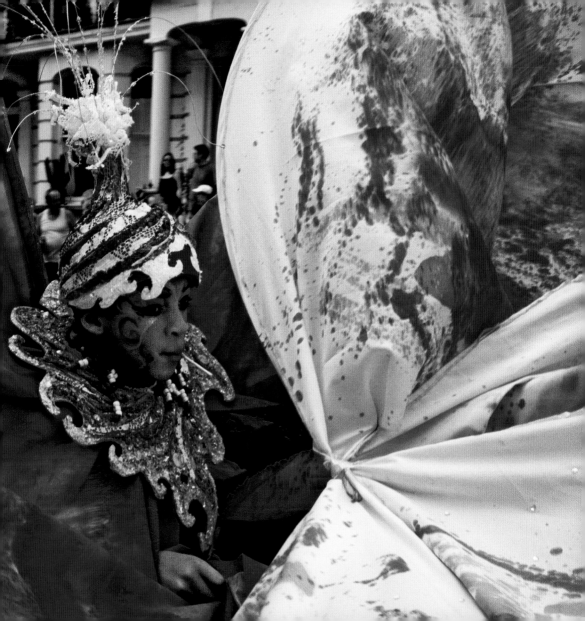

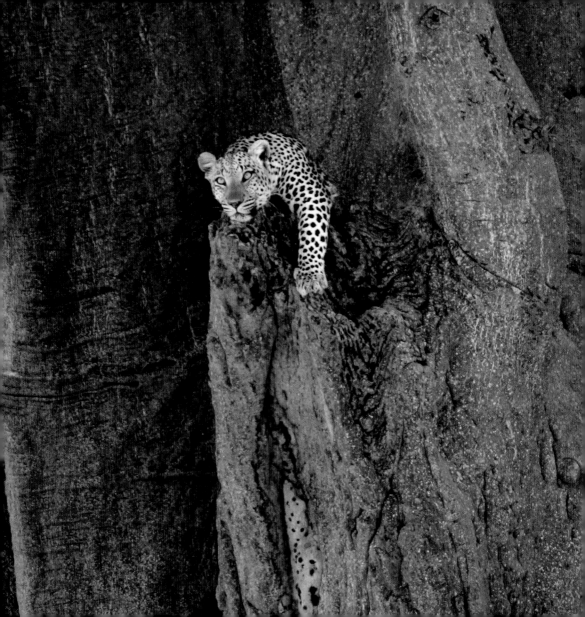

In Disney's *Fantasia*, one of the most daring and innovative animated films ever made, classical music was illustrated, without a word, in brilliant and wholly original ways. At times the animation was a story line, with characters and events both humorous and tragic. But the most unusual sequences in the film interpreted classical music with pure color abstractions. Colors literally coincided with single notes. Washes of color imitated subtle phrases of the score. Blasts of neon represented brass instruments. Violin sections were illustrated with dancing pastels. Together, music and color drew on every human emotion. ❧ Palette is symphonic—sometimes a single clear note, a flash of orange. At other times a cacophony of sounds, a riot of color. The emotions color can arouse are like notes in a score: subtle, raucous, muted, drenched, hyper-real or atmospheric.

Palette

The way color is used in a photograph can cast the eye into a major or a minor key—discord or harmony. And the photographer can use palette to compose, to illuminate, to titillate, to bless. ❧ As exciting as early photography was to a world that had never known fixed reality, it was available only in black and white for half a century. Although a number of inventors searched for a way to create color photographs, it wasn't until 1903 that the French brothers Auguste and Louis-Jean Lumière devised the first viable technique. They patented the Autochrome, a process that used colored starch in glass plate film emulsion to filter light. Autochromes had a luxurious tonality but required long exposures, so the images were usually stiff, or posed. National Geographic's photographic archive has hundreds of these early works, preserved mostly through the heroic efforts of one staff photographer, Volkmar Wentzel. And they are precious both in their rarity and in their subtle palette (see, for example, the little girl

with fan, page 410). ✐ Color photography advanced quickly from glass plates to film, from long exposures and difficult processes to easier and more portable techniques. The legendary Ernst Haas was one of the early photographers to really explore color in photography. After years as a black-and-white photojournalist, documenting war in Europe, Haas fell in love with color in the late 1940s. He said, simply, "Color is joy," and went on to push color photography into the realm of the poetic. Haas introduced hues and tones never seen before in color photographs. He often saw palette *as* the subject and felt that it could elicit powerful emotions. Haas found beauty in peeling paint and drops of oil and drifting snow. His images are celebrations of pure, and often abstract, color. ✐ Together with light, palette is the most important element in setting the *mood* of a photograph. Color can wash over a scene with incredible delicacy or blazing intensity. Most of us can recall pictures made in dense fog or of roaring sunsets; of softest pink at twilight and of the musty greens of a forest; of the pulsing wash of aurora borealis or the chaotic colors of Mardi Gras. Each calls forth an entirely different emotional response. ✐ At times colors come at us like bullets. I remember roaming a popular section of Hong Kong one night and feeling almost assaulted by the neon signs that blazed against the night sky. The pictures I took that night were simply compositions of raw color—neon against black sky. ✐ The palette of a photograph can even be the simple gradations of gray in a black-and-white photograph. Landscape photographer Ansel Adams was famous for seeking a rich tonal range in his work, and his prints are exquisite grada-tions, from black to white. Adams gave us an appreciation for the world of subtle tonal variations. Those variations can happen with color as well. Imagine the yellow across a field of wheat, the

countless reds and oranges of an autumn maple's foliage. ✑ A few years ago I began a project that I photographed entirely in black and white and then hand-colored. Hand-coloring photographs is an old technique, most often used to add touches of color to portraits. I chose this technique because it sets a romantic, timeless mood, and I wanted to give a feeling of ancient, untouched wilderness. With no background at all in painting or drawing, I set out to render the colors I recalled from each scene. I gathered a few props—leaves, stones, feathers—to remind me of the more subtle hues present in nature. But most of my color choices actually came from my memory of an overall palette of colors in each photograph, from the mood and intensity and luminescence of the black-and-white photograph. With light as my teacher, allowing the gradation in tone to lead the way, I instinctively knew a great deal about how to lay down the color. ✑ Even so, I discovered that the palette of a scene was far more complex than I had known. Who knew how much yellow was present in nearly everything on the planet? What a revelation to realize the saturation of purple in shade, or the bruising colors that scoured a stormy sky. Although I had worked with color film for 25 years and thought that I understood it, this project required me to revisit the basics of color. ✑ Color, in a scientific sense, is really no more than the reflection of white light. And that white light is, of course, composed of many colors. Those we see are the colors of the visual spectrum—red, orange, yellow, green, blue, and violet. Objects absorb certain wavelengths and reflect others back to the viewer. We perceive these wavelengths as varied colors, and we give each a specific name. Most people can identify between 150 and 200 colors in the color spectrum. ✑ A warm palette includes reds, yellows, and oranges, and is often vivid and energetic. These colors tend to

advance and dominate an image. A cool palette contains blues, violets, and greens, and tends to be soothing. Colors affect us in numerous ways, both emotionally and physically. Studies show that strong red colors raise blood pressure, while cool colors have an opposite, calming effect. ✑ In a photograph, the balance of color can create a mood of elegance or tranquillity, playfulness or sadness. We judge color by the company it keeps. When pure color is placed against pure color there is a vibrancy or urgency to the image. On the other hand, those same colors, placed against more muted hues, can create a splash of attention in a calm space. A perfect example is the photograph on pages 394-395. In a palette of soothing greens, the vivid red umbrella balances and ignites the whole. ✑ The possibilities of palette have been an inspiration to photographers for more than a century now. The handful of colors in the visual spectrum can combine in endless ways, depending on how pure or saturated or bright they are, and which colors have joined forces to create a new hue. Although celery, emerald, and teal are all variations of the color green, each hue is distinct; each is differentiated by its saturation and intensity, and by the other colors that have crept in to change its nature. Anyone who has tried to match colors, like browns, knows that some browns have a distinctly yellow tone (chocolate), while others seem to be almost gray (taupe), and still others have an undertone of red (mahogany). So brown is never really just brown. Blue arrives in endless disguises. Yellow tinges a million hues. Red announces itself in countless playful ways. Violet, a combination of red and blue, charms; green—yellow and blue—calms; and orange, built from red and yellow, accents. Black, greedy black, bounces no light rays back and leaves us in the dark. Only white, which holds all colors in neutral majesty, is truly white.

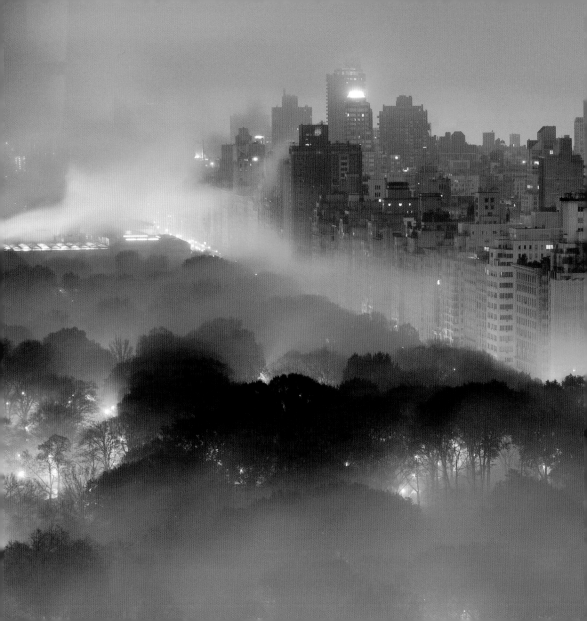

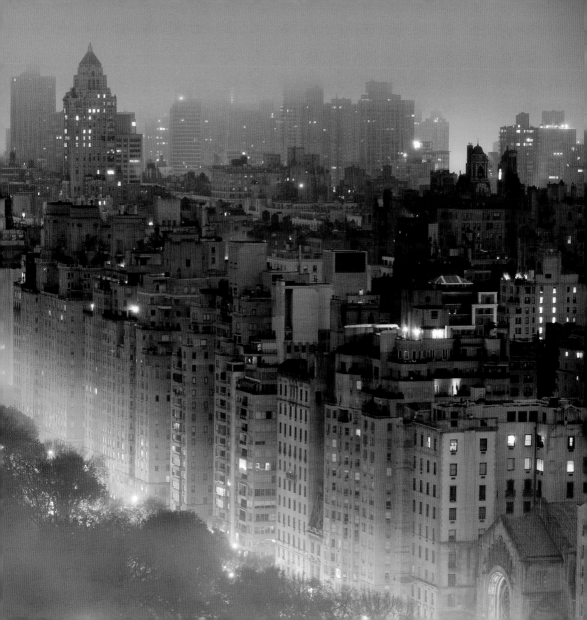

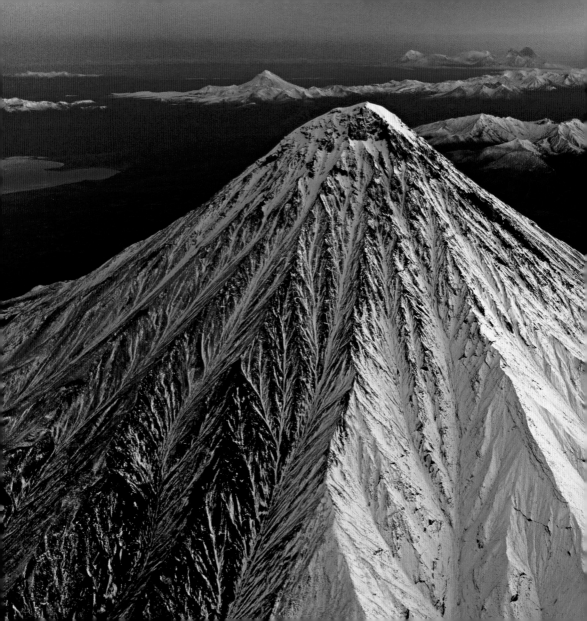

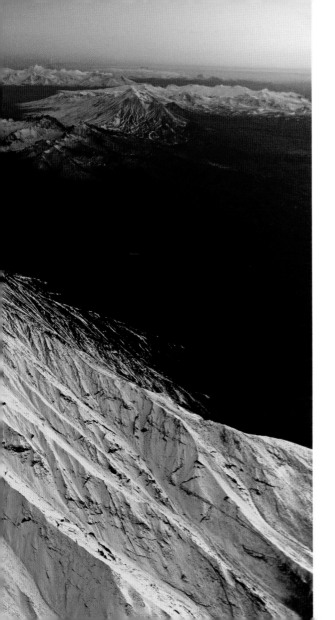

MICHAEL MELFORD
Kamchatka, Russia
An aerial view of the towering Kronotsky
volcano

preceding pages (345-357)
MICHAEL MELFORD
Montana
Snow covers boulders alongside McDonald
Creek in Waterton-Glacier Park

JODI COBB
Notting Hill, London, England
An elaborately clad participant swirls
a hand-painted costume during a parade

BEVERLY JOUBERT
Okavango Delta, Botswana
A leopard rests in an ancient baobab tree

JOEL SARTORE
Madidi National Park, Bolivia
Macaws fly in unison through dense foliage

JIM RICHARDSON
New York City, New York
Light pollution and fog blur the city skyline

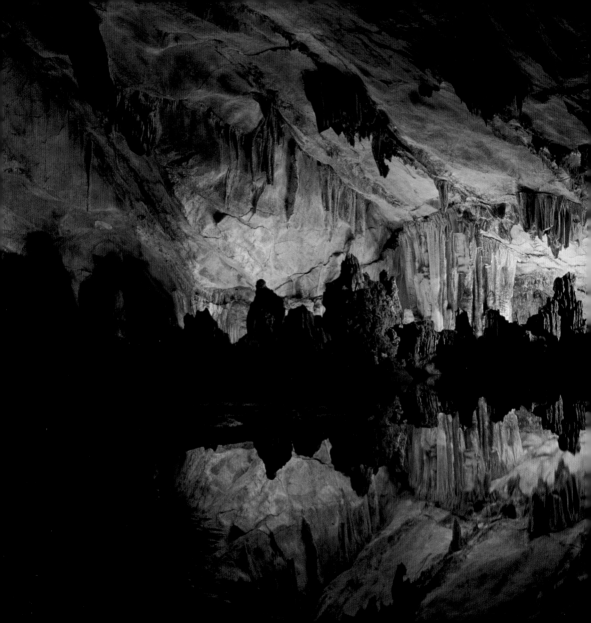

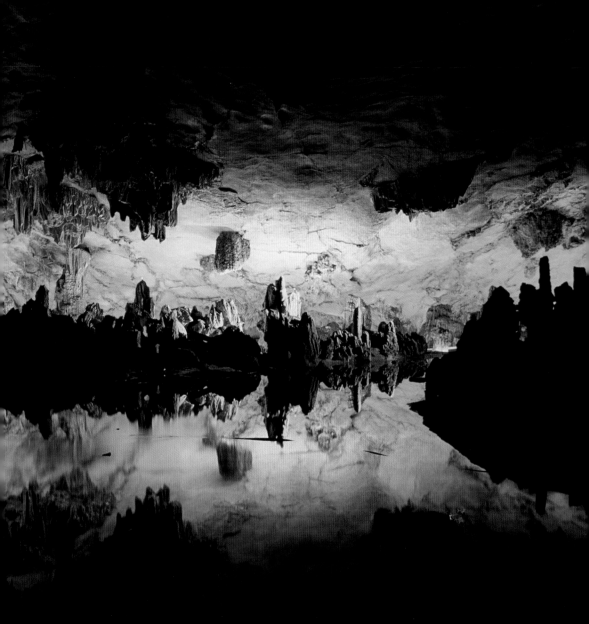

I cannot pretend to feel impartial about colors. I rejoice with the brilliant ones and am genuinely sorry for the poor browns.

~ Winston Churchill

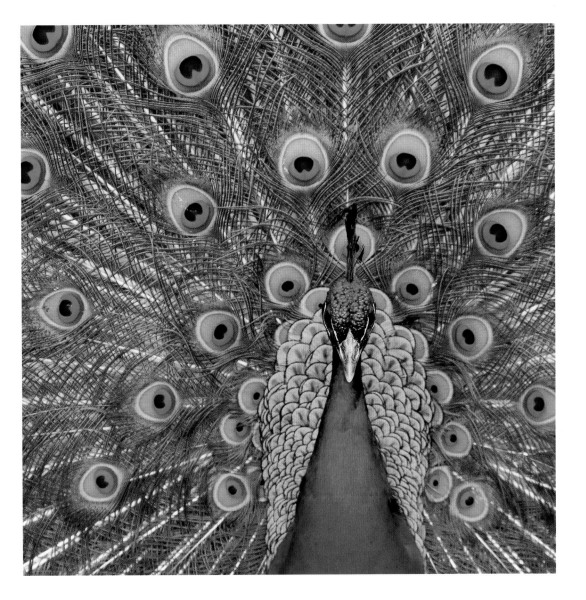

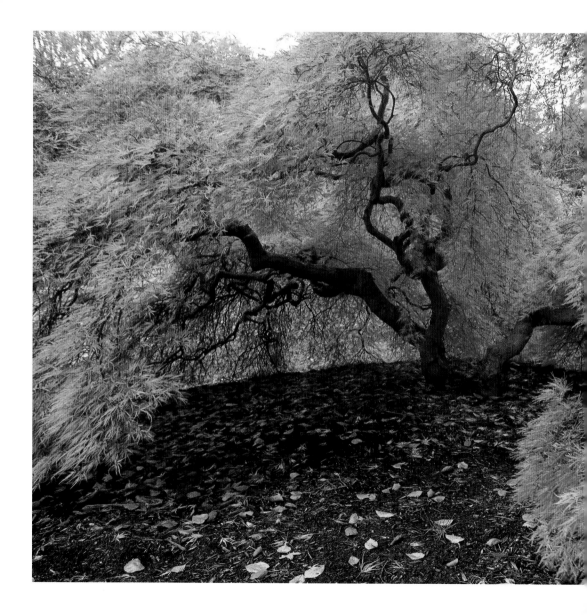

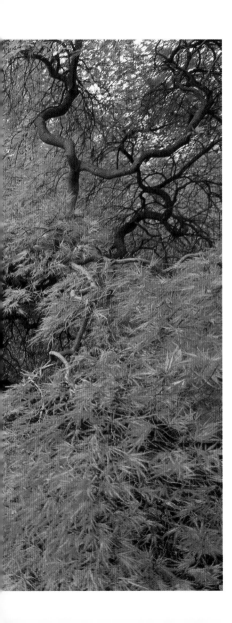

MELISSA FARLOW

Asheville, North Carolina

Orange leaves cover a Japanese maple
at the Biltmore Estate

preceding pages (360-363)

RAYMOND GEHMAN

Guangxi Autonomous Region, China

Blue light illuminates Reed Flute Cave

KEVIN KNUTSON

Seattle, Washington

A peacock displays its beautiful symmetry

TARIK MAHMUTOVIC
Calgary, Alberta, Canada
A boxer-Labrador puppy looks shyly at the camera

following pages
ROBB KENDRICK
British Columbia, Canada
A cowboy wears traditional vaquero gear

JAMES P. BLAIR
Yellowstone National Park, Wyoming
A trumpeter swan glides across Yellowstone River

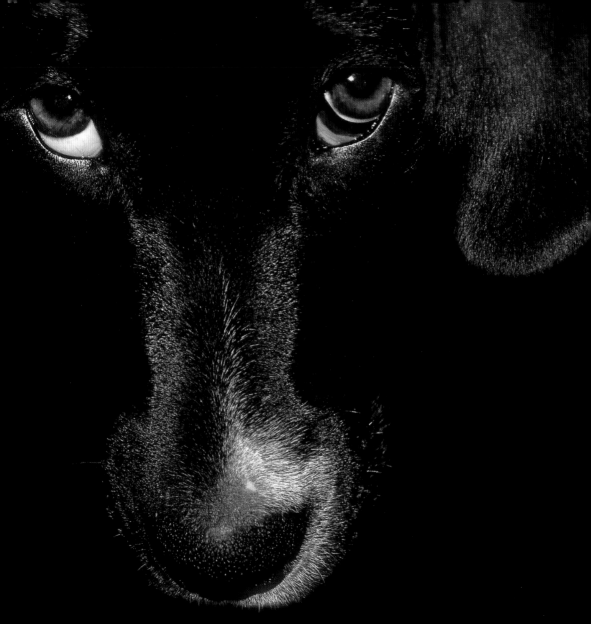

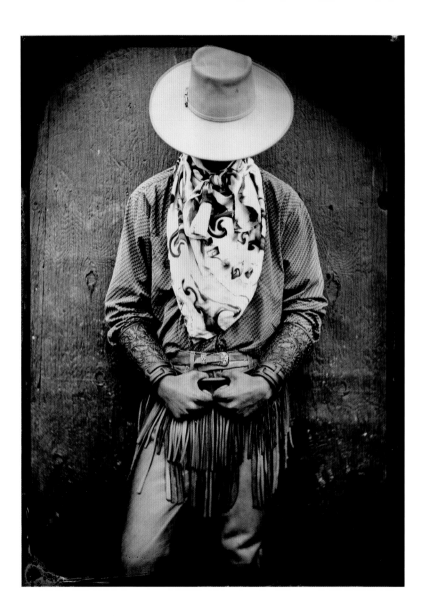

Beauty without colour seems somehow to belong to another world.

~ Murasaki Shikibu

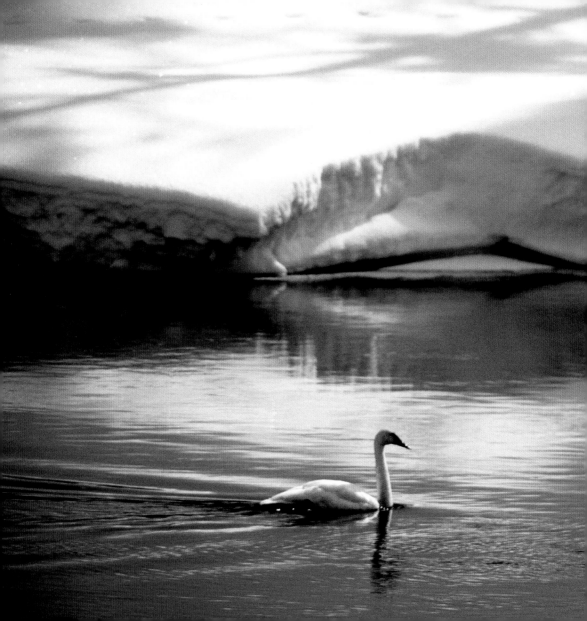

CARSTEN PETER

Kamchatka Peninsula, Russia

The setting sun illuminates a slowly
turning cloud

following pages

JAMES L. AMOS

San Diego, California

Dancers at the San Diego Ballet rehearse
in costume

RAYMOND GEHMAN

Virginia

Fog hovers over the James River in the
George Washington National Forest

373

Color is my day-long

obsession,

joy and torment.

~ Claude Monet

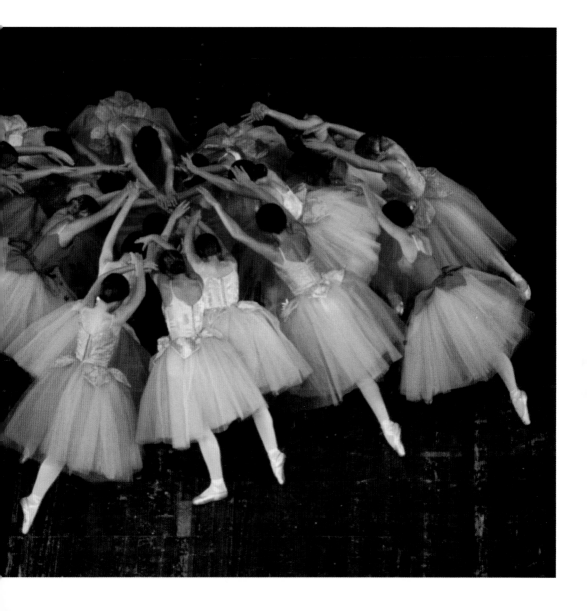

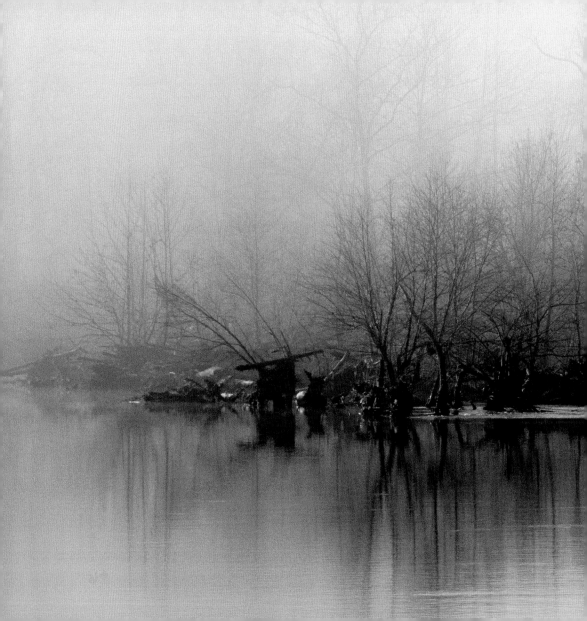

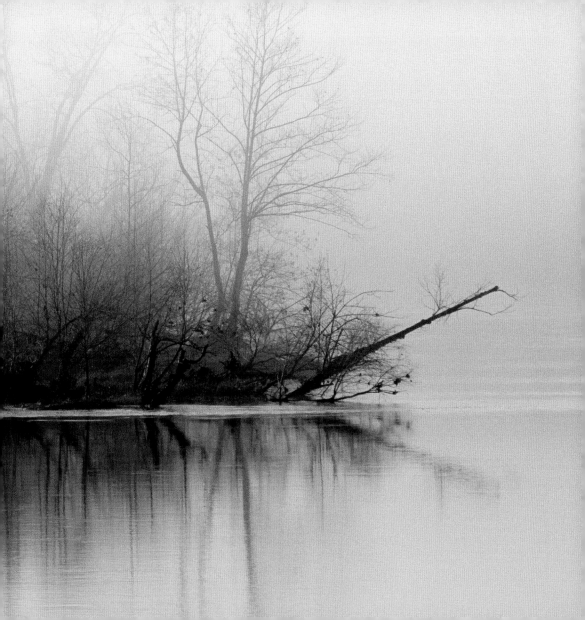

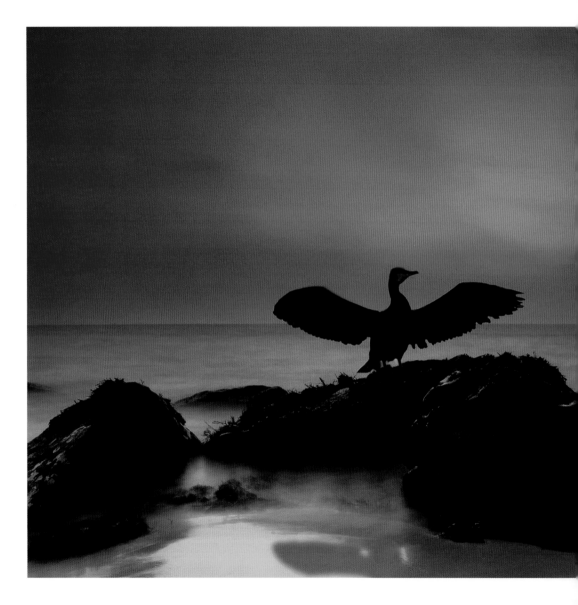

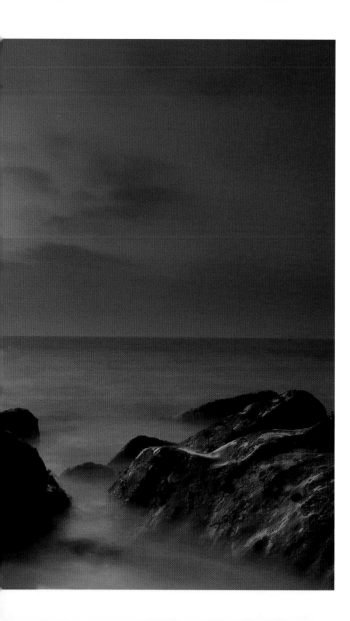

JOSH EXELL

Cornwall, England

A cormorant dries its wings at the water's edge

JIM RICHARDSON

Sand Hills, Nebraska

Parallel lightning strikes streak the night sky

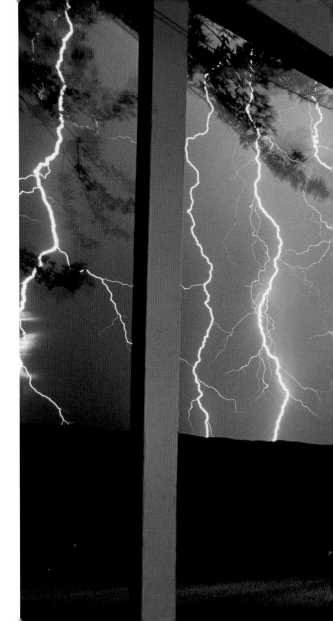

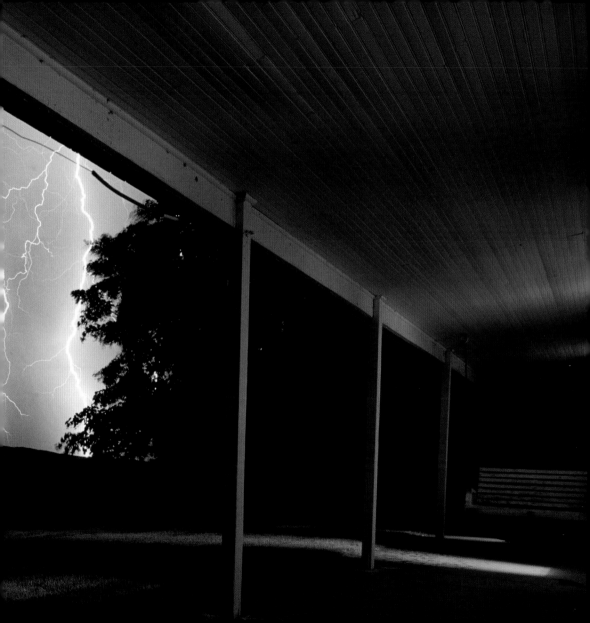

JAN VERMEER

Holland

Icelandic poppies open their delicate petals

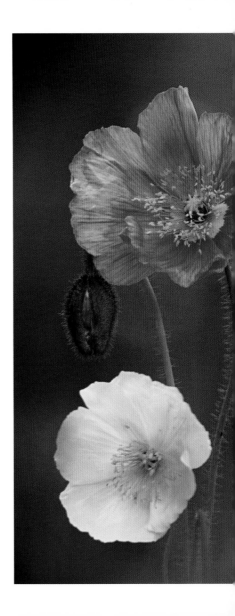

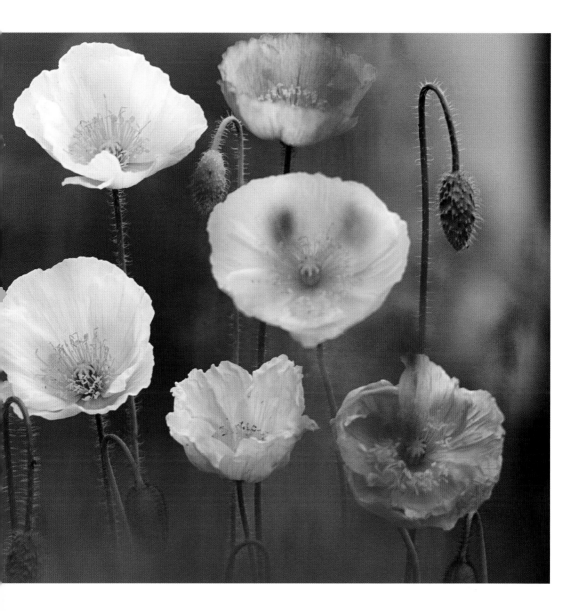

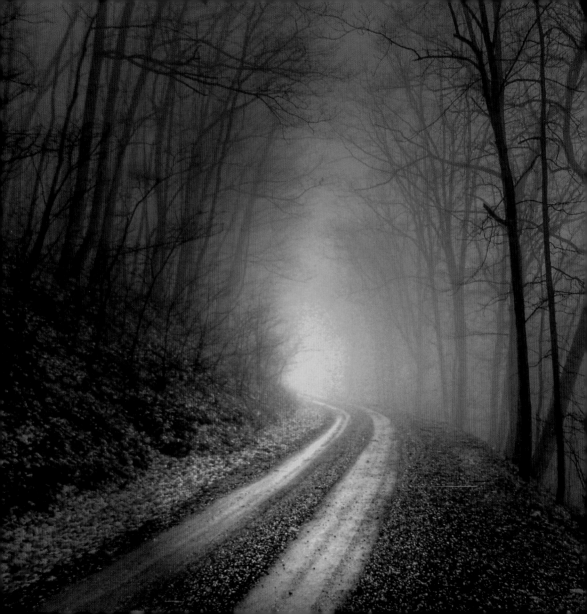

ROBERT MILLER

Thomas Jefferson National Forest, Virginia

Distant light illuminates narrow tracks
through the woods

following pages

FRITZ HOFFMANN

Shaanxi Province, China

A member of an opera troupe prepares
for a performance

Bringing the exotic near, rendering the familiar and homely exotic, photographs make the entire world available as an object of appraisal.

~ Susan Sontag

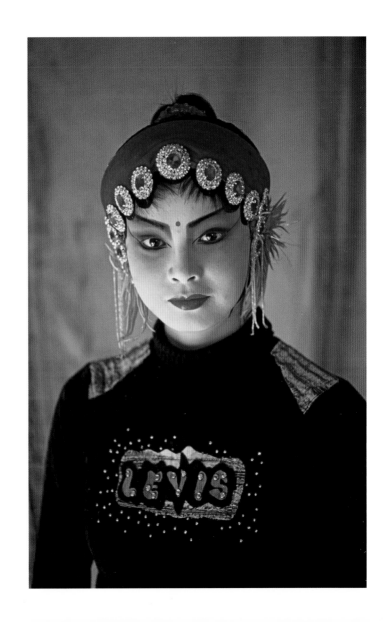

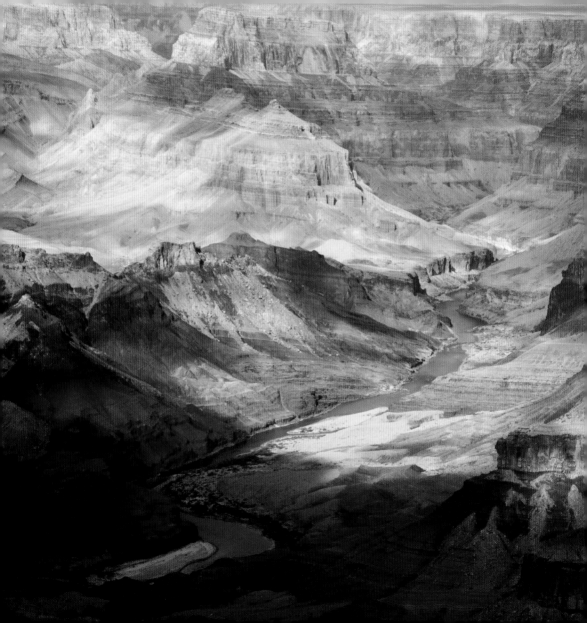

ANNIE GRIFFITHS

Grand Canyon, Arizona

The Colorado River winds between stratified canyon walls

following pages

TUI DE ROY

Sea of Cortés, Mexico

A fin whale swims through a winter feeding area

MELISSA FARLOW
Olympic National Park, Washington
Leaves on a maple tree begin to change color

following pages
JUSTIN GUARIGLIA
Tokyo, Japan
A lone person wanders amid the green
of a manicured garden

Discovery consists of seeing what everybody has seen and thinking what nobody has thought.

~ Albert Szent-Györgyi

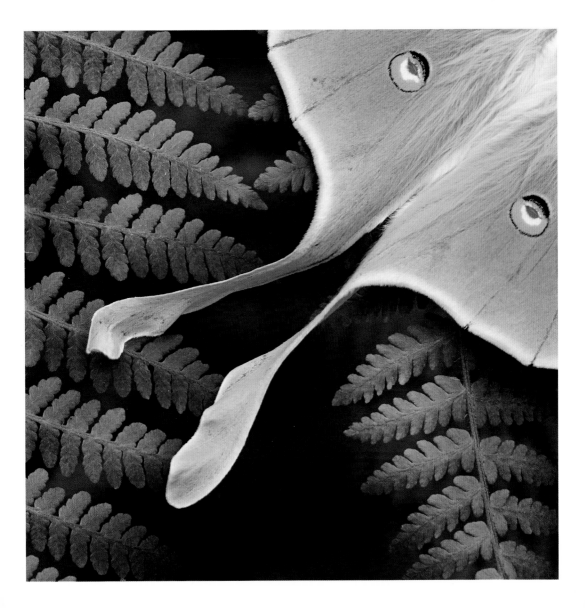

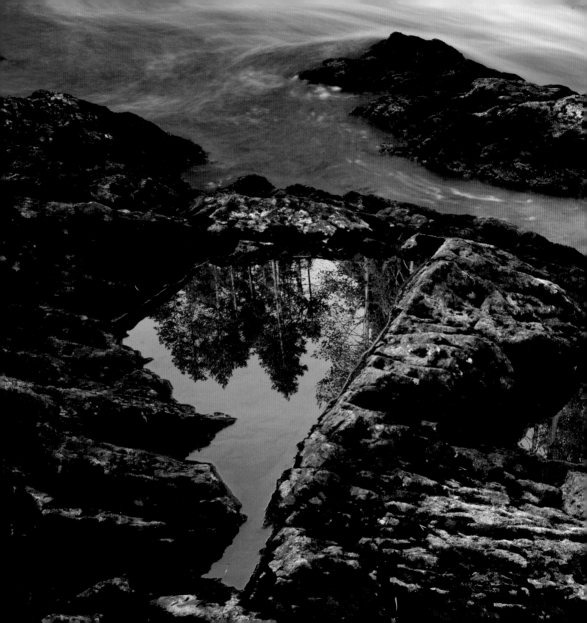

PETER ESSICK

Oulanka National Park, Finland

Rocks and trees are reflected in pools of water along the Oulanka River at sunrise

preceding pages

AMY WHITE & AL PETTEWAY

Fairview, North Carolina

A luna moth rests on a fern

BILL CURTSINGER

Antarctica

A leopard seal's eyes glow through a veil of plankton

following pages

MICHAEL S. YAMASHITA

Kashgar, China

A sudden snowstorm surprises factory workers
on a break

B. ANTHONY STEWART

Middleton Place Gardens, South Carolina

Pink blossoms add color to a river view

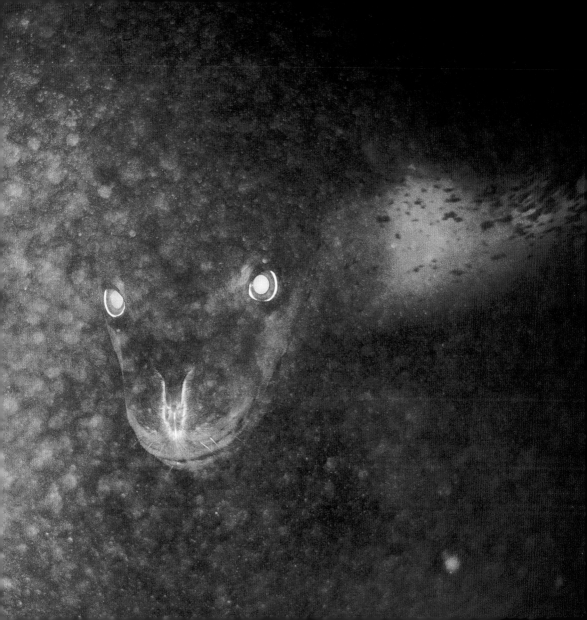

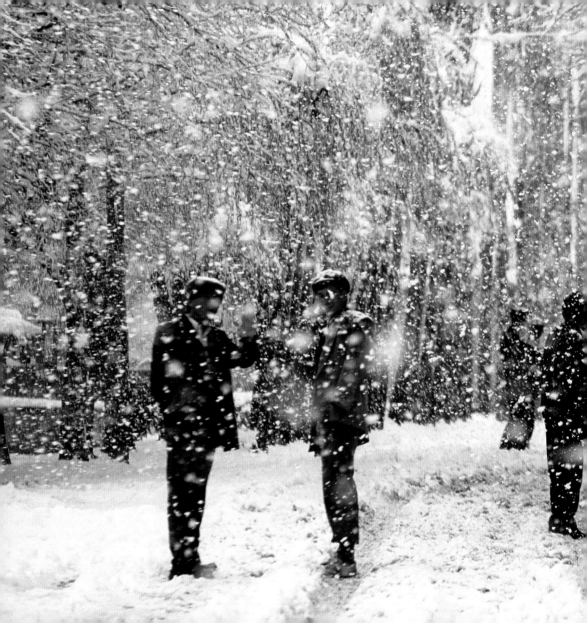

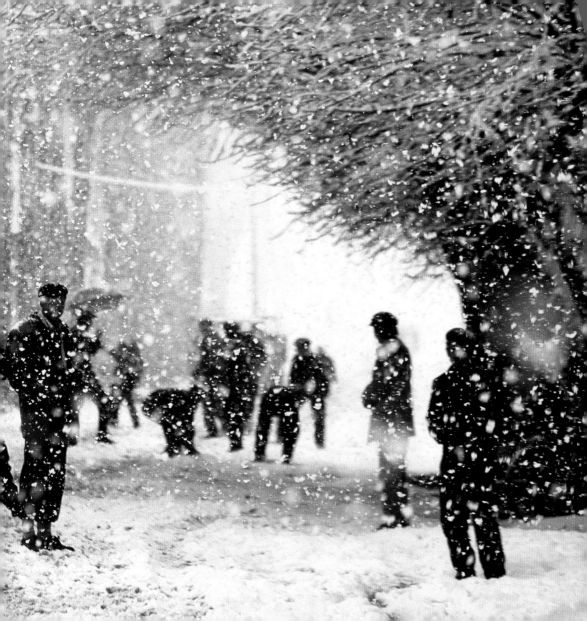

Spring comes: the flowers

learn their

colored shapes.

~Maria Konopnicka

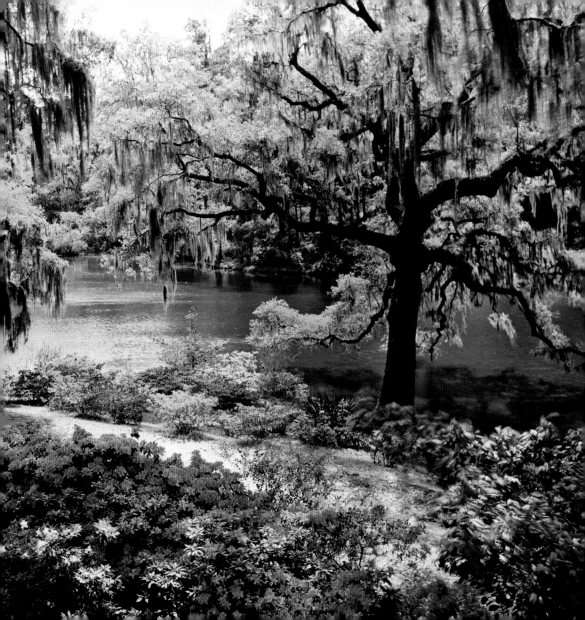

SISSE BRIMBERG

Washington, D.C.

Confetti falls on dancers performing
The Nutcracker

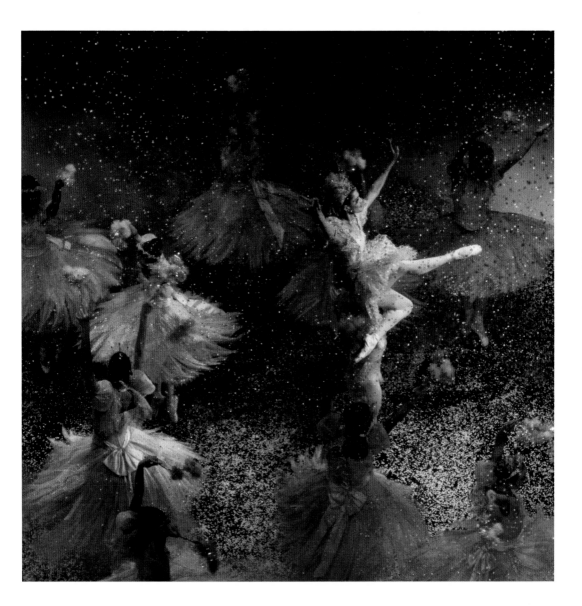

MICHAEL S. LEWIS
Diafarabé, Mali
Yellow fabric billows in the wind

following pages
FRANKLIN PRICE KNOTT
Bali
A nine-year-old dancer wears her gilded crown and costume

JIM BRANDENBURG
Scotland
A wooden swing hangs from a tree

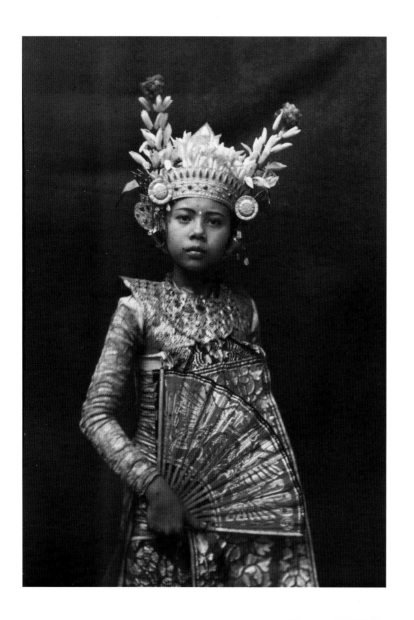

It's not what you look at that matters, it's what you see.

~ Henry David Thoreau

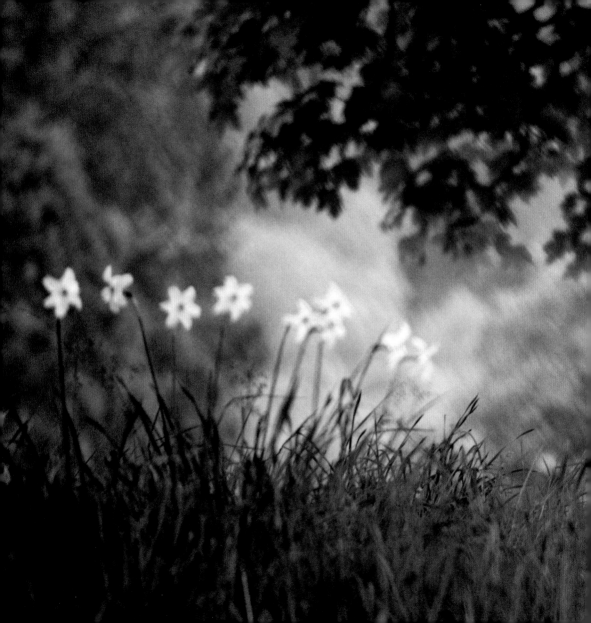

If I had influence with
the good fairy . . .
I should ask that her gift
to each child in the world
be a sense of wonder
so indestructible that
it would last throughout life.

~ Rachel Carson

Wonder

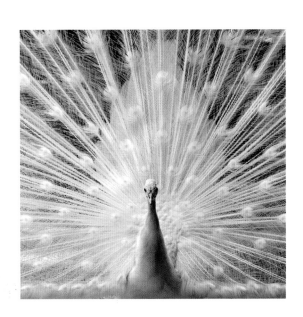

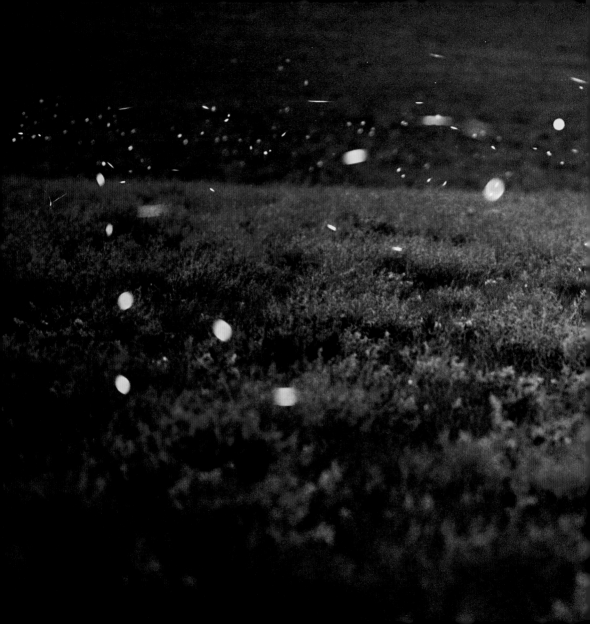

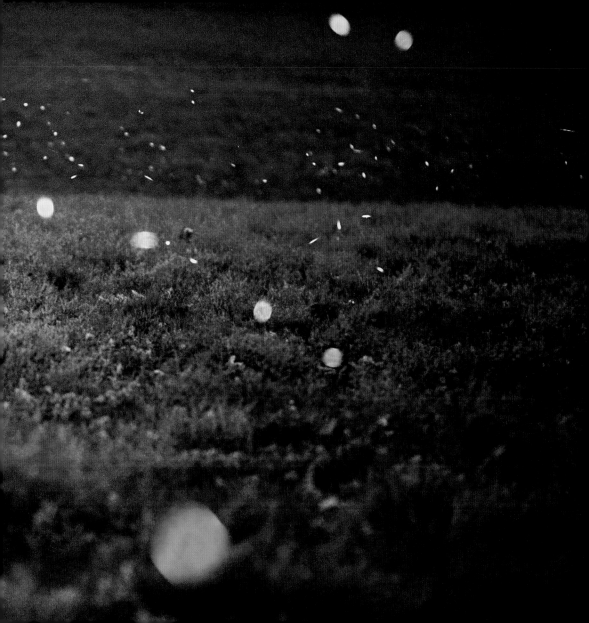

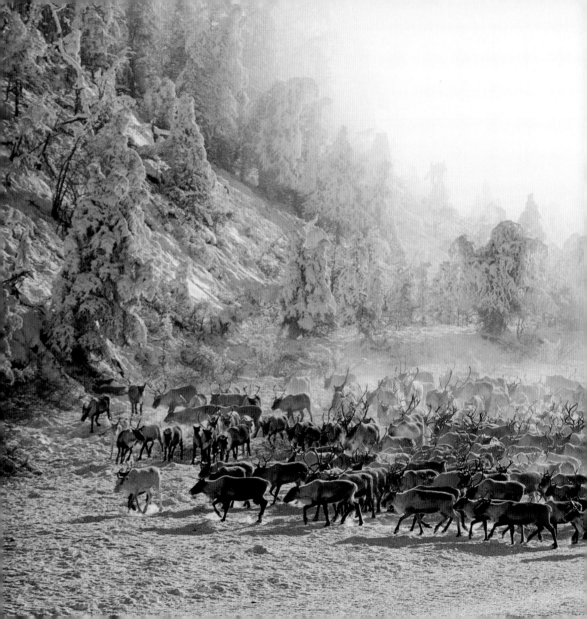

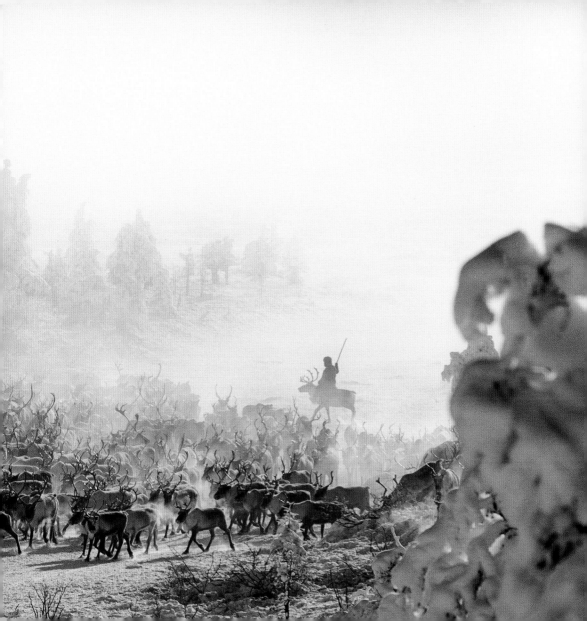

The craziest and most curious photographers on Earth are those who seek wonder. They tend to think very big or very small, micro or macro—the adventurers who go inside volcanoes and chase tornadoes and pull sleds to the North Pole, the endlessly curious, scientific photographers who want a view inside the womb or into the cosmos. They swim with sharks and sea snakes and jellyfish. They lie in the mud and commune with reptiles, or camp in a tree for weeks for a chance to photograph a wild silverback gorilla. They suffer. They endure hordes of insects and battle foot worms and frostbite, and try not to drown when a friendly whale gets a little too friendly. They sometimes risk their lives for a glimpse of a wonder that no one else has seen. To capture wonder in a

Wonder

photograph is to bear witness—to have proof that extraordinary things do exist. These pictures take our breath away. We can't turn the page. We want to share them with others. Nearly everyone has seen an amazing photograph and rushed to show it to someone else immediately. These photographs are gifts. They lift us out of a jaded world and make us gasp. Who knew that hippos could surf or that humans could stand at the edge of an exploding volcano; that the mouth of a clam (pages 418-419) could be so beautiful or that a manta ray could be large enough to dwarf a group of divers (pages 496-497)? How can 16 people free-fall from a plane and join hands in midair? How humbling to see the sad guardians of Easter Island standing tall beneath the Milky Way, centuries after their human creators have passed away (pages 498-499). Sometimes photographers witness extraordinary sights unexpectedly: the sudden, surging beauty of the aurora borealis, or the quickening sight of 10,000 starlings flying in formation.

Dolphins arrive out of nowhere and choose to perform for us, flying before the boat. A young gorilla takes a sudden interest in a single leaf. A butterfly decides to dance on a little girl's forehead. The volcano erupts. The tornado descends. We can hardly believe our eyes. The trick for the photographer in these situations is to pick his jaw up off the floor and capture the moment before it dissolves. And even when the photographer manages that, there is an immediate, haunting fear that technology has failed, or that the photographer himself has failed. Somehow he missed it. Something must have gone wrong, preventing the image from really being recorded. A photographer friend in Iowa had his car picked up by a tornado years ago, and had the presence of mind to shoot as he was tossed through the air. But when he got back to the darkroom he was so rattled that he nearly destroyed the negatives through nervous mistakes. But when photographers survive their nerves and suddenly see the image appear on a sheet of film or the back of the camera, the thrill is— wonderful. ⮑ More often, the pursuit of wondrous images requires patience and courage and stamina. Photographer Carsten Peter was *intentionally* chasing tornadoes when the tables turned on him in South Dakota. He had spent months hunting down such a beast and, suddenly, the monster of all tornadoes was bearing down on him. Peter is a photographer who has crawled into the belly of volcanoes and clung to the ceiling of ice caves. On this day, however, he needed to run for his life. But on this day, he also got the picture (pages 452-453). ⮑ Maintaining patience and passion over long stretches of time is perhaps the biggest challenge for a photographer who seeks to make unique images. These photographs are the result of great commitment. Photographer Paul Nicklen grew up as one of the only non-Inuit children in his Arctic village of Kimmirut. He has

returned again and again to both the Arctic and the Antarctic to document the effects of overfishing and global warming. His miraculous images of polar bears and narwhals and seals and icebergs thrill us and help us understand the wonders that are at risk. ❧ Other stunning images are achieved because the photographer has become incredibly knowledgeable about his subject. Michael "Nick" Nichols and biologist Michael Fay gave months of their lives to a mind-numbing trek through the wild jungles of the Congo to capture images of wildlife and plant species that had never been seen before. Their efforts led to the creation of millions of acres of preserved wilderness. Renowned underwater photographer David Doubilet knows as much about the sea as any marine biologist. In his extraordinary career he has personally discovered three species of marine life. Doubilet has also pioneered photographic techniques that have allowed him to show us a new world of images. His breathtaking image of a pod jellyfish (pages 470-471) took every bit of his artistic, scientific and technological knowledge to capture. And we are the amazed beneficiaries. ❧ The best thing about wondrous photographs is that they inspire us to keep looking. Photographer Diane Arbus said, "A photograph is a secret about a secret. The more it tells you, the less you know." Great photographs make us sit up and ask for more. At times they whet our appetite and make us want to travel and snorkel and climb and spelunk and see for ourselves. They spark the child inside each of us. At other times they make us grateful that we can sit in a comfortable place and witness the wonders they have revealed. ❧ Photographers and technical wizards continue to push the envelope, allowing images of sights never seen or known about before. Astronomers have used photography to number the stars and to record cosmic rays. Early images from the moon were

astonishing, but pictures from the Hubble telescope have made us gasp at the sheer beauty of the cosmos. Microscopic lenses can charm us with the facets on a crystal, or horrify us with the view of a bedbug. And fiber optics take us places that we never dreamed of going: inside the human body. Digital photography, with its extraordinary sensitivity, has made it possible to record scenes formerly too dark to register on film. It has made photography more affordable, and put terrific cameras in the hands of millions of amateurs. But there has been a price to pay for the magic of digital photography. One of the saddest things is that there has been a rapid loss of innocence—not among photographers, but among the general public. People are so aware that digital photographs can be altered in a computer, that there is a new skepticism about the truth of a great image. When a photograph seems too wondrous, there is doubt about its authenticity. Did he clone those fireflies? Did she add stars to the sky? Is it a fake moonrise or a manipulated rainbow? Fortunately, the dedicated photographers who seek wondrous images tend to disdain manipulated images. They are after the real thing. As the photographs in this chapter and in this book show, wonder and beauty are never far apart. William Henry Fox Talbot, inventor of one of the earliest photographic processes, said in the late 1800s that the charm of photography was that the photographer often discovered things for the first time as he recorded them. This remains true today. Photographers continually surprise themselves. They are seekers, and when the stars align, the pinnacle is reached, or the mountain explodes, they triumphantly move on to the next adventure. These photographers are the ones chasing through life with a jar, hoping to capture the photographic firefly before its light goes out.

MICHAEL POLIZA

Sossusvlei, Namib Desert, Namibia

Normally dry grasslands amid the dunes
turn green after an unusual rainstorm

preceding pages (415-427)

PHIL PUMMELL

Sarasota, Florida

An albino peacock displays his feathers

JIM RICHARDSON

Strong City, Kansas

Lightning bugs fly over a field of wild alfalfa

FRED BAVENDAM

Lembeh Straight, Indonesia

Colorful details of a small giant clam

DEAN CONGER

Russia

Reindeer move through a sunlit and
snow-covered Siberian valley

JIM RICHARDSON

Flint Hills, Kansas

Controlled fires burn across Kansas hills

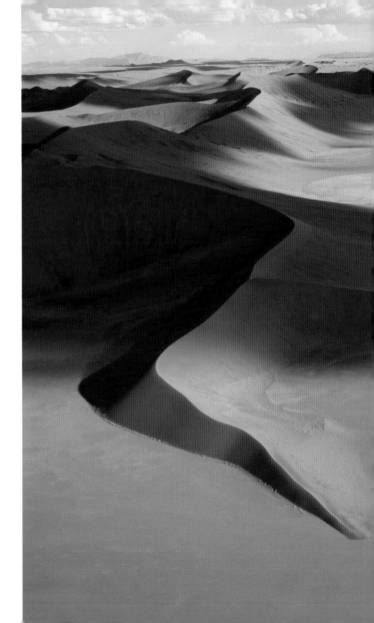

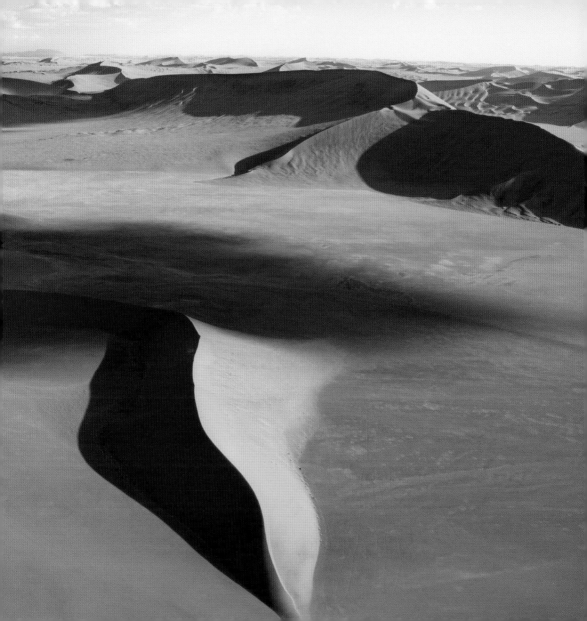

PAOLO PATRIZI

Rome, Italy

A large flock of starlings paint the sky with
their aerial display

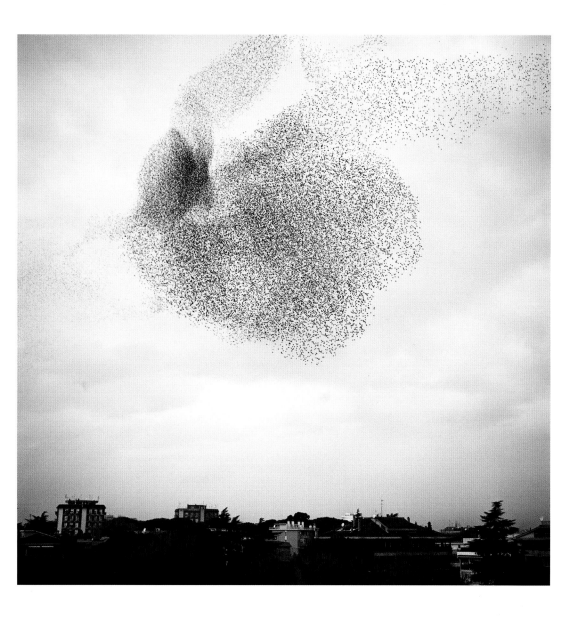

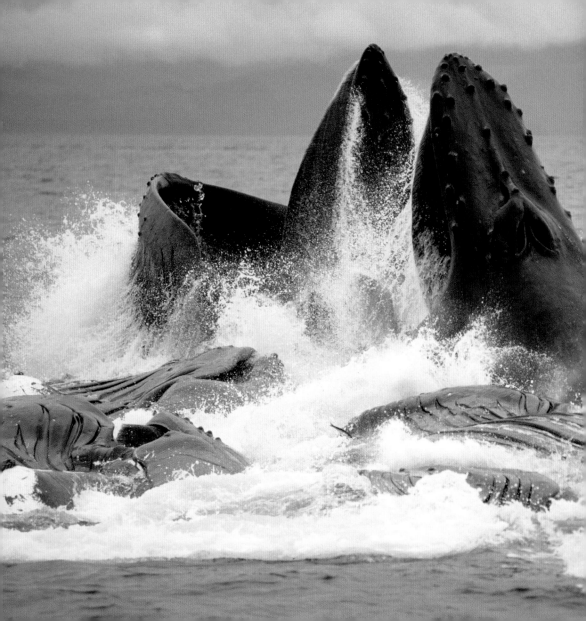

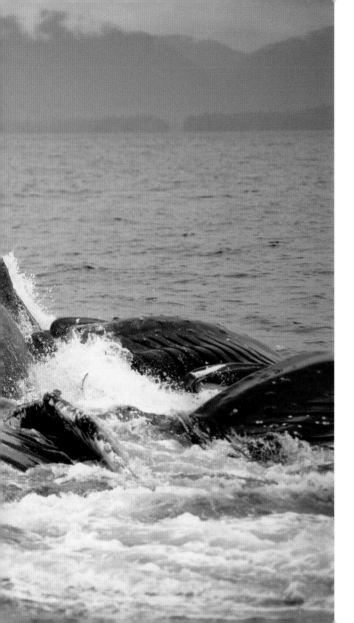

FLIP NICKLIN

Alaska

Humpback whales feast on a school
of herring

following pages

LOWELL GEORGIA

Chesapeake Bay

A sailboat lies in the water after overturning
during a race

JAMES A. SUGAR

San Francisco Bay, California

A tower of the Golden Gate Bridge reaches
up through the clouds

The virtue of the camera is not the power it has to transform the photographer into an artist, but the impulse it gives him to keep on looking.

~ Brooks Anderson

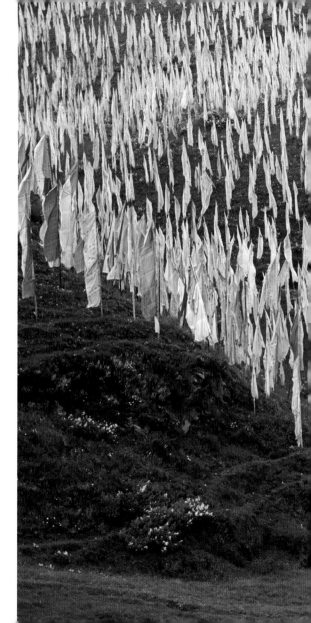

ALISON WRIGHT

Kham, Tibet

A man and horse walk under a sea
of still prayer flags

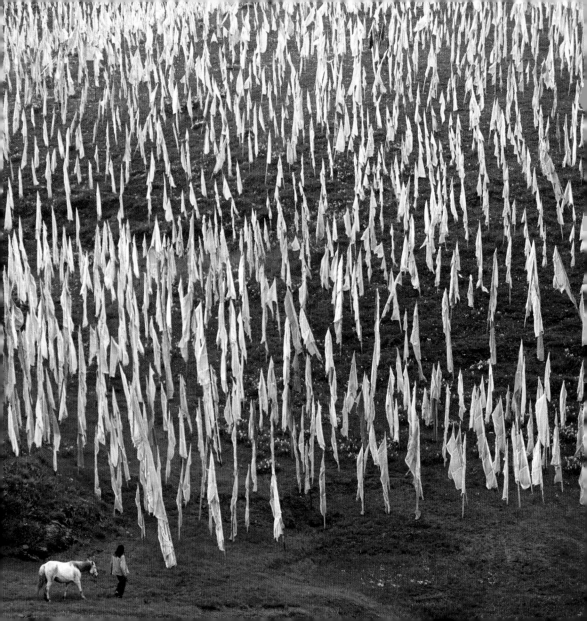

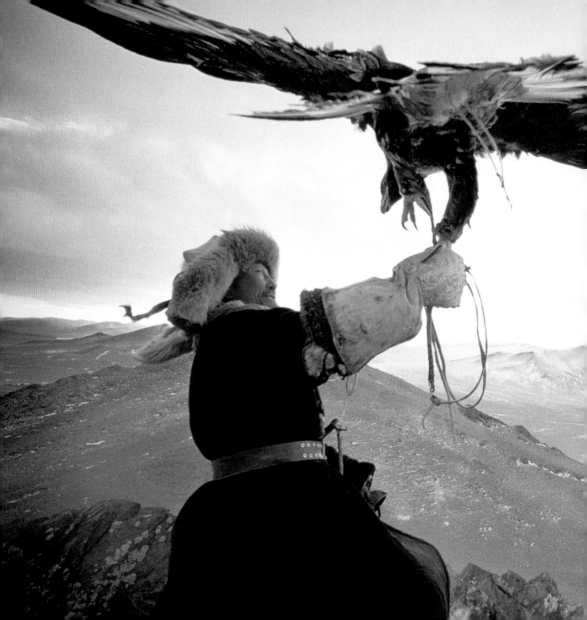

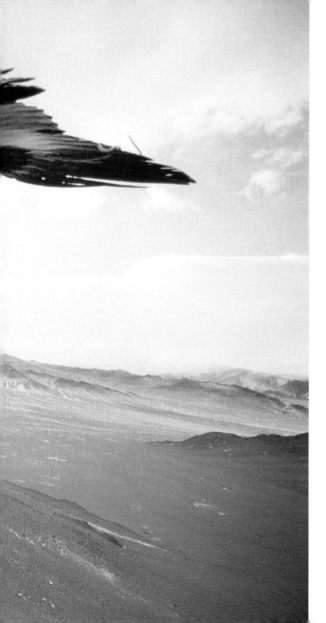

DAVID EDWARDS
Bayan-Olgiy, Mongolia
A Kazakh hunter shies slightly as his golden eagle spreads its wings

following pages
DAVID McLAIN
Talladega, Alabama
A mother gently holds her young daughter

CHRIS NEWBERT
Papua New Guinea
Colorful tentacles of a feather duster worm bend with moving water

PAUL NICKLEN
Pleneau, Antarctica
A group of crabeater seals share a small slab of ice

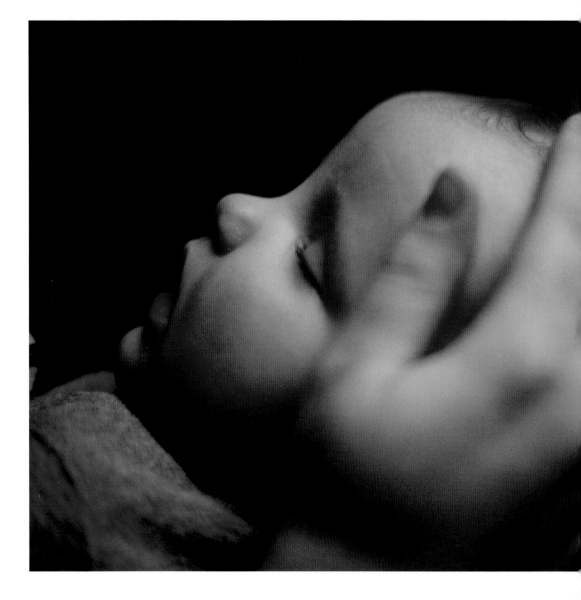

There is a

road from the eye

to the heart that does not go

through the

intellect.

~ Gilbert Keith Chesterton

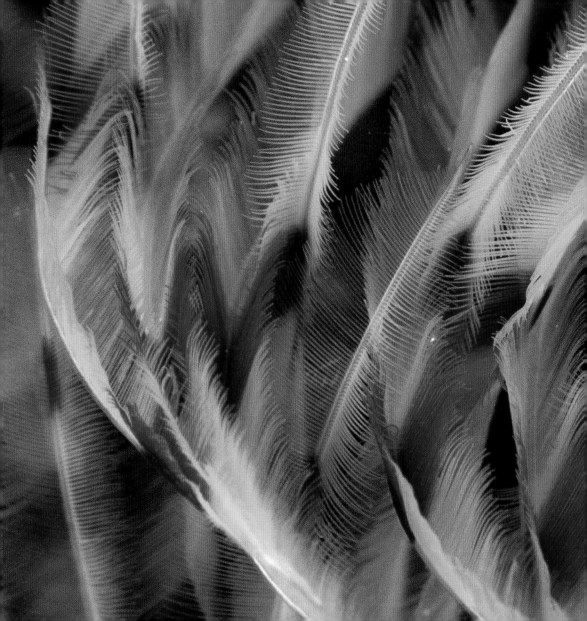

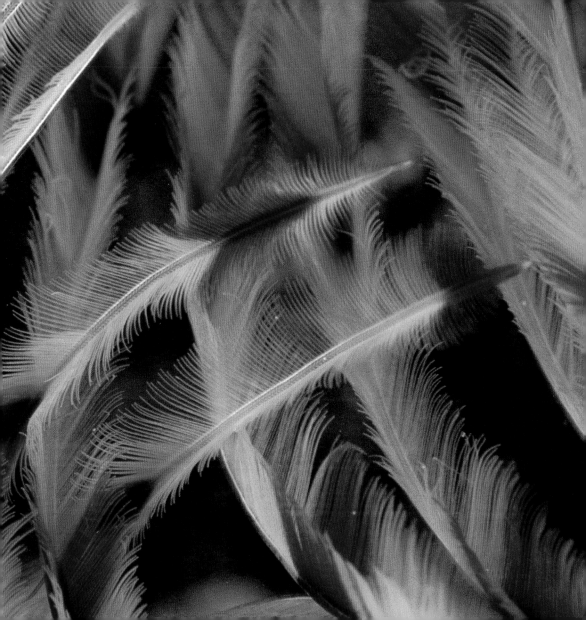

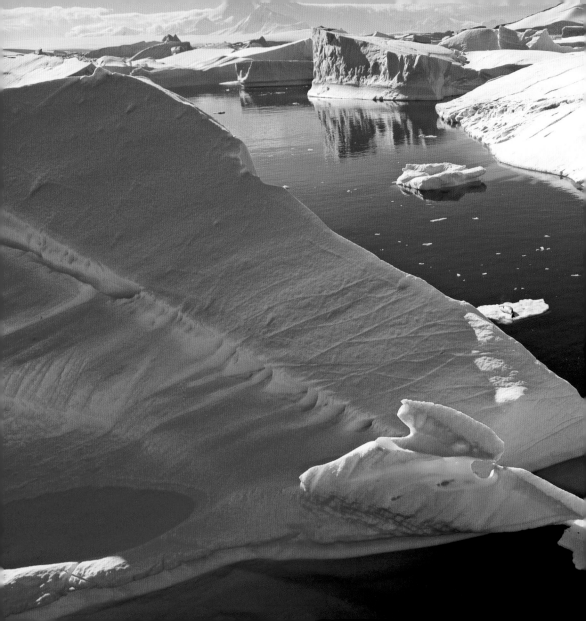

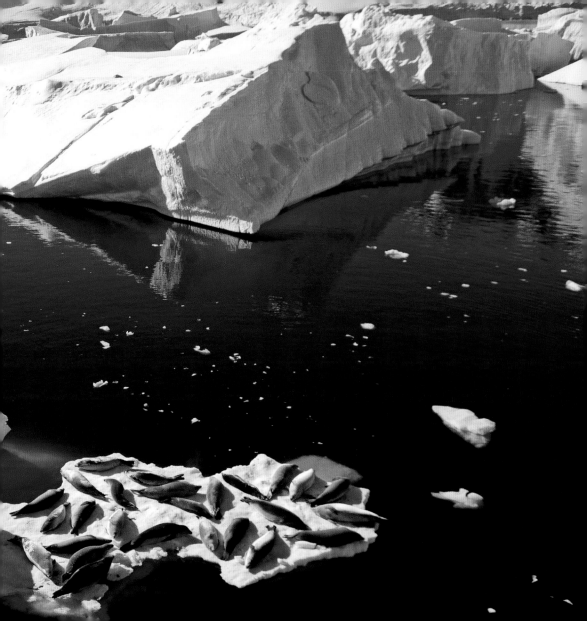

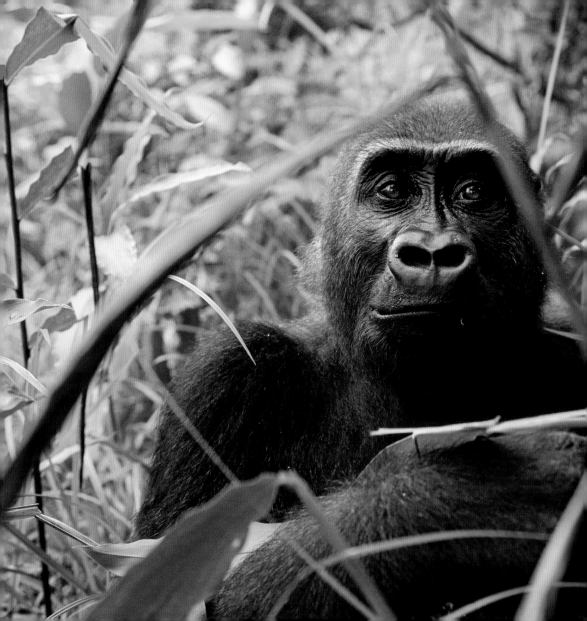

MICHAEL NICHOLS

Batéké Plateau National Park, Gabon

A once captive gorilla looks up from its food

following pages

JOEL SARTORE

Quito, Ecuador

A glass frog's underside is photographed
at a captive breeding facility

CARSTEN PETER

Manchester, South Dakota

An F4 tornado kicks up dust as it moves
across flat land

The most beautiful experience we can have is the mysterious—the fundamental emotion which stands at the cradle of true art and true science.

~ Albert Einstein

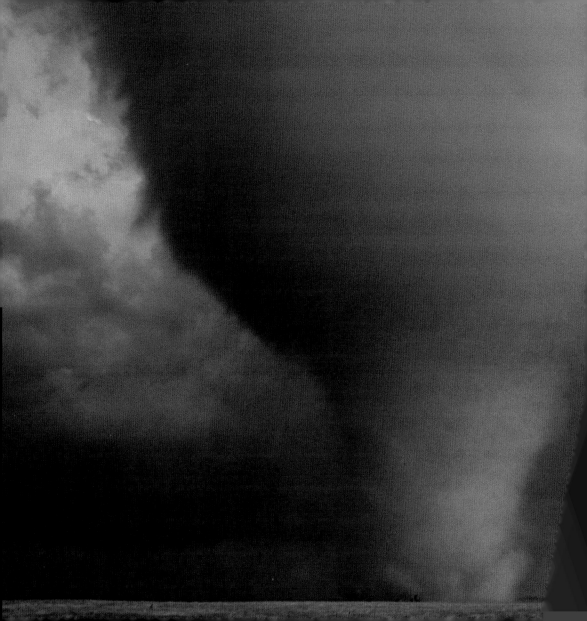

PETER ESSICK

Monterey, California

A school of sea nettles is captured on camera
at the Monterey Bay Aquarium

following pages

MICHAEL MELFORD

West Bank, Israel

Salt crystals cover rocks in the Dead Sea

PEARY ARCTIC EXPEDITION

Arctic Ocean

An aurora dances in the sky beyond the masts
of an icebound ship

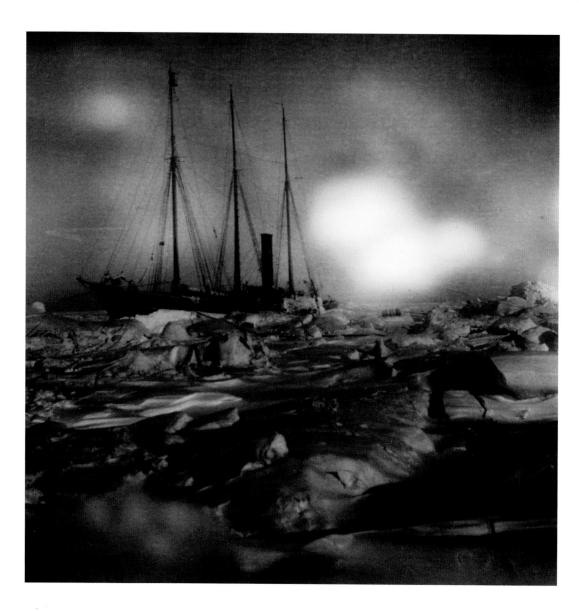

Mystery creates wonder and wonder is the basis of man's desire to understand.

~ Neil Armstrong

JOEL SARTORE

Bioko Island, Equatorial Guinea

Tail feathers of a little greenbul bird fan out
behind closed wings

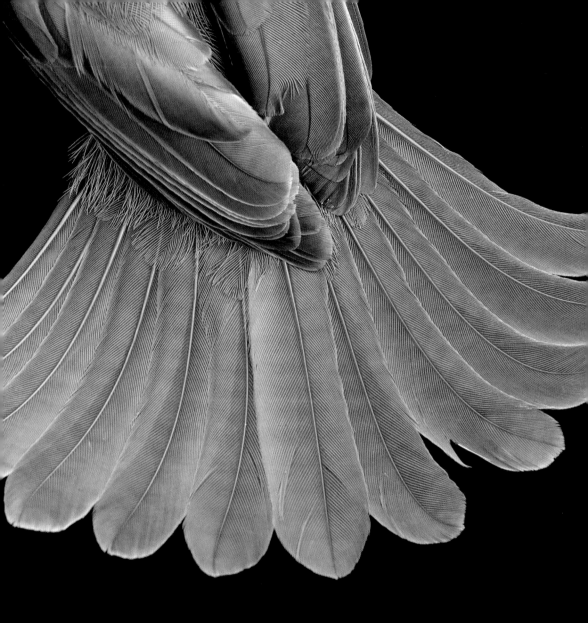

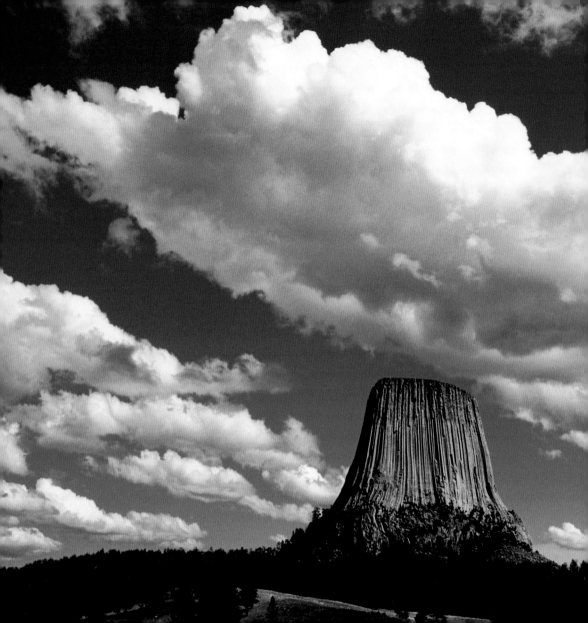

RANDY OLSON

Devil's Tower National Monument, Wyoming

Pulp clouds hang over Devil's Tower

following pages

CHARLES KREBS

Washington

A microscope photograph reveals the
iridescent wing scales of a sunset moth

JOEL SARTORE

Lincoln, Nebraska

A child delights in her encounter with
a zebra butterfly

463

I think the world really boils down to

two types of people—

those who see shapes in cloud formations,

and those who just see clouds.

~ Danzae Pace

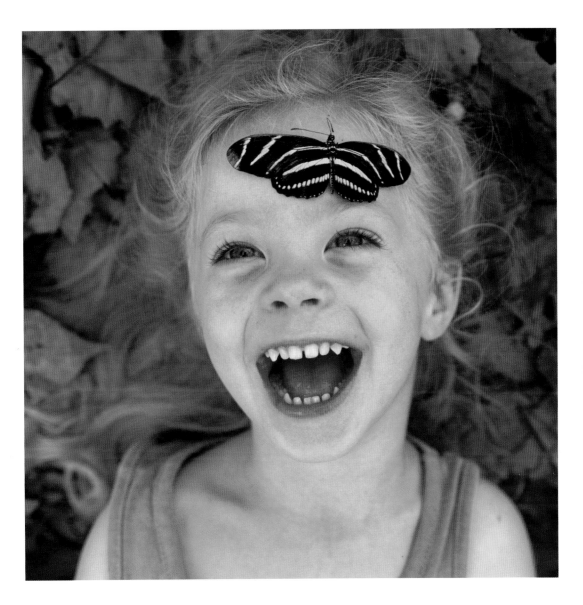

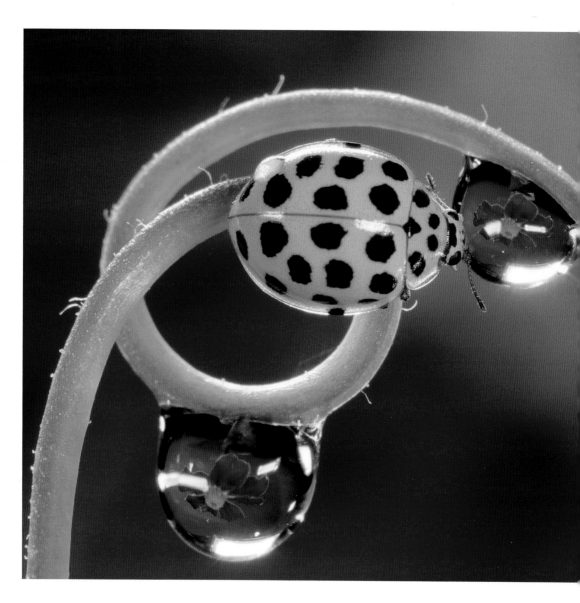

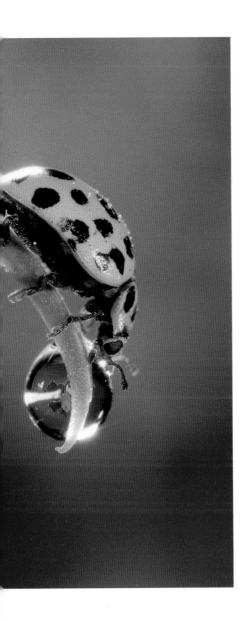

JEF MEUL

Europe

Ladybugs quench their thirst on raindrops
mirroring the reflection of a nearby flower

DAVID DOUBILET

South Africa

A jellyfish hovers just under the surface
in a split-level view

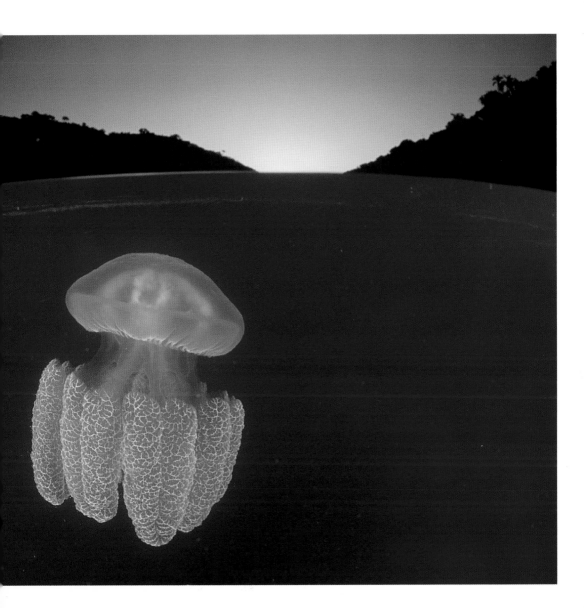

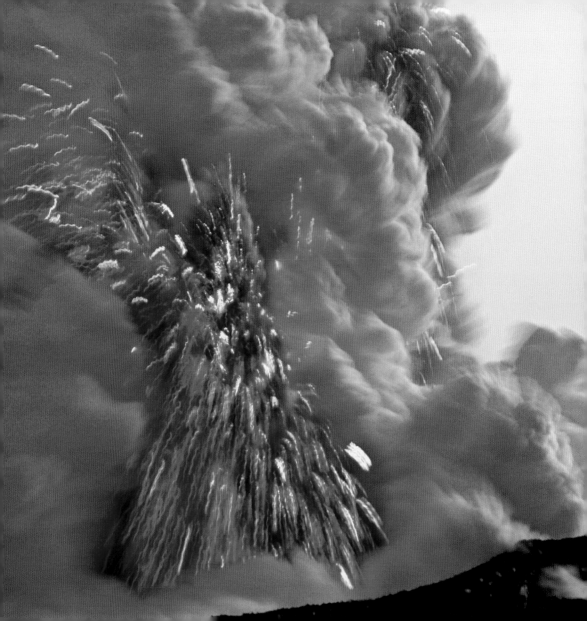

STEVE & DONNA O'MEARA

Big Island, Hawaii

Lava, steam, and ash are ejected from
Kilauea volcano

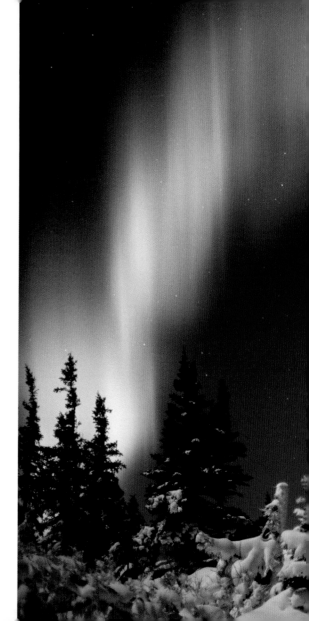

NORBERT ROSING

Wapusk National Park, Canada

Green lights of the aurora borealis dance over
snow-covered trees

following pages

CARSTEN PETER

Germany

A climber moves across the ceiling of an ice cave
in southern Germany

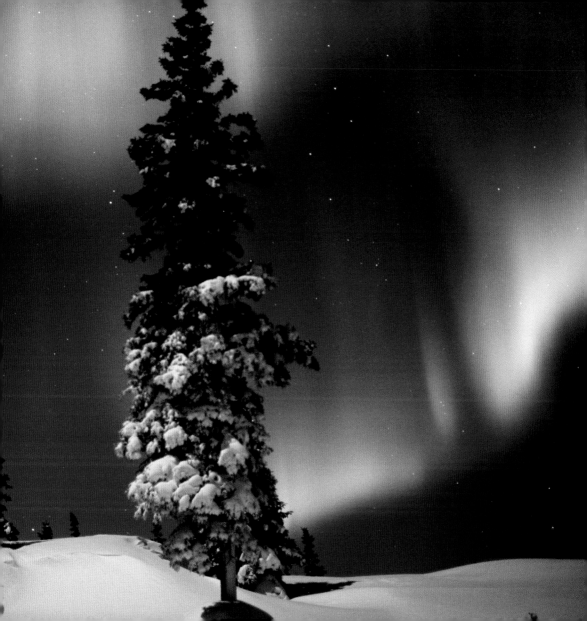

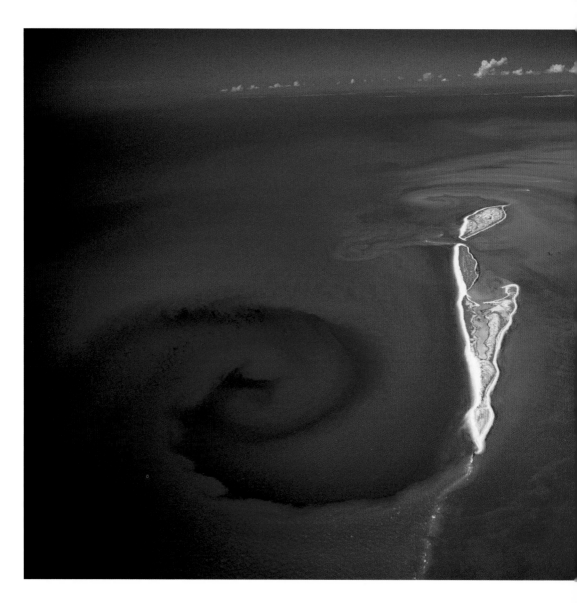

DAVID DOUBILET

Australia

A tidal swirl churns slowly off the coast
of the Lacepede Islands

following pages

DON TAYLOR

Outer Space

The Soul Nebula glows brightly against
its inky backdrop

The larger the island of knowledge,

the longer the shoreline

of wonder.

~ Ralph W. Sockman

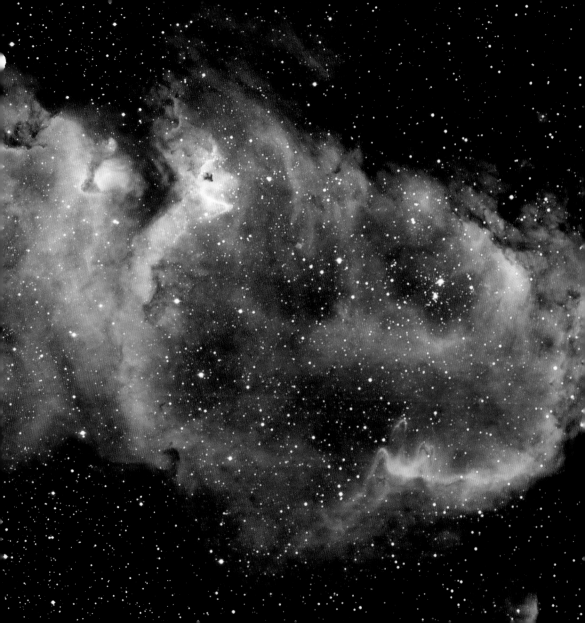

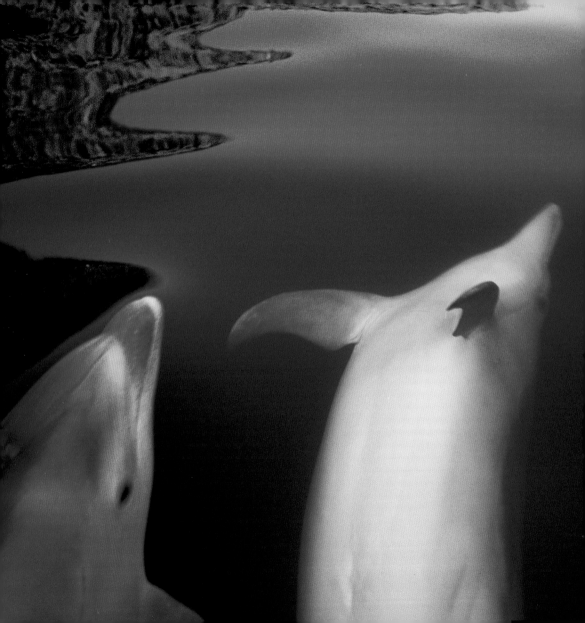

ANNIE GRIFFITHS

Fiordland National Park, New Zealand

Two bottlenose dolphins play in
Doubtful Sound

JOEL SARTORE

Madidi National Park, Bolivia

A young woman drapes herself in the photographer's
camouflage netting

following pages

JODI COBB

Leshan, China

A man rests against the foot of the 71-foot
Great Buddha of Leshan

PAUL CHESLEY

Haleakala National Park, Hawaii

Sea and mist fill the spaces of an eroded lava flow

JIM BRANDENBURG

Yellowstone National Park, Wyoming

An aerial view shows the bold colors of Grand
Prismatic Spring

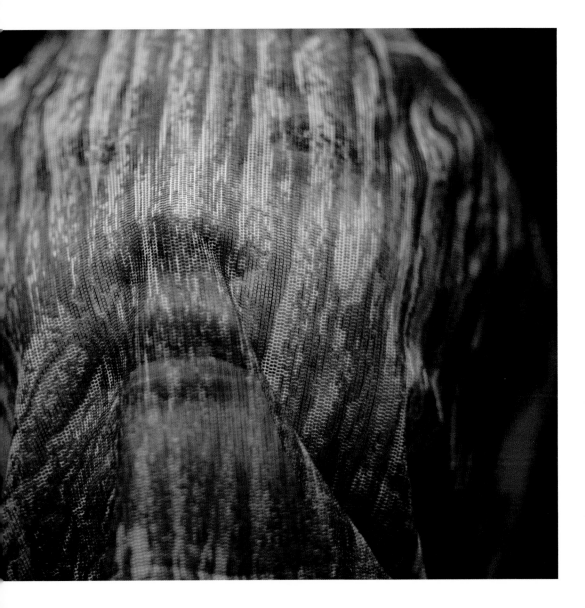

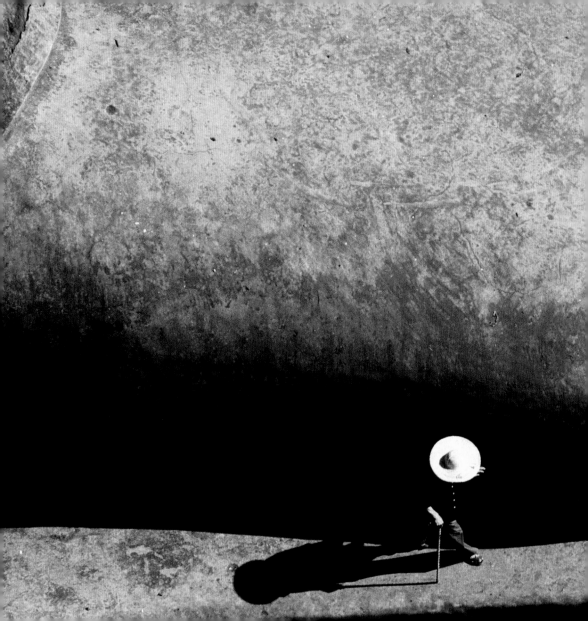

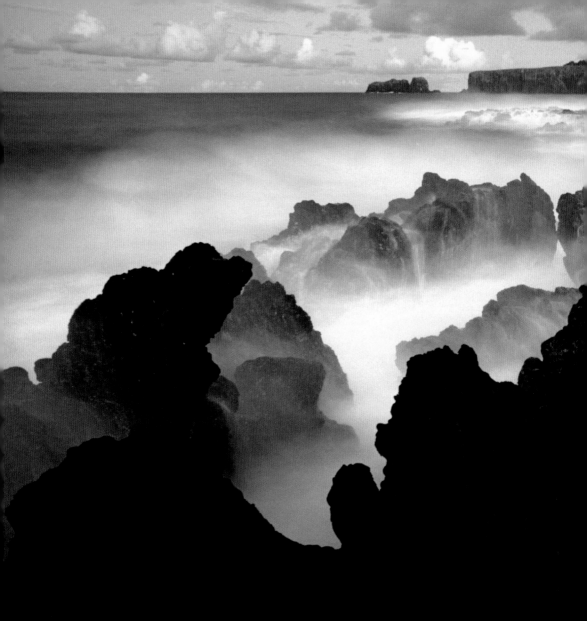

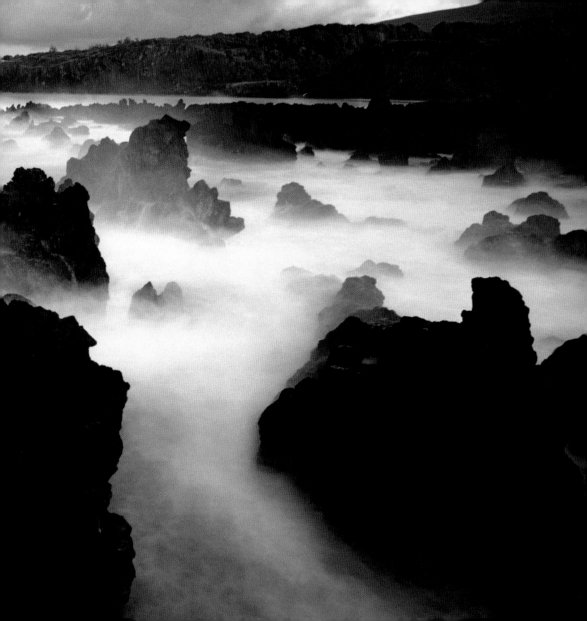

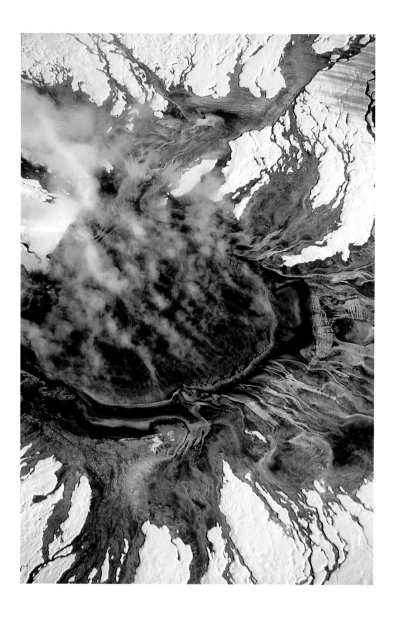

The capacity for wonder has been called our most pregnant human faculty, for in it are born our art, our science, our religion.

~ Ralph W. Sockman

YVA MOMATIUK & JOHN EASTCOTT

Denali National Park, Alaska

Denali and the Alaska Range are reflected in a pond

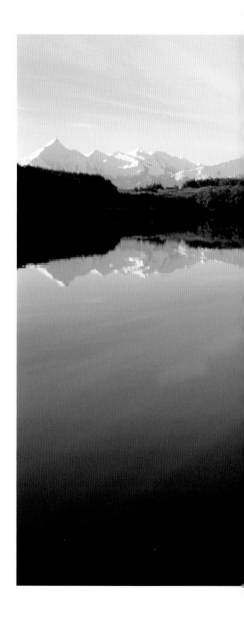

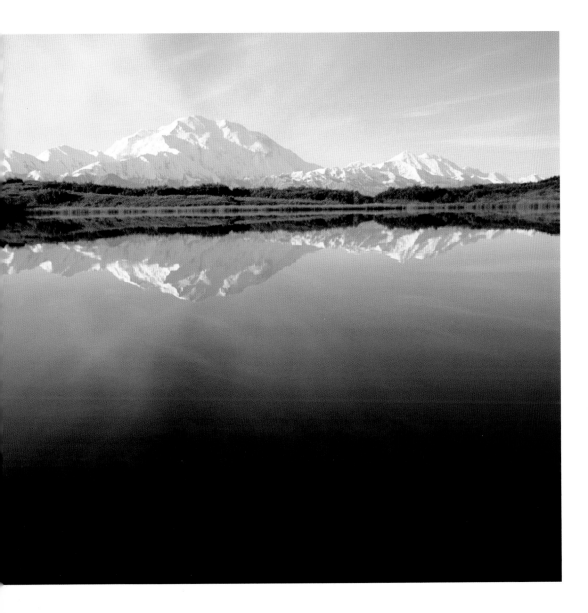

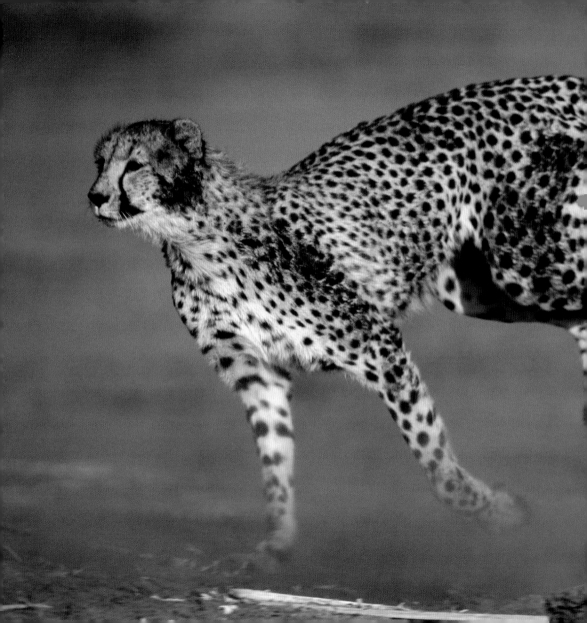

CHRIS JOHNS
Okavango Delta, Botswana
A young cheetah eyes its prey

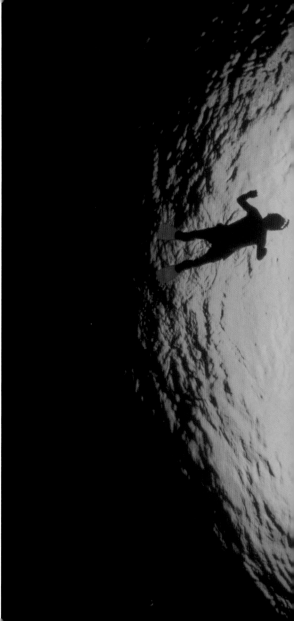

FLIP NICKLIN

Louisiana

Divers watch and photograph a manta ray in
Flower Garden Banks National Marine Sanctuary

following pages

STEPHEN ALVAREZ

Easter Island, Chile

The Milky Way spotlights the famous *moai* statues

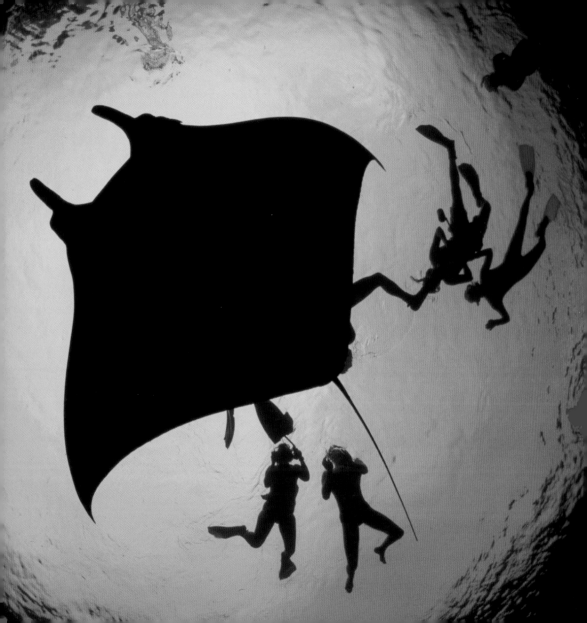

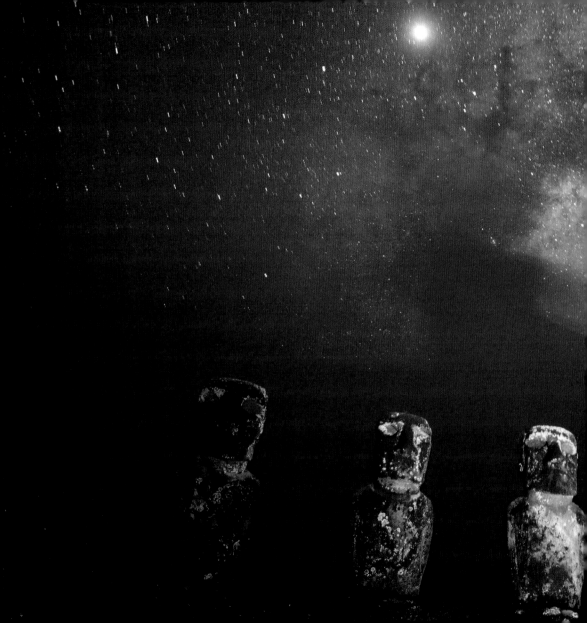

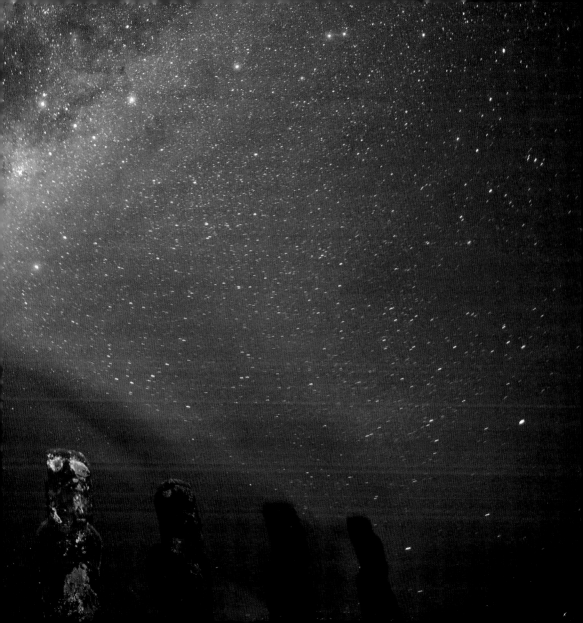

JULES GERVAIS-COURTELLEMONT

Pont-l'Abbé, France

A woman wearing traditional clothing
leans on a wall

Acknowledgments

It takes a village to build a book, and *Simply Beautiful Photographs* was born in an extraordinary village. ❧ Team visionaries were Nina Hoffman, President of the Book Publishing Group, and Maura Mulvihill, Director of the Image Collection, who had the idea to create a book featuring some of National Geographic's loveliest photographs, many of which, for the very first time, can be purchased for private enjoyment. ❧ Artist on board was Marianne Koszorus, Books Director of Design, who presides over the design of more than 50 National Geographic books annually and yet agreed to add her personal artistry to the design of *Simply Beautiful Photographs*. She was aided in the eleventh hour by her talented designer Allison Morrow. Thank you, Al. ❧ After a career as a photographer, having the opportunity to write a book about the elements that make a photograph beautiful was both daunting and delightful. Fortunately, I had the skilled mentorship of Editor in Chief Barbara Brownell and her able assistant, Bridget English, to guide every sentence and help a photographer become a writer. ❧ None of us would have survived without the calm and confident leadership of project manager and director of illustrations Meredith Wilcox. Meredith may field more emails than President Obama in her role as project manager. For nine months, she kept this beautiful train on the track. ❧ The photographs are truly beautiful because of the skill of our extraordinary production and manufacturing teams, including Gary Colbert, Mike Horenstein, Chris Brown, Phil Schlosser, and Rachel Faulise, who presided over every image and made sure that it would shine on the pages of this book. And Image Collection picture editor Lori Franklin fielded countless requests for new images and better scans with efficiency and enthusiasm. Thank you all. ❧ Most important, I would like to thank the amazing group of photographers whose work is featured in *Simply Beautiful Photographs*. After more than 30 years as a photographer at National Geographic, I thought that I understood the talent of my colleagues. But after spending weeks going through their astonishing work, I had the urge to send fan letters to them. For every image that is published in National Geographic publications, there are hundreds that, for one reason or another, are not chosen for a specific article. Many of the photographs in this book have never been published. For me, the greatest reward of photo editing this book has been finding those magnificent photographs and letting the world see them. Enjoy.

Index of Photographers

ROBERT MILLER
pages 384-385

GEORGE F. MOBLEY
pages 170-171

YVA MOMATIUK & JOHN EASTCOTT
pages 54-55, 304-305, 492-493

W. ROBERT MOORE
pages 160-161

CHRIS NEWBERT
pages 444-445

IAN NICHOLS
pages 238-239

MICHAEL NICHOLS
pages 58-59, 152-153, 282-283, 288-289, 324-325, 327, 342-343, 448-449

PAUL NICKLEN
pages 200-201, 206-207, 220-221, 270-271, 316-317, 322-323, 446-447

FLIP NICKLIN
pages 12-13, 236-237, 432-433, 496-497

RICHARD NOWITZ
pages 80-81

HARRY OGLOFF
page 176

RANDY OLSON
pages 88-89, 234-235, 254-255, 462-463

STEVE & DONNA O'MEARA
pages 472-473

WINFIELD PARKS
pages 50, 100-101, 243

PAOLO PATRIZI
page 431

PEARY ARCTIC EXPEDITION
page 458

HEATHER PERRY
page 337

CARSTEN PETER
pages 372-373, 452-453, 476-477

JOE PETERSBURGER
pages 294, 340-341

MICHAEL POLIZA
pages 428-429

PHIL PUMMELL
page 415

STEVE RAYMER
pages 268-269

RICH REID
page 203

JIM RICHARDSON
pages 138-139, 356-357, 380-381, 416-417, 426-427

NORBERT ROSING
pages 116-117, 474-475

SUSIE POST RUST
pages 306-307

JOEL SARTORE
pages 104-105, 226, 350-351, 450-451, 460-461, 467, 484-485

PHIL SCHERMEISTER
pages 107, 186, 310-311

ABIGAIL EDEN SHAFFER
pages 6-7

JAMES L. STANFIELD
pages 2, 52-53, 60-61, 90-91, 144-145, 154-155, 184-185, 190-191, 232, 250, 258-259, 262-263, 266-267, 272

MARIA STENZEL
pages 86-87

B. ANTHONY STEWART
pages 102-103, 404-405

JAMES A. SUGAR
pages 436-437

DON TAYLOR
pages 480-481

JAN VERMEER
pages 382-383

AMY WHITE & AL PETTEWAY
page 397

MAYNARD OWEN WILLIAMS
pages 94-95, 130

GORDON WILTSIE
pages 252-253

EDWIN L. WISHERD
page 195

KONRAD WOTHE
pages 296-297

ALISON WRIGHT
pages 438-439

MICHAEL S. YAMASHITA
pages 98-99, 319, 402-403

To Purchase Prints
High-quality prints of many of the spectacular photographs featured in this book can be ordered for your personal enjoyment at www .NationalGeographicArt.com. Ordering instructions and our everyday low prices can be found on the site.

Professional Photo Buyers
Most of the photographs in this book are available for editorial and creative licensing. For details, please visit www.NatGeoCreative.com.

ADDITIONAL CREDITS INFORMATION
The following images are from the collection of Minden Pictures: 14-15 (Foto Natura), 110-111, 140-141, 146-147, 166-167, 246-247, 292-293, 296-297, 304-305, 308 (Foto Natura), 382-383 (Foto Natura), 390-391, 412-413, 418-419, 432-433, 444-445, 468-469 (Foto Natura), 490, 492-493, 496-497

Simply Beautiful
Photographs
Annie Griffiths

PREPARED BY THE BOOK DIVISION

Barbara Brownell Grogan, *Vice President and Editor in Chief*

Marianne R. Koszorus, *Director of Design*

Carl Mehler, *Director of Maps*

R. Gary Colbert, *Production Director*

Jennifer A. Thornton, *Managing Editor*

STAFF FOR THIS BOOK

Meredith C. Wilcox, *Project Manager*

Annie Griffiths, *Illustrations Editor*

Tiffin Thompson, *Picture Legends Writer*

Moriah Petty, *Editorial Assistant*

Michael O'Connor, *Production Editor*

Nicole Miller, *Design Production Assistant*

Mike Horenstein, *Production Project Manager*

Rob Waymouth, *Illustrations Specialist*

Al Morrow, *Design Assistant*

MANUFACTURING AND QUALITY MANAGEMENT

Christopher A. Liedel, *Chief Financial Officer*

Phillip L. Schlosser, *Vice President*

Chris Brown, *Technical Director*

Nicole Elliott, *Manager*

Rachel Faulise, *Manager*

Since 1888, the National Geographic Society has funded more than 13,000 research, exploration, and preservation projects around the world. National Geographic Partners distributes a portion of the funds it receives from your purchase to National Geographic Society to support programs including the conservation of animals and their habitats.

National Geographic Partners
1145 17th Street NW
Washington, DC 20036-4688 USA

Get closer to National Geographic explorers and photographers, and connect with our global community. Join us today at nationalgeographic.com/join

For information about special discounts for bulk purchases, please contact National Geographic Books Special Sales: specialsales@natgeo.com

For rights or permissions inquiries, please contact National Geographic Books Subsidiary Rights: bookrights@natgeo.com

ISBN 978-1-4262-1726-5

Printed in China

18/PPS/3